Edited by Robert Klanten, Hendrik Hellige, Michael Mischler, Vicky Tiegelkamp, Jan Rikus Hillmannn

We are a Homepage . Jan Rikus Hillmann, General Manager Design, it's immaterial GmbH, Berlin . Vicky Tiegelkamp, General Manager, playframe digital media studio, Berlin

"Some designers are in a position to always assume that the average internet user is an idiot. Our job, as developers, is to create systems that educate. I truly do not believe that e-commerce or brochure sites have to be boring to navigate. I truly believe we are on the cusp of re-defining this medium, as standards come into play, technology continues to flourish, and statistics relax a client into taking risks - we just might be sitting on something enormously bigger than we initially thought." (CHAOS Mailinglist / Joshua Davis)

R: Taking risks is, in a nutshell, what 72dpi is all about. The experiments here represent an active and offensive negation of the self-evident / generally applicable / accepted truths of the Web, a vanquishing of the status quo of the Web. They stand for movement, courage and an active, progressive and productive engagement with the medium.

"The fact that the Internet was not in fact originally conceived for design purposes has been viewed as a challenge rather than a deterrent..." (PlanetPixel)

V: For months now, we have been standing in the sidelines watching as commercial design retreats into superficiality. Websites are constructed in an almost identical way, despite the fact that we already have the technical possibilities for discovering and developing new ways of navigating and the structural and architectural possibilities for this have long since been thought of. They have to be used and exploited, but the problem is that neither agencies nor clients feel confident enough to do so. There is no more experimentation, no more fun, not like in the early days. No, users have been branded as idiotic machines, too stupid to find their way around unless the main navigation takes place up at eye level and the submenus are on the left. Left, because Europeans and Americans read from left to right. There is even a name for this off-the-peg web design in the USA: left-side navigation.

"The body of expertise that has developed around the question of user-friendliness or navigation solutions appears to have sacrificed itself to an unusual philosophy of consensus." (Alexander Baumgardt)

I have the impression that designers are retreating into niches. Complex DHTML sites which do justice to the medium and which are exciting in their functioning as well as in their storytelling, as for example the Adobe site http://www.defytherules.com are becoming the exclusive, handmade variety. Flash animation is the name of the game at the moment. Animate, whatever kind of rubbish - forget about content, form and function.

"In all of this, it is irrelevant whether this frustration is due to the onslaught of the corporate players or the Flash masturbations of the cutting edge, which increasingly masks lack of content and authenticity beneath ambitious animation."(Thomas Noller)

But what does it all mean? Have designers become too comfortable? At Amazon.com, there are numerous books on how to use Flash in the Top 10 best-selling computer books. For designers today, learning Flash means earning money. Has the great web design sell-off begun?

R: Designers must finally realize their potential as "designers", not as traditional graphic artists in the context of the Web. Design is a generalized discipline which unites structuring, conception, development and management with the ultimate aim of guaranteeing both the use quality and the formal aesthetic quality of a product. The current dilemma is that design has no real position while web design has only a superficial identity. As a discipline it has a fundamentally flawed location in the new economy workflow. For many outside the profession, design means "rounding edges" and "making things pretty", and, unfortunately, for too many so-called designers, pure Flash-masturbation. Design can only develop its potential if it comes to be seen and used as a comprehensive, conceptual service from the beginning of the production process.

"Effective communication depends on using resources, and resources are inextricably linked with aesthetics." (Gui Bonsiepe)

The task of designers is the professional bridging of the gap between self-expression (the artist) and problem-solving (the engineer), to make their mark with a recognizable portfolio of work and thus to create an identity, a profile. Design is about understanding and using form and content, not the debate about them. In the fields of interaction, interface and usability. As professionals providing a service on the Web, we are in the contradictory position of having to coach the customer in the new medium while at the same time trying to sell them our service. Now is the time to sell and to bedazzle at one and the same time. The so-called truths of the Web will finally be examined for the purpose of innovation.

V: The few who go that bit further and risk the unthinkable - maybe even take a step backwards in the process - gaining a new view of the whole - they are the engineers of new, interesting constructs. People like Joshua Davis. He calls me in response to my email inquiring as to whether he would be interested in contributing something to 72dpi. Rapidly and excitedly he talks to me about ferns, chaos theory, mathematical equations. He writes "...we must look beyond the web's boundaries for inspiration in order to bring to the table something never seen before. Maybe we can find such forms in nature?" Ferns, for example, he says . When his chapter arrived, I was confused. And he was pleased. He phoned back two days later and said "Well, did you understand my chapter?". I said "No, not really". "That's just what I wanted" he replied and chuckled to himself. The fern as a means to achieving the goal. I liked that.

R: For me, it is precisely this all-embracing and questioning way of thinking that marks out a designer. Nature and society are systems with innate interlinkages and networking and enormous potential for examples and metaphors which designers can use (and which are being used in the area of bionics) precisely with a view to usability and quality. Nature shows us applications with 100% efficiency. The only amazing thing is that nobody in the new economy seems to have realized this: many agencies demand more courage from their clients; I think, however, there must be more than this: honesty, authenticity and substance in web communication. An open dialogue of credibility is something creative, not a communication neurosis devoid of content concealing through animation. This also means finally vanquishing conservative navigation metaphors.

The marketing sovereignty on the Net has relegated usability, creativity and efficiency to peripheral parameters even though they are the basis of any form of communication. Everyone is talking about one-to-one communication but no-one seems to understand that what it is about is a concrete and substantial dialogue, a synthesis of new information on the basis of a conversation.

Websites today predominantly work on the principle of persuasion, just like traditional advertising. What they should, however, be about is convincing people and building up an equal relationship through a communicative partnership. The sad fact is that because people have more faith in the McKinseys of this world who think in progressive business units than in designers who think in progressive communicative solutions - the basis of the medium - they are simply servicing and operating the channels passively rather than actively shaping and molding them.

Design too has to learn to act and convince in an economical way on the Web and to raise its profile. Creativity, efficiency and quality are the key parameters here and the convincing features of an appropriate and innovative communicative solution. Design is always at the start, design is a catalyst preparing the way for marketing. Design must create meaning and have meaning. Something that cannot really be said about too many of the services on the Web.

V: Good design is also a question of inspiration and courage. Chance, play, an evening out clubbing, music, film, love, sex, day-dreaming together with experience, sampling and the constant exchange with friends, checking, weaving further - all of these lead to new things.

"Inspiration comes from everything. The problem is not where to obtain it, but where not to." (Eddie Pak)

R: Chaos, coincidence, destruction, storytelling are methods which have extraordinarily offensive creative potential. Each experiment is an indicator of a process of innovation and progress. It should serve one purpose alone: either experimental sounding out, discovery of new forms of communication. Or else simply personal expression.

V: Many of those who really play with the medium, who try things out and thus have a sort of role model function, they are the deconstructive, crazy sites that are making noise. These experiments, mainly the product of young designers are often so associative, wild and new that they are closer to art than to the craft of design. The Net demands that new methods for storytelling are considered. These means are now being added to by the parameter of interaction. Storytelling is the symbiosis of information and emotion. Alongside the facts we are also transporting visual and emotional knowledge. If we are telling a story by digital means then, in the best case scenario, this can consist of all media that are at our disposal, such as video, text, sound, animation and graphics. Complex contexts and connections can then be explained and narrated quickly, at a glance even.

"When I view someone's website, I am mostly interested in what that person is trying to say. What he/she is trying to say is also a matter of how they are saying it. Whether that's with plain ASCII text or using a video stream, the underlying factor is the message." (Jeremy Abbett)

From ones and zeros we now have new forms of presenting. Scripts are being written which throw visuality into a random number generator. Many designer portfolios no longer bother wasting their time with one-off commissions - they no longer see these as a challenge. Thus, complex, highly intelligent and often humorous experiments are created and the sites themselves become exciting magazines or art events (i.e. volumeone.com, feed.de...).

"Webart, in other words, is a little bit ahead of its time and for that reason perfectly wonderful, most notable and not sufficiently documented." (David Lindermann)

R: It is important to take a self-confident position: Call and Response, encoding/decoding. Away with passiveness. The Web offers us the best opportunity for offensive and innovative self-expression. Web design always means engaging with the new medium, its possibilities, a personal or written communication goal and, on a personal level, not settling for less. Regardless of whether we are pursuing greater self-expression or the engineering idea, a creative solution to a problem will be initiated. This engagement, the active process means at its core molding a medium. Progress not adaptation. Courage, creativity and idealism are the budget.

"The web designer competently commands all these components in a new framework of a new medium and connects them with the unseen aspect, the architecture, which is hidden beneath the single dimension of the screen. And it is exactly this which brings designers closer to what they sometimes can and always want to be: a Diva or interface to happiness." (Sabine Fischer)

"However, an awareness of the interrelationships between design, narrative delivery, interactivity and the experience of information can provide insights and possible answers to effective visual communication in the interactive arena." (Matt Owens)

"There will be places where I seem to be arguing with myself. I am." (N. Nezanova)

please wait
while
loading

0% 50% 100%

ivier_Chêtelat. Henrikk_Karlsson < method_inc.
ww.smashstatusquo.com

system
- people ▶
 - newbies
 - oldies
 - goldies
- facts
- figures
- partners
- contact
- live

programs goodies notes

?

contexta server

install supermodel pro 2.06

contexta trash

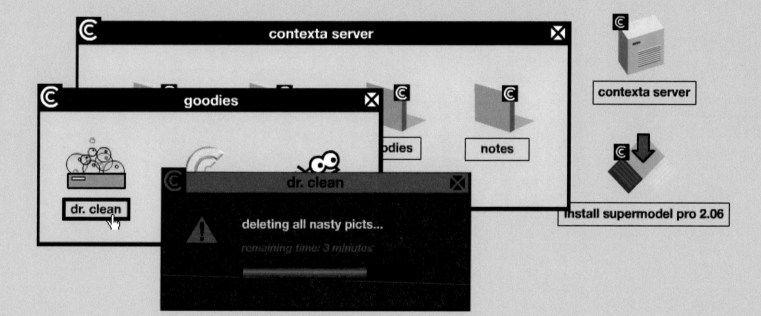

contexta server

contexta server

goodies

dr. clean

dr. clean

deleting all nasty picts...

remaining time: 3 minutes

odies

notes

install supermodel pro 2.06

contexta trash

?

contexta server

install supermodel pro 2.06

contexta trash

▶

Ad nauseam, complaints about information overload, information saturation, and the information explosion have been popularized. In view of all this polemizing, which has sprouted a thriving offshoot industry, a literary expert recently formulated the following daring proposal: "I assert that the great intellectual challenge of this Information Age is not to come up with a grand unified theory in physics, or to discover the origins of human life. The great challenge is to make better use of what we already know." (1)

This proposal is particularly important for design. It sets different priorities for academic research. Academics are all too familiar with - and maybe even suffer from - the careeer enhancing rite of publishing. Although no-one is against the production of new knowledge, the rite´s dark side ought to be kept in mind. The various academic areas resist every attempt to be informed on a subject-specific basis. For example, the Harvard University library catalogues subscriptions to more than 90000 periodicals. Today historians have approx. 5000 academic journals from their special field at their disposal. Instead of one-sidedly investing vast resources in the production of new knowledge, a part of these resources could be used to make already existing information more available - for the benefit of society as a whole. The philosopher Richard Rorty frankly recommends:"...that sociologists and psychologists should stop asking themselves whether they are following rigorous scientific procedures, and should rather start asking themselves whether they have any suggestions to offer their fellow citizens on how our lives, or our institutions, could be changed." (2)

It is exactly at this point that designers can start out from since they have - or at least should have - the competence to dismantle cognitive complexity or to present information using rhetoric and aesthetic resources. Due to the fact that this term can easily lead to misunderstandings and quasi-automatically evokes the old discussion of "form" versus "content", one can also talk about sensory management. But then difficulties arise. Although the telegraphic signal transmission scheme developed by Shannon and Weaver has served as a model for communication in discourses on graphic design – and semiotics – for decades, it s explanatory value is very limited in terms of visual design. The reason being that it explicitly excludes the semantic dimension – as stressed by the authors of the Information theory themselves.

How do signals become information and how does information become knowledge? This transformation process of can be explained by an example. Train schedules usually consist of an initially disordered databank including train numbers, connections, departure and arrival times and special service offers. This data turns into information once it has been structured, when its state of disorder is transferred into an ordered state. In order for the data on train connections to make sense, it must be received by an interpreter who knows the meaning of train connections and is able to draw respective conclusions. If not, the data does not make sense and cannot be assimilated. Information in its turn transforms into knowledge once the information is internalized by an interpreter and can be turned into knowledge that can be acted on.

Although knowledge is commonly understood as a phenomenon bound to individuals (heads, or rather brains as knowledge depots), two authors from the management field offer a broader definition: "Knowledge is a dynamic mixture of structured experiences, values, context information and expert insight that provides a framework for evaluating and incorporating new experiences and information. It originates in the heads of those who know and is applied there. In companies it is often embedded not only in documents or archives, but also in company routines, processes, procedures and norms." (3)

Even if this definition of knowledge as, above all, instrumental knowledge should not be accepted without qualification, it still brings a revealing element into play for information design: knowledge in the sense of accumulated experience must - also in companies and institutions - be communicated inter-subjectively; in other words, it must be made perceptible and possible to be experienced. This ability of knowledge to be experienced is linked to the presentation of knowledge. The presentation of knowledge is in and of itself a core design issue because without design, knowledge cannot be presented, it instead remains abstract and uncommunicated. Thus, here we can see that design in its variant of information design has an essential function. This is the good news. The bad news is that we still do not have a clear definition of what information is:

"Today, in the Information Age, we are struggling to understand information. We are in the same position as Iron Age Man trying to understand iron. There is this stuff called information, and we have become extremely skilled at acquiring and processing it. But we are unable to say what it is because we don´t have an underlying scientific theory upon which to base an acceptable definition." (4)

Designers are not known for generating new knowledge. This is not their area of expertise. However, they can play a vital role in the presentation of new knowledge. Design IT particularly in the form of CD-ROMs and websites - in other words in the form of interactive media - opens up new perspectives never even dreamt of by Otto Neurath, one of the founding fathers of information design in the 1920s.

Among the general public, graphic design is predominantly associated with advertising: it is identified with the domain of persuasion, as something that is used to influence purchase decisions or to mold visually public identities for companies and institutions. It could, however, become a key discipline to stem the tide of the information explosion. For this to happen, reliable basic principles need to be formulated, because the cognitive demands of this type of work - knowledge presentation - are enormous. The audio-visual resources used by designers for this purpose will open up a new field for design research, in which there is everything to play for.

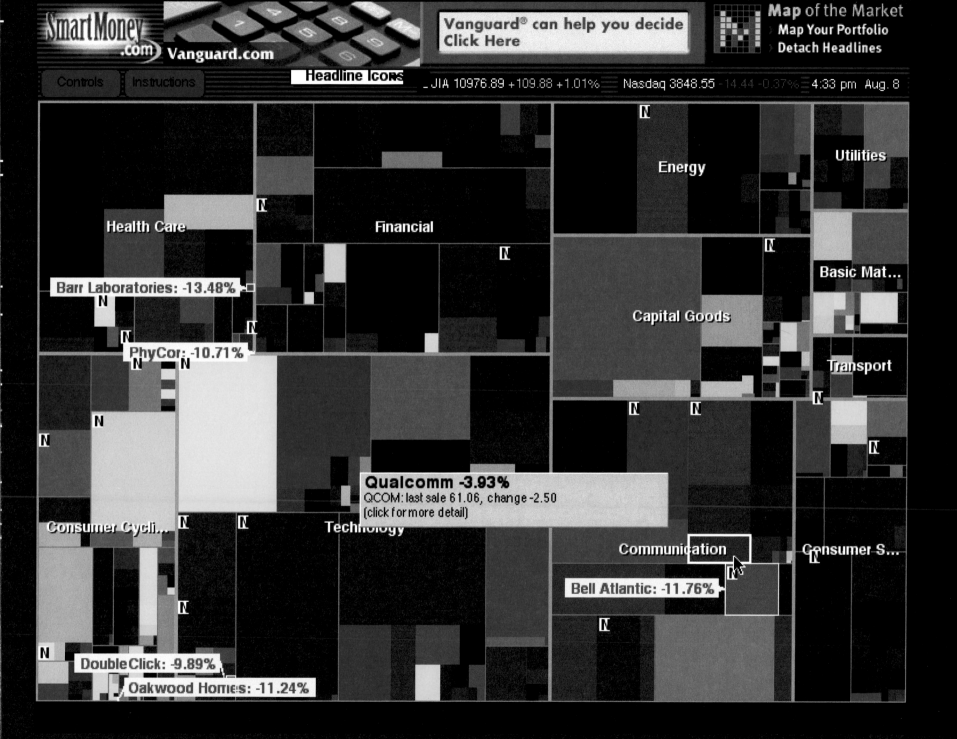

It is unbelievable that the investigations into usability, which take place under the banner of usability engineering, often reveal only an extremely simplistic definition of use, which greatly limits the applicability of the results of these investigations. Even if definitions of what design is currently vary quite a lot from each other, at least two constants are still generally accepted: on the one hand, the aspect of quality of use and on the other the aspect of formal aesthetic quality (which includes the domain of play).

It is the focus on users' concerns from an integrative point of view that differentiates design from other disciplines, including ergonomics (or human factors) and cognitive sciences. Furthermore, a holistic approach to design does not put aesthetics into quarantine, but includes aesthetics as a constitutive attribute of everyday use of artifacts. Aesthetics is not an add-on that can be dismissed or not taken into consideration when designing a product or message. This understanding of what use - and design - is about, stands in opposition to the interpretation by a representative of usability engineering and cognitive sciences:

"There are essentially two basic approaches to design: the artistic ideal of expressing yourself and the engineering ideal of solving a problem for a customer." (5) In this opposition between art and engineering, between an artist-centered approach and a client-centered approach, design does not figure at all; it is simply subsumed under usability engineering. Design is evaporating into the status of a non-identity.

We can look for the factors that have led to this dichotomy. Maybe it stems from the entirely understandable reaction to "cool" design with corresponding websites which may be aesthetically attractive but are not user friendly. While no-one is disputing this, there is the issue of the uncritical interpretation of "usability", which is simply taken for granted in all this. Usability seems to principally be something that usability engineering can measure. No designer would deny the importance of testing a design, however, an interpretation of use to the exclusion of the aesthetic dimension relegates design to the role of passive victim of aesthetic decisions - or non-decisions - which take place regardless. In the process of self-censure a significant component of use and practical day-to-day interaction with artifacts is conjured away. Concern for aesthetic quality cannot simply be dismissed as an obsession with surface glitter and thus be swept under the carpet, simply because aesthetic quality is a difficult concept - it falls through the criteria net of usability engineering.

The claim that "the way you get appropriate design ideas (and not just good ideas for cool designs that nobody can use) is to watch users and see what they like, what they find easy, and where they stumble" (6) is in truth nothing new - it is in fact what designers do anyway. Furthermore this quote does not explain how appropriate innovations in design come about. Now that the world has been divided into two opposing camps - in other words design has been explained away - innovative solutions are explained with recourse to the des ex machina in the form of "inspiration" and "creativity". Exploring usability from this narrow viewpoint with scientific methods is like examining the physiology of breathing without considering oxygen. This is of course possible and such a project would probably be able to attract serious research funding and would most likely end with the standard phrase that still further research was needed in this area - but it does not really get us very far. The malaise of interactive design - particularly of software for teaching and business - that is felt far and wide will certainly not be lifted in this way.

Criticism continues to be directed at the one-sided interest, e.g. of the user in finding information on a website, since this one-sided interest overshadows the central issue, which is in fact what designing interactive tools is all about, namely, serving communication, fostering communication and enabling interaction, which also provides fun. Of course quick access to information is desirable, of course slow websites which have too many graphic components and annoying self-referential animation are an irritation - but speed alone is not an absolute goal. By contrast, effective communication is always a goal of web design and CD-ROM design.

Effective communication depends on using resources, and resources are inextricably linked with aesthetics. They can be summarized under the term rhetoric - naturally a modernized rhetoric, which takes new technical possibilities into account. Conventional wisdom understands that grammar has the function of formulating texts (speech) by obeying established rules, whereas rhetoric has the function of adding aesthetic quality (ornatus) and minimizing tedium in order to attract and hold the attention of the public. Here design research could be on the threshold of a new field, in which the interaction of sound, language, image, movement and music are analyzed, in other words everything that is understood by the term "audiovisualism". A very fertile object of study could be just around the corner for the design discipline.

Sources

(1) Willinsky, John Technologies of Knowing. Boston: Beacon Press 1999, 4.

(2) Richard Rorty. "Does Academic Freedom have Philosophical Presuppositions?" in The Future of Academic Freedom, ed. Louis Menand. Chicago: University of Chicago Press, 1996, 20. Zitiert in Willinsky (1), 94.

(3) Davenport Thomas H. und Laurence Prusak, Working Knowledge. Cambridge Mass: Harvard University Press 1998, 5.

(4) Devlin, Keith, Infosense: Turning Information into Knowledge. New York: W.H. Freeman & Company 1999, 24.

(5) Nielsen, Jacob, Designing Web Usability. Indiana: New Riders Publishing 1999, 11.

(6) Nielsen, 12.

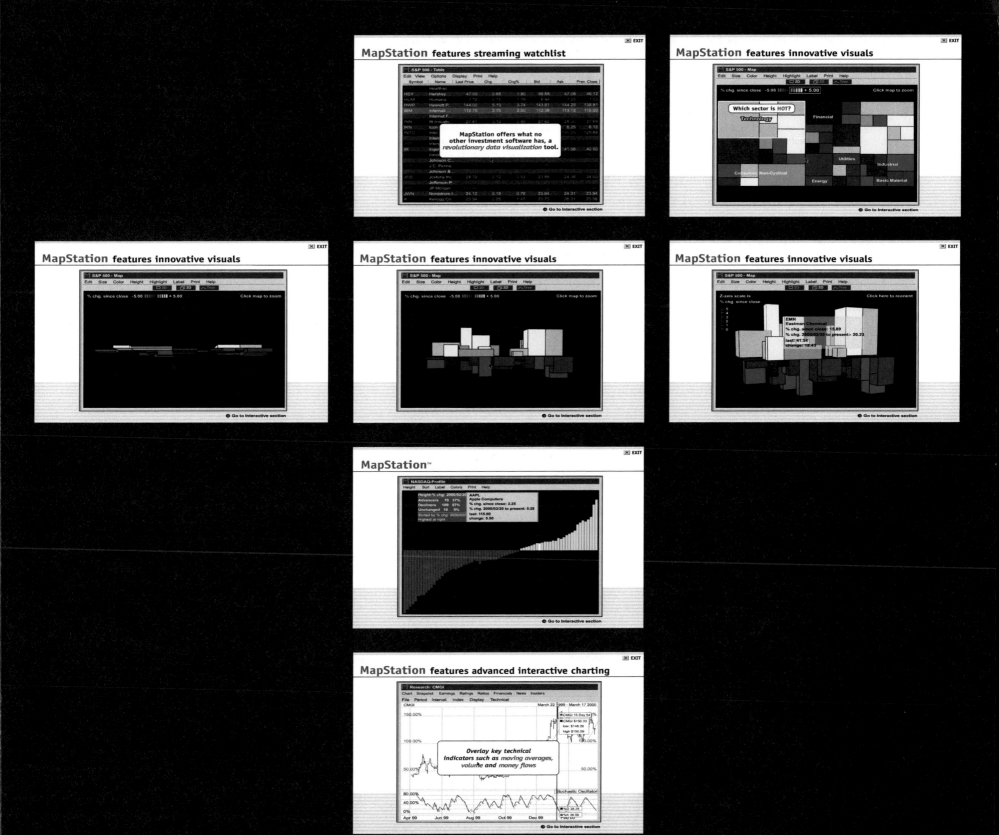

e-Types

information
typography
work
revolution
tools

drag / doubleclick to scale

INFORMATION

contact

about

ABOUT

e-Types is a design-community, founded by a gr
young danish designers, educated at the Dani
School and at the Royal Academy of Art in C
Allready at school they worked together
create their own graphical workshop. S
graduating in the summer of 1997 e-T
established.

For further information pleas

QUIT

NAVIGATOR

IN OUT CENTER RESET

0 1 2 0 1 2 3 4 5 6 7 8 9 0 1 3 5 7 9

for www.mycity.com.br

worked together with	mars	http://www.re-p.at , http://notdef.org
		mail: mars@re-p.at
	anna	no website YET !
		mail: anna@mailr0.or.at

..// MP3 - PIX - SHOCKWAVE - PROJECTS - LOAD - POST - LINK - MAIL - K

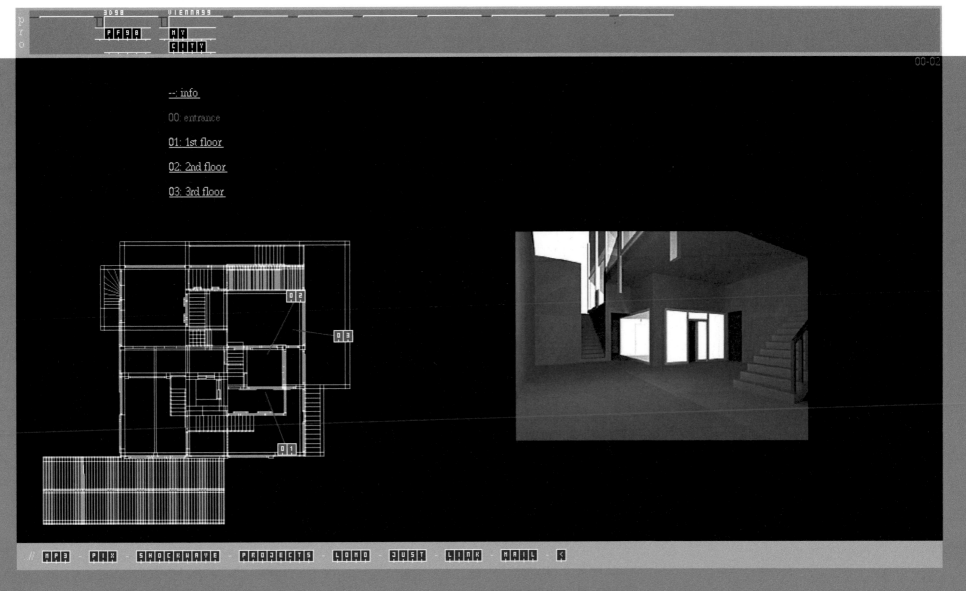

--: info

00: entrance

01: 1st floor

02: 2nd floor

03: 3rd floor

CLOSE →←

GET IT RIGHT

Give your housekeeper a raise
every time you get one.

Vestir

SPORT FURNISHINGS →
SHOES →
MADE-TO-MEASURE →
SUITS →

Agnona Cashmere Robes
Battistoni
Belvest
Borsalino
Brioni
Bruno Magli
Canali
Cruciani Cashmere Sweaters
Frey

Incotex Trousers
Isaia
Les Copains Sweaters
Lidfort
Longmire Cufflinks
Luciano Barbera
Mario Testoni
Oxxford Clothes
Petronius Ties

Ralph Lauren Purple Label
Silvano Lattanzi
Stefano Brancini
Valextra Leather
Ermenegildo Zegna

| HOME | WOMEN | MEN | COSMETICS | CO-OP | GIFT | FREE STUFF | SHOP BARNEYS |

ARNEYS
EWYORK

♂

CONTEMPORARY
CLASSIC
SARTORIAL
DESIGNER
CO-OP

WOMEN

| HOME | WOMEN | MEN | COSMETICS | CO-OP | GIFT | FREE STUFF | SHOP BARNEYS |

BARNEYS
NEWYORK

MAIN FLOOR
SECOND FLOOR
THIRD FLOOR
FOURTH FLOOR
FIFTH FLOOR

Der Audi Konfigurator

A4

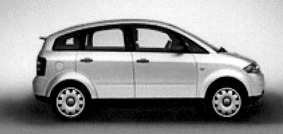

Herzlich willkommen zum Audi Konfigurator. Mit dem Audi Konfigurator für den deutschen Markt können Sie sich ein genaues Bild von Ihrem neuen Audi machen – von der Motorisierung über die Lackierung bis zu den Sonderausstattungen. Und das alles hochaktuell, denn in der Konfiguration sind Sie direkt mit der Baubarkeitssoftware der AUDI AG verbunden. Dabei ist auch ein Blick in die aktuelle (aus rechtlichen Gründen) unverbindliche Preisliste möglich.

Und nun viel Spaß mit dem Audi Konfigurator!

Bitte wählen Sie ihr Modell aus:

A2	▼
A3	▼
A4	▼
A6	▼
A8	▼
TT	▼
allroad quattro	▼

▶ **Intro** ▶ Impressum ▶ Gesetzlicher Hinweis ▶ Bedienhinweise

A2

Wählen Sie bitte eine Innenausstattung. Ein Klick auf die Farbkombination gibt Detailinformationen.

Innenausstattungsfarben
Sitzbezüge/ Teppich/ Armaturentafel/ Himmel

grau/ grau/ schwarz- grau/ hellgrau

hellbeige/ hellbeige/ dunkelbeige- hellbeig e/hellbeige

Innenausstattungsfarben

1.4 TDI 55 kW 5-Gang	EUR 17.850,00
Ebonyschwarz Perleffekt	EUR 420,00

Alle Preise	**EUR 18.270,00**
incl. Mwst.	DM 35.733,02

Operating or Using? Future-orientated Interface Conception . Tanja Diezmann . Professor of Interface Design, Department of Design, FH Dessau Technical University

The devices and programs of the future will have to orient themselves more to the way in which they are used and they will have to become more useable/user-friendly for the user. The time taken to carry out endless "trial and error procedures" or to read innumerable instruction manuals could be better spent if there were more logical interfaces and more intelligently conceived devices that from the beginning include the interplay of screen semantics and hardware and which have grown in step with the complexity of today's communication, interaction and transactions. It is unfortunately all too rare for user expectations and system reactions to be in line with each other with regard to navigation. Machines react differently than people expect. The calls for intuitive interfaces are getting louder, but these will not be answered. We just have to think, for instance, of the laborious and pedantic way in which children learn the difference between colors. All that we can achieve are approximations to this vision, which above all is the expression of a desire for user friendliness. We can aim to design interfaces that are so understandable and logical that they give the user the opportunity to work with them autonomously - this is the goal of good interfaces, freedom and orientation in the data sphere.

In the future, interfaces will determine whether a product is successful, or not. Competition will become greater and the principle of being "first to market" which has allowed all providers to wash their hands of their unreasonable interfaces over the last few years will not longer be valid. Increasingly processes become digitalized, making interfaces the only point of contact with people or between people (e-mail, newsgroups, communities). Whether we are talking about e-commerce, e-finance or even strictly virtual services, hardly any of them do not confront the user with confusing databank screens, which hide the processes to which the data are subject during the search, selection or navigation. But this is in fact the function of the interface: to make connections between data visible and navigable. This means that we are no longer simply talking about two-dimensional pages constructed like catalogues, which are also not very trendily designed. No, we are talking about new, dynamic data constructs, that do not simply react to queries, but in and of themselves make statements about volume, quality and contexts of various data.

Wouldn't we ideally like the information to come to us at the touch of a button? That is exactly what individual information access is all about: every user is interested in what is offered from different points of view and every user processes information differently. This means that we need interfaces that allow manifold access possibilities, access options that go beyond "A-Z searches" to "relevant categories" and "current information", which allow a combination of wishes on the part of the user and, alongside the rational, also allow for human aspects, e.g. imprecise or unrefined searches. In other words what we should be developing is "real virtuality", not "virtual reality".

We can design interfaces that pick up on or address (as the case may be) human behavioral and perceptual mechanisms and attempt to find a new, separate semantics which is appropriate to the medium. To learn from the effects of the real, from the connections and structures and to transform or to model these is worthwhile, but for that they do not have to be reproduced in their manifest form.

Are we all not wasting much too much time these days trying to master our computer, mobile phone or the Internet? Would the time not be better spent using these devices? It seems that at the moment we are more concerned with operating these things rather than actually "using" them - or does it have something to do with the fact that there are so few alternatives? Maybe with all our searching we have forgotten that our real goal is to find; that we do not want to engage primarily with the Net and the ever growing range of devices for accessing it, but that we want to get information and data from it and we want to communicate via it, that what we want is simply to use it? What other rational explanation is there for the millions of Web, computer and mobile phone users who are tormented every day by innumerable offers with hierarchical, linearly organized menus and two-dimensional page set-ups? Should the consumption of information and its presentation not be adjusted to suit changed habits and the volume of information be proportional to its dynamic and its complexity?

In today's (still) digital - tomorrow perhaps already bio-technological - sphere, definitely somewhere non-physical or in the "virtual", possibilities for creation exist which reach far beyond our current definition and make designs possible that make use of the essential of today's electronic media. Whether it is the networked dimension, the global, the spatially and temporally autonomous, multi-media or the never-been-before present that sends data and information around the world instantaneously and which makes it possible for publications to be called up in a matter of seconds anywhere in the world! By means of any of these options we have the capacity to do much more in the form of buttons we can "press" and windows that bring order to our desktop than we ever could in reality.

We can design information structures or recognize them in existing data, we can organize them, we can make connections between data and information inclusive of all their complexity visible and navigable. This can lead to "navigable structures" which allow users to navigate and model the data structures individually. Here we can also develop cognitive models which communicate to users an "image" of the system without copying it and giving them a superordinate orientation aid. The logic, the behavior of the system, through its consistency, can then quickly become a system or interface that is easy to understand - users become autonomous, the system is subject to them, not vice versa.

The goal of design and drafting work in interface design is always the achievement of an ideal interface or to realize what is desirable from the user's point of view. Our questions need to clearly relate to the future, not to what is possible today, but to what is imaginable.

HAMBURG

understand?

THOMAS **POPINGER**

NEW YORK

of the cheap underwear,

but you can't tal

THOMAS **POPINGER**

PEOPLE

WEB DESIGN

#6A6A6A

<REFERENCES>

CRACKDESIGN

601 WEST 26TH STREET
16TH FLOOR
NEW YORK 10001

VOX. 212.366.9738
FAX. 212.604.0698

MAILTO:

BOT@CRACKDESIGN.COM

INTERACTIVE DESIGN

3D ANIMATION

SOFTWARE SOLUTIONS

CONSULTING

WWW.III.ORG

WEB PRESENCE, INTRANET

WWW.I-20.COM

WEB PRESENCE

</REFERENCES>

BBS.THING.NET

WEB PRESENCE

br br CONSULTING /font /font /p /td td width="30%" height="102" valign="top" font size="1" color="#666666" ||--- /font /td td width="19%" height="102" bgcolor="#606060" p
font size="1" color="#666666" + /font font size="1" br /font a href="http://bbs.thing.net" target="_blank" onMouseOver="document.bgColor='#93A29D';MM_swapImage
('document.thing','document.thing','img/thing.gif','#934828607690')" onMouseOut="MM_swapImgRestore()" img src="img/thing_gr.gif" width="69" height="28" border="0" name="thing" /a br br font face="Arial,
Helvetica, sans-serif" size="1" BBS.THING.NET br br WEB PRESENCE /font /p /td /tr tr td width="8%" bgcolor="#606060" font face="Arial, Helvetica, sans-serif" size="1" MAILTO: /font /td td bgcolor="#616161"
colspan="3" p font size="2" face="Arial, Helvetica, sans-serif" a href="mailto:bot@crackdesign.com" onMouseOver="document.bgColor='#627173';MM_swapImage
('document.mail','document.mail','img/grb.gif','#934828692770')" onMouseOut="MM_swapImgRestore()" img src="img/grb_gr.gif" width="16" height="16" name="mail" border="0" /a font size="1"
BOT@CRACKDESIGN.COM font color="#666666" |--- /font/p /td td width="30%" bgcolor="#606060" font size="1" face="Arial, Helvetica, sans-serif" color="#666666" + /font font size="1"
face="Arial, Helvetica, sans-serif" </REFERENCES> /font /td td width="19%" bgcolor="#6A6A6A" /td /tr /table /body /html

description about **MONO***crafts.

using " TYPO-launcher "

t

a

b
t

► Our goal is to show y a n
e n
r

semi-automatic
description
about:**MONO***crafts TOKYO, JAPAN

BACK TO TOP ◄

welcome to **MONO***crafts.

FINGERTRACKS:
mouse-generated arts on programmed field.

| TYPO | FINGER | BOT | BEA |

[coming soon...]

TYPO | FINGER | BOT | BEAMZ | | NEW | MONO* | NOTE | OUTER | SIGN | EMAIL |

0 1 2 0 1 2 3 4 5 6 7 8 9 0 1 3 5 7 9

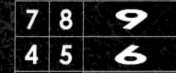

A SPACE FILLED WITH REACTIVE &WIRED TYPOGRAPHICS.

VOL3. NERVOUS MATRIX.

Reactive 3*3 Matrix with 10-KEY typing.
* This was made for this TYPOSPACE's index.

Another funny version is also avaiable.
▶ CLICK TO LAUNCH

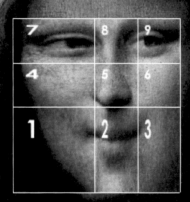

TYPOSPACE Vol.3
NERVOUS MATRIX on MONA LISA

design

trash

art

stephan_hub
ralph_amm
birte_steff
www.sinnzeug.

Mouchette

a thirteen years old artist. nice
suicide kit :-)
http://www.mouchette.org

Hyper Island: Creating a University for the New Economy . Jonathan Briggs . Professor New Media Business & Management, New Media Design & Technology Hyperisland- School of Media Design, Karlskrona, Sweden

At the heart of Hyper Island is a building. It is a disused naval prison from 1860 and was found and renovated by Lars Lundh in 1996. It remains a historic monument and local museum staff were involved in monitoring renovations. The building is full of character and immediately allowed both staff and students to create a strong sense of ownership and personality.

At the centre of the course are a number of principles: project centred learning, teamwork, industry involvement and interdisciplinary thinking. Instead of a fixed curriculum, the course revolves around a set of projects. Each project will introduce a number of core ideas or build upon those in earlier units. A group will tackle each project, with group members taking on different roles and using and acquiring various skills. To guide and stimulate activity, external experts are invited to present to the students. These guest lecturers are drawn both from the new media industry and well beyond and have included architects, furniture designers, town planners and the police. The aim is to enlarge rather than narrow problem solving and creativity and to get students thinking "out of the box".

This lateral thinking is exactly what new media designers need in their work, whether they are visualizing a user interface or writing the business plan for a start-up (and we would expect all Hyper Island graduates to tackle both).

The course still has a strong academic component with students encouraged to write, research and defend their ideas. They are also expected to develop critical skills and to support each other in their learning. It is this support by a "community of learners" that characterizes the School&Mac226;s philosophy and this support does not end when students leave. During the course&Mac226;s industrial training period in industry and after graduation students remain part of this community and this is most noticeable in the amount of daily communication they have with the school.

The day-to-day operation of the School is run by a very small staff whose priority, perhaps surprisingly, is to manage the team building and the group work, rather than to teach the technology, the business or the graphical tools and techniques. This subject-based teaching is facilitated from outside by lecturers from both industry and academia. However, almost all of the responsibility for learning is placed squarely on the shoulders of the students. While this is initially very unfamiliar and often leads to argument and debate, each set of learners has responded by building themselves into a tightly knit cohort of highly confident and perhaps even arrogant individuals who have planned events, sought additional sponsorship, invited international speakers and defined their own extra projects.

Hyper Island was designed by a group of people who wanted to create an exciting, challenging and productive learning environment, but it was also designed to directly address the needs of the emerging new media industry. Traditional courses in computer science, graphic design and business all produce people who are too narrowly focussed. Potentially they may be highly skilled in this or that tool, or be able to harness traditional design or business thinking, but today&Mac226;s new businesses need people who can look beyond their subject and help build links between widely diverse areas of knowledge. In all the constituent disciplines there is an urgent need to create people who can communicate with professionals outside their area and who can keep up with change.

Most new media education focuses on producing graphic designers or programmers. Hyper Island aims to train "producers" who have a good understanding of both software and design but whose main role when they start working is to pull a team together and work with clients to deliver what they need. The response from potential and actual employers has been incredible.

During the course students spend 20 weeks working for a new media company before returning to the School to complete their exam work. From the very first cohort, it was clear that students had very definite opinions about where they wanted to go, with students targeting all the major agencies across the world. Now, five cohorts later, Hyper Island has placed students with companies large and small in San Francisco, Los Angeles, London, New York, Oslo, Copenhagen, Madrid as well as Stockholm, Malmo and other Swedish cities. For many, this relationship has turned into a permanent job and Hyper Island graduates now form a network for exchanging ideas across the industry. These ideas, in turn, feed in to what current students are taught as companies queue up to teach at the School and students exchange ideas via the Internet on a daily basis.

This "network" is one of the unexpected results. It was not planned. As many businesses eventually discover that the main importance of the internet is not simply about marketing, but about opening up two-way communication with customers, suppliers and employees. The same is true in education - allowing students (and experts) to communicate opens up new possibilities for collaboration and new ways of exploring ideas. Technical problems are immediately shared and solved, perhaps even by a traditional competitor. Ideas are sketched and available for comment and review. This is one of the real opportunities for distance learning, but many universities faced with the technology are rushing to "put their course material on line", rather than recognizing that the real strength, as demonstrated by Hyper Island, is supporting and extending an established learning community, one that has been formed through close contact and mutual problem solving and is maintained by daily or weekly contact using the complete range of technology.

Hyper Island is a school that is not just about the new technology, but has also been defined and shaped by this new technology. The familiarity of a curriculum has been replaced by the chaos of constant change. Instead of a fixed period of study, participation extends out into the students´working lives. For those of us in new media who help companies understand and harness the Internet, WAP and broadband technologies, these types of transformations are familiar. Hyper Island is only one way of experimenting with the formats of higher education and, as with business models, many more experiments will be needed to train the flexible and imaginative knowledge workers that we need.

al in wonderland — ☐

planlos — ☐

— ☐

reception
work
water

☐ — sonja gardens

☐ — orpheus

☐

captain stelios
lounge
pneumatic

choose

your

navigation

system

washing

ss_rain >
rs_eberle, vassilios_alexiou, gunnar_bauer
w.lessrain.com

al in wonderland

planlos

navigation

shockwave
graphical
selector
text only
blank

01 — reception
02 — work
03 — walter
04
05
06
07
08
09
10 — captain stelios
11 — lounge
12
thamesmead
shoot'em up

3 days in
london

16
17
18
19
20
21
22
23
24
25
26
27
28
29

sonja gardens

orpheus

washing

COMPANY CULTURE IN BERLIN

OLE SCHUMANN

DS™
START
SPRACHE
LANGUAGE
DEUTSCH

√DS™'/001 ENGLISH

03
01 04
00 05
06
13
11 10
07
12 09 08
02

DESIGNER
SHOCK

DS™BERLIN c/o DD™HEADQUARTER
DESIGNERDOCK (DD®), 10967 BERLIN, GRIMMSTRASSE 27
T ++49 (0)30 691 19 21, F ++49 (0)30 690 419 51
DS™/DESIGNERSHOCK™ IS A REGISTERED TRADEMARK

001

MENUE

012012345678901357 9

B.

WHAT PROJECTS ARE YOU CURRENTLY WORKING ON AND WHAT ARE THE PROBLEMS WHICH
YOU REGULARLY COME ACROSS AND HOW DO YOU DEAL WITH THEM?

DESIGNER
SHOCK

DS™BERLIN c/o DD®HEADQUARTER
DESIGNERDOCK (DD®), 10967 BERLIN, GRIMMSTRASSE 27
T ++49 (0)30 691 19 21, F ++49 (0)30 690 419 51
DS™/DESIGNERSHOCK™ IS A REGISTERED TRADEMARK

i·so·met·ric

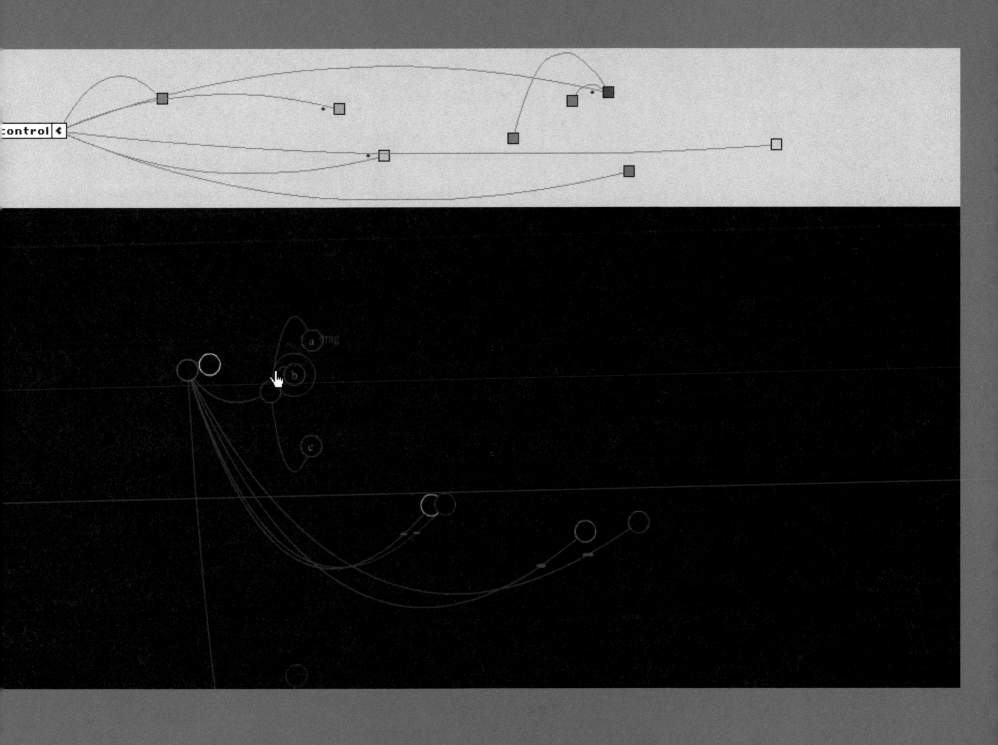

control ◄

a drag

b

c

Creating Complexity from Simplicity . Joshua Davis . Kioken Inc., Senior Design Technologist, New York, USA

A Fern. Strange as it seems, the basic shape of a fern can be captured in a simple stick drawing. To make a fern of curving, intricate complexity, all that is required is this simple shape, and a few basic rules. The only rules are that the stick shape is free to repeat itself at many different levels of scale, that it is placed in an upright direction, and that it connects with what is already on the page. From this combination of a few simple rules and high levels of autonomy - of order and chaos working in tandem - emerges the beautiful complexity of a fern. (quoted from : Margaet J. Wheatley, 1994, page 131 - Leadership and the New Science) My work should reflect the nature of a fern and be comprised of tiny little objects that all talk to each other and the more I add these little objects the more complex and intense the nature of my work becomes. Where it is more rewarding to explore than to reach conclusions, more satisfying to wonder than to know, and more exciting to search than to stay put.

Where do you find inspiration? Nature. Tons of science. Physics is probably a major area of inspiration - yet at the same time is an area of ideas that confuses me the more I read and try to understand it. I love literature on Chaos Theory - we have spent a better part of lives trying to organize, classify, file, associate, identify, label and dissect everything we see. So I sit down and I think about nature and chaos. I think about randomness, patterns, signals, systems, and the nature of living in this pulse.

As Einstein is often quoted as saying: No problem can be solved from the same consciousness that created it. As children, we engage in our first attempts at drawing. The basic idea was to copy lines and movements from someone else's work, and hopefully through trial and error we would gain the ability to draw and then begin the process of finding our own voice (or method of art). Taking design into unexplored areas, as Einstein suggests above, means that we must force ourselves to re-invent the wheel. So while there are great resources and fantastic web-sites on the net, we must look beyond the web's boundaries for inspiration in order to bring to the table something never seen before. Maybe we can find such forms in nature?

--Interface: Resonance | a concept
Two points in space (x,y, is z too ambitious?) connected by a scintillating gossamer cord. Pluck the cord. Wave function manifests. Function within specific range (amplitude check one-two, one-two...) results in specific behavior.
Two cords (reqs. min. 3 pts. in space) plucked - waves collide in space/ether/medium. Constructive or destructive interference occurs - regardless - new wave function(s) formed. Function(s) within specific range(s) results in specific behavior(s).
Behavior(s) may be the creation of new wave function(s) vis-a-vis plucking existing cords or creation of NEW point in space connecting to previously existing point resulting in new cord.
Wait a minute.

Start with two points in space (x,y, would z be that bad?) and one connecting cord. Cord is plucked. Wave function in specific range (gotta be a way to check amplitude) results in creation of new point in space whose coordinates are dictated by. . . range of the original wave function (but what does 'dictate' mean?
What is the mathematical/geometrical/trigonomicalmaybereaching relationship between the wave function and the coordinates of this new point?). New point then connects to _closest_ existing point, creating new cord. New cord is plucked. Mayhem ensues.

Shoot. Forget fourth coordinate. Must be a way to map in four dimensions, no? Not real time but perhaps relational time? Visually, this might be done using a sliding color-scale to show elapsed time/duration of each point and cord. Red is old, violet is new or some such crap.
Patterns may emerge. Patterns WILL emerge. If the plucking of each cord were truly random...

Antiweb CHAOS Mailinglist ● | enter e-mail address

● subscribe ○ unsubscribe | submit

St. John, U.S. Virgin Islands + honeymoon = yahoo !

info | email | key ☐ not visited ☑ visited ☐ current

July

S	M	T	W	T	F	S
						01
02	03	04	05	**06**	07	08
09	**10**	**11**	**12**	**13**	**14**	**15**
16	**17**	18	19	20	**21**	22
23	24	25	26	**27**	28	29
30	31					

August

S	M	T	W	T	F	S
		01	02	03	04	05
06	07	08	09	10	**11**	12
13	**14**	15	16	17	18	19
20	21	22	23	24	25	26
27	28	29	30	31		

September

S	M	T	W	T	F	S
					01	02
03	04	05	06	07	08	09
10	11	12	13	14	15	16
17	18	19	20	21	22	23
24	25	26	27	28	29	30

THE MONTHS

01	02	03
04	05	06
▶ 07	08	09
10	11	12

Jellyfish

a study of duplicated particle systems in order to re-create the notion of a living sea creature

Click for v.1 & v.2

Antiweb CHAOS Mailinglist ● | enter e-mail address

○ subscribe ○ unsubscribe | submit

St. John, U.S. Virgin Islands + honeymoon = yahoo !

info | email | key □ not visited [] visited □ current

April								May								June							
S	M	T	W	T	F	S		S	M	T	W	T	F	S		S	M	T	W	T	F	S	
						01		01	02	03	04	05	06						01	02	03		
02	03	04	05	06	07	08		07	08	09	10	11	12	13		04	05	06	07	08	09	10	
09	10	11	12	13	14	15		14	15	16	17	18	19	20		11	12	13	14	15	16	17	
16	17	18	19	20	21	22		21	22	23	24	25	26	27		18	19	20	21	22	23	24	
23	24	25	26	27	28	29		28	29	30	31					25	26	27	28	29	30		
30																							

THE MONTHS

01	02	03
04	05	06
07	08	09
10	11	12

karate chopping teddy bear
MadCatz - PantherXL Joystick
pad of graph paper
dual box monitor toggle
Pottery Barn desk lamp
Imation CD burner
SGI - 21 inch monitor
4 black milk crates
Associates in Science poster
Kioken logo - wallpaper 1280 x 1024
SiliconGraphics 320
Fuji digital camera
Sony PCG-XG18 laptop
win98 testbed box
Microsoft Intellimouse (laser) (2)
Altec Landsing subwoofer
SGI / Polkaudio speakers
Casio Cassiopeia
Microsoft Intellimouse (laser) (1)
PrayStation.com / Kioken.com New York City headquarters
Samsung Sprint PCS phone

b e n c h u n <MIT.EDU>
With regard to your resonance ideas, here are some wave equations that you
might find useful. I thought of this as you mentioned the fourth time dimen-
sion. This comes from acoustics; perhaps you could map sound on to the
interface as well. We start with: newton's law, the adiabatic gas law, and con-
tinuity (conservation of mass). I will skip the derivation, but if you are inter-
ested I can photocopy my notes for you.

In any case, the result is very elegant:

$$\frac{d^2(p)}{d(x^2)} = \frac{1}{c^2} \cdot \frac{d^2(p)}{d(t^2)}$$

Where $d^2()$ is the second partial deriv-
ative and $d()$ is the first partial derivative and c is the speed of wave propaga-
tion in the medium. You have to be sure to get your units right, but I imagine
that frobbing c would give some control over the "speed" of the animation. So
now we have a relationship between pressure p, time t, and space x. For this
interface, I imagine mapping p on to a color to visualize the pressure wave. I
imagine your "point in space" as a point source for pressure. This equation is
only for one dimension, but easily generalizes using vectors in the derivation.

How would you describe your style?
Anti - style : I build frameworks - and 9 out of 10 times I honestly do not know the end result. Each framework I build has instructions - it's these instructions that decide what the end result will be, not me, I just give the system parameters. and it's getting worse because now I'm liking the use of random functions that behave erratically on their own. A marriage of programming and design. I always talk about that. As developers, designers, and artists - we shouldn't assume that the general viewing public is an idiot. We should try to evolve the medium by making intuitive systems that educate the user - not design to what level we think they can handle.

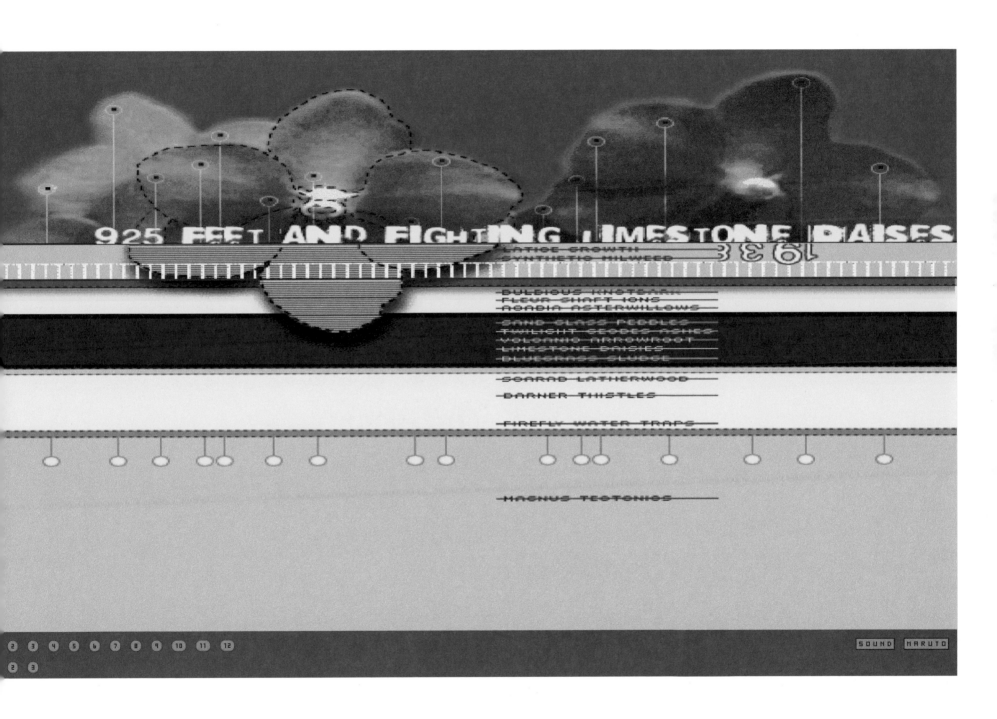

925 FEET AND FIGHTING LIMESTONE DAISES

1938

LATICE GROWTH
SYNTHETIC MILWEED

BULBIOUS KNOTBARK
FLEUR SHAFT IONS
ACADIA ASTERWILLOWS

SAND GLASS PEBBLES
TWILIGHT GEODES ASHES
VOLCANIC ARROWROOT
LIMESTONE DAISIES
BLUEGRASS SLUDGE

SCARAB LATHERWOOD

BARNER THISTLES

FIREFLY WATER TRAPS

MAGNUS TECTONICS

012012345678901 3579

A. Once upon a forest and several blades of grass ago... - It is the first 4 words of a children's book I wrote entitled "Stardust and Twilight Ashes".
Q. Who is Maruto ?
A. Maruto is a fictional character I have created to explore design, sound, and digital story telling.
Q. What is he doing ?
A. Maruto is attempting to define the surroundings and environment of his fictional world with motion and sound. In the beginning the forest was static, yet little by little Maruto is learning how to open up more portions of his reality to us through interactive installations.

maruto Evil King of the Mosquitos.

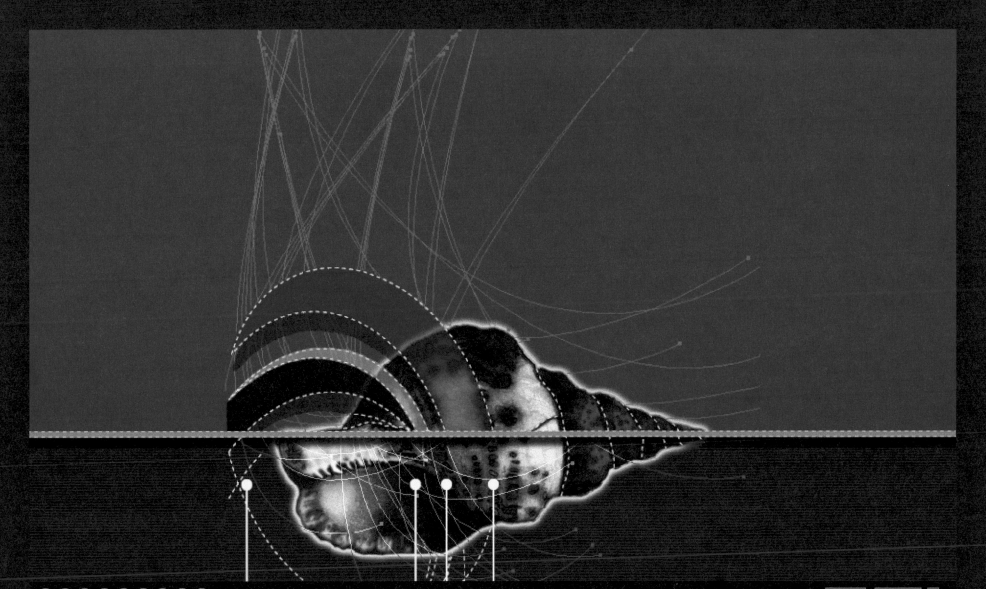

once-upon-a-forest is the nemesis of what we
perceive the web to be. No easy, short domain
name. No easy to use navigation. No instruc-
tions. No Faq's. No Ads, No Links, No Tech Sup-
port. No Help. No Answers.
The basic e-mail function is used to receive mail
- but in the several months the work has been
online - NO ONE has ever received a response or
reply e-mail from Once Upon A Forest.
The work is meant to provoke questions not an-
swer them. Do you wish to end your session?

sodaconstructor

load model... ▼ | simulate ▼ | auto reverse ▼ | gravity off ▼ | free mass ▼ | clear

g | f | k

what is sodaconstructor?

- sodaconstructor animates and edits two dimensional models made out of masses and springs
- springs can be controlled by a wave to make pulsing muscles
- models can be constructed that bounce, roll, walk etc, try some of the ready made models or try to build your own

how to load a model | sodaconstructor control panel key

load model... ▼ simulate ▼ auto reverse ▼ gravity off ▼ free mass ▼ clear

g f k

what is sodaconstructor?

- sodaconstructor animates and edits two dimensional models made out of masses and springs
- springs can be controlled by a wave to make pulsing muscles
- models can be constructed that bounce, roll, walk etc, try some of the ready made models or try to build your own

how to load a model **sodaconstructor control panel key**

sodaconstructor

load model... ▼ | simulate ▼ | auto reverse ▼ | gravity on ▼ | free mass ▼ | clear

g f k

what is sodaconstructor?

- sodaconstructor animates and edits two dimensional models made out of masses and springs
- springs can be controlled by a wave to make pulsing muscles
- models can be constructed that bounce, roll, walk etc, try some of the ready made models or try to build your own

how to load a model | **sodaconstructor control panel key**

USSR

life from the other side

DJ VADIM

hi-res!
florian_schmitt, alexandra_jugovi
www.hi-res.ne

7HREE

RAPHICS

/ RO 7HR 7W N7Y IGH7 7WO 7HOUSAND

S0 .: THE WHAT } 0

RAPHICS

RAPHICS

TRACKING NUMBER 928 8475 2845

Eighty or so years ago, Walter Gropius heralded the concept of "form follows function" as the main idea behind the Bauhaus. When the Web hit the scene in the early 90s, it seemed to be the furthest thought from the minds of designers. To start with, consider the sites that proclaimed "DESIGN SHOULD HURT" (amid flashing colors and Netscape Navigator 1.0 tricks). It's still a pervasive problem, what with MIDI sound files and scrolling JavaScript on dozens of amateur sites all over the Net.

To stand out against the background of all the mediocre sites out there, your site needs to tackle the structure first, long before anybody pushes a single pixel. It's all about the joy of being frugal and smart with design. Rather than creating a pretty interface and putting in some words after the fact, it means that content follows form, not the other way around. So how do you get there? First, you understand the strategy and know your users. Then, you define a cohesive content strategy and smart information architecture. Finally, you create detailed functional page flows – all before tackling the hefty realm of visual design.

For starters, you need to look at why you're building the site. Why does the world need it? In order to begin the barest bones of structure, you need to understand the imperatives, goals and strategies behind the site.

The type of site you build will have an enormous impact on every aspect of design – a massive online banking site will need to function, look and feel differently than a personal home page or a funky webzine. If you're working with your client, find out what thought they've given to the strategy – chances are, they've got many ideas about what they're trying to do. If it's your own project, spend some time thinking about what you want to accomplish with it. It's worth writing out a plan that outlines the strategy and goals of the site – as it develops over time, you can check your plan to see if you're on track or veering off onto a road you never expected to travel. Once you've considered the why of the site, you need to consider the who. It's like that old zen question, "If a tree fell in a forest and nobody heard it, did it make a sound?" If you build a great strategy for your site and don't consider who your users are, does your site make a sound? Probably not. Start by determining who your intended audiences are. If you took a prototypical person in this audience, what would she be like? What would she want to know and accomplish – and what would she not want or need? Not only should you describe your user's desires, you should delve deeper. What kind of car does she drive? What's on her desk at work? Is she wealthy or a starving student? Is she old or young? Give her a name and a face - find a photo (from a stock library or a magazine, for instance) to show who she is, and refer back to it frequently.

Within this audience exercise, you might also realize there are secondary user segments for your site. Who might these groups of people be, and what do they want to know? Also consider whether there are people who might come to your site unintentionally. For example, the website Maxi (http://www.maximag.com) started out by addressing women in their 20s and 30s. However, the majority of the users of the site ended up being 14-18 year olds. Although Maxi didn't set out to talk to these younger girls, the girls ended up being an unintentional audience. Consider these other potential users as you develop your site.

When you seat yourself in the heads of your users and see the world through their eyes, you begin to understand what information they need. This content extends beyond just the written word. It includes the tools they might require, the graphics that might better tell a story, and anything that expresses or explains what needs to be communicated. Bring your description of the prototypical users, complete with photographs, and brainstorm what content your users need. Work with your client and team (if you have one) and get every idea out there on paper. As you generate ideas, think of what you'd need to do to attract your audience, get them to interact and transact, and return to your site again. Don't evaluate the ideas when you're coming up with everything – the main point is to brainstorm and not immediately judge. Once you've got your big list of potential content, you'll notice the information falls into some natural groupings. When you graphically sketch out these groupings, you have the beginning of your site map. The site map shows the relationships between pieces of content, the flows through the information and the paths your users will take to get to what they want to know. It's also the first estimation of how big your site will be, which is useful as you begin to plan the site production and design.

With the flows of information and the understanding of your prototypical uses, you can create user scenarios. These operate much like stories describing what brings a user to a site, what they're looking for on the site, and what happens once they're there. Scenarios are powerful – they unearth the fine detail of the user interactions and experiences on the site, and they pull up important implications for every aspect of site design. (For example, "Vicky wants to buy a digital video camera. She isn't sure what type of camera she'd like to buy, so she clicks on the Video Camera Reviews section...") The final step in creating the site structure is designing functional page flows, which bring the site map to life. Though the site map shows at a high level how users move through all the tasks online, it doesn't show the detail of how the user needs to interact with the site. Page flows are a wireframed HTML walkthrough of the site (without design elements). Within these page flows, the navigational needs become apparent. In addition, by clicking through the wireframes, missing areas of content and functionality come to light. When the wireframe page flows are complete, it's important to document the user interface components and decisions to make it easier for the site to be designed.

Do all these steps sound tedious to your inner designer? Consider that by including all these structural activities - business imperatives, user research, content strategy, information architecture, user interface design - you're creating an excellent foundation for your site. With that foundation in place, you have the freedom to push your design exploration into new territory. In addition, having a good outline of reasons and strategy in place makes it more likely that the site will evolve over time, and not be thrown out when the newest, latest color palette or technology makes the scene. A little frugality can go a long, long way.

ChickClick is a network of independent
female-powered Websites and services.
More than one million girls and young
women plug into our intelligent, sassy
and creative content. ChickClick
represents the diverse voices and
passions of this dynamic generation.
ChickClick's content originates from a
unique combination of an experienced in-
house editorial team, more than 30
affiliates, and daily contributions from
users.

LINKS

http://www.chickclick.com
http://www.estronet.com

CHERRY
sucker
PLAY WITH YOUR WORDS

hey...
cAn
i hAVe a
tAMPon?
GRRLgap

"Then, we throw in great free features,
like email, homepages, and instant
messaging - keeping ChickClickers
connected to us and to one another. Check
us out and tap into what the Internet
generation is all about." (Chickclick,
2000)

NET-150

----- Choose One ----- ⬍

Ted Baker | Ted Baker Woman | Edward Baker | Teddy Boy | Teddy Girl | Search
Underwear | Fragrances | Accessories | Shoes | Ted Specials

TED BAKER ONLINE

Ted's Laundrette

Taking care of Ted consists of several easy to understand guides on how to look after your clothing to keep it in the best possible condition for the longest possible time.

Each guide presents the most relevant information first then gets into more detail as you choose to access more information, so you can choose as little or as much as you want (and as your attention span can bear).

While laundry may not be the most stimulating topic simply **reading** this guide and picking up a few tips can have dramatic **effects** on the state of your clothes over time.

Welcome to Ted's Laundrette

Ted Baker | Ted Baker Woman | Edward Baker | Teddy Boy | Teddy Girl | Underwear
Fragrances | Accessories | Ted Specials | Shoes

TED BAKER ONLINE

© close

Size Chart

Ted family: Ted is no ordinary design label, and has his own system for sizing his clothes. Use our size chart to find out which Ted size you are...

Ted/ Edward Woman Boy Girl

Ted Baker | Ted Baker Woman | Edward Baker | Teddy Boy | Teddy Girl | Search
Underwear | Fragrances | Accessories | Shoes | Ted Specials

TED BAKER ONLINE

About Ted Investors Ted News Downloads Competitions Shock - Ted

Sink
everything including the kitchen sink

PULL THE PLUG

© Are you new to Ted? Click here to log in or register a new account.

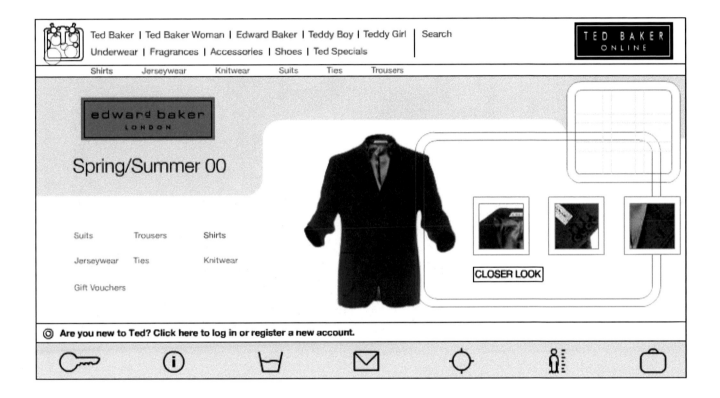

Ted Baker | Ted Baker Woman | Edward Baker | Teddy Boy | Teddy Girl | Search
Underwear | Fragrances | Accessories | Shoes | Ted Specials |

TED BAKER
ONLINE

Shirts Jerseywear Knitwear Suits Ties Trousers

edward baker
LONDON

Spring/Summer 00

Suits Trousers Shirts

Jerseywear Ties Knitwear

Gift Vouchers

CLOSER LOOK

Are you new to Ted? Click here to log in or register a new account.

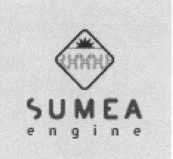

SUMEA
e n g i n e

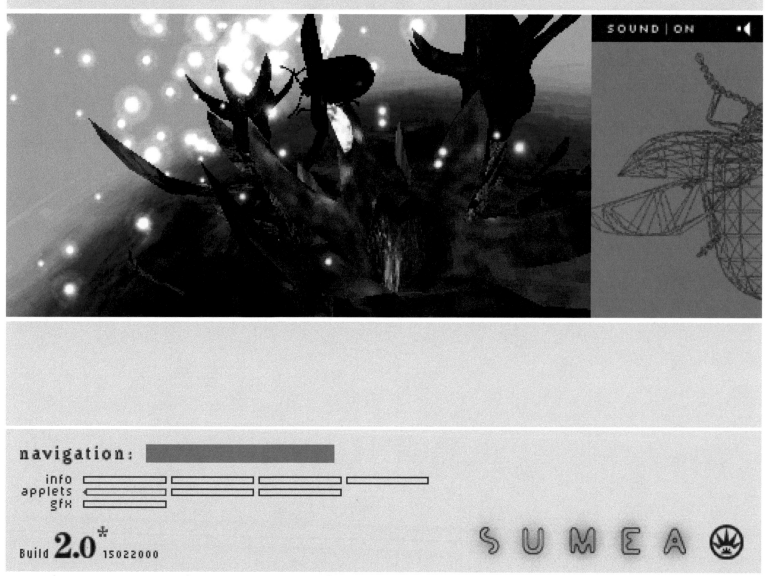

SOUND | ON

navigation :

info
applets
gfx

Build **2.0*** 15022000

SUMEA

SUMEA
e n g i n e

SOUND | ON

move mouse over the applet mousebutton pressed down to move the camera

navigation:

info
applets
gfx

Build 2.0* 15022000

SUMEA

0 1 2 0 1 2 3 4 5 6 7 8 9 0 1 3 5 7 9

DAILY SCHEDULES ②

MTV2 FEATURES ④

THIS MONTH'S HIGHLIGHTS ③

① MTV2 PLAYLIST

PLAYLIST/SCHEDULES

2

Five Senses to Communicate . Jeremy Abbett, Fork Unstable Media, Creative Partner, New York, USA
"If you specialize in one thing, you can't really call yourself an all out killer." - young graffiti artist in Style Wars

The Web has allowed designers to become publishers without having to burn a hole in their pockets. In this regard the medium has become a prevalent form of expression for anyone who decides to take the time to create anything of their choosing. I remember when I was grow-ing-up skateboarding and going to shows like 7 Seconds and the Suicidal Tendencies' - this was before Suicidal got big with the jock scene - the popularity of zines. These paper copy-machine, cut'n'pasted, glue-backed based publications were full of stories of the latest exploits of some obscure band or individual as well as reviews of the latest vinyl being released. Also includ-ed was a comic-strip that some budding cartoonist would create portraying the local version of some social epiphany. Zines were then distributed by word-of-mouth from hand-to-hand or at some social gathering that the local authorities were not too keen on. These black and white publications held my interest because of the raw energy they held as well as the insight into another person's perspective. I do not consider myself a voyeur, but I do take a particular pleasure knowing how others view the world and the environment they live in and zines were a peek into someone's "quick burst of nervous energy laid out on paper". This without having to satisfy anyone but themselves, albeit dependent on the publication's purpose. I liken the zine to that of a website. Not unlike a zine, a website is a publi-cation that requires nothing more than someone deciding to create it. And many websites, personal in nature that is, are journals that contain nothing more than text that is created, like a zine, in bursts of nervous energy and uploaded onto a server for those who are willing to see it. For people making zines, the next logical step would be to graduate from black and white copy paper and move up to color. While the option of color is incredibly seductive, the costs of creating a color zine are far beyond most people's budget for self-publication, not to mention the completely different textural feel of color copies. While the cost of bandwidth falls so does the ability to load big files on to a website.

When I view someone's website, I am mostly interested in what that person is trying to say. What he/she is trying to say is also a matter of how they are saying it. Whether that's with plain ASCII text or using a video stream, the underlying factor is the message. For a designer this is where style is a fac-tor, for when you have the chance to create whatever you like, the possibil-ities are limited only by what you are able to produce yourself and how you choose to produce it. If you have to produce a website by yourself or any-thing for that matter, the first step is figuring out what makes it tick. In this case the underlying structure is HTML, the basic building blocks of a graphical Web. From here, the options are practically limitless as to what can be done when you learn a little, or a lot, of pro-gramming. Of course there are designers who have no idea, or at the very least, a vague idea of how the Web works. It is these designers that I see as the snapshot variety. Creating pretty pic-tures and pushing pixels around with no regard for the medium's boundaries. Just like in print design, a designer is able to make more com-pelling pieces if they understand their medium and the ways it can be manipulated.

Besides knowing the intricacies of a medium, designers also have to know a wide array of things that bring into play how they decide to communicate a message. When a designer is able to take all they know and put it into a solution that suits not only the client, in this case themselves, but also other people outside of the target audience it creates an interest in such a way that can only be seen when it is made public. Regardless of what is considered a standard design education in a four year college course, if a designer stops learning, thereby losing touch with the environment in which the piece is going to be potentially placed (in this case the ever-changing Web), then the consequence is a piece that ends up being a black hole of sorts. In this regard designers can be seen as generalists with interests in all things that will aid them in the process of finding solutions that focus not only on the visual, but also on the other four senses that we as humans use to communicate. While it is good to focus on or specialize in one area, if you lose sight of your environment and the changes that is goes through, then you will lose touch with the audience you are trying to reach.

STOCKHOLM
VÄLKOMMEN ÅTER

SUTURE

LOCATION OVERVIEW (CLICK TO ACTIVATE)

SHELF OF INVENTIONS - Creativity and invention are
the engines of mobility

ROBOTIC AREA SHELF OF INVENTIONS

PERSONAL VISIONS SIMULATED WORLD

SPEED

LAB.01

Robot Gallery
Robotics fascinate man because with it he can create
artificial life which can even be put to good use. But
robots are hardly as efficient as humans. Currently, their
coordination level is less than that of an insect's brain.
Research is still ongoing. The robot gallery gives an
overview over the different species and their applications.

DISCOVER THE NEXT
LAB.01

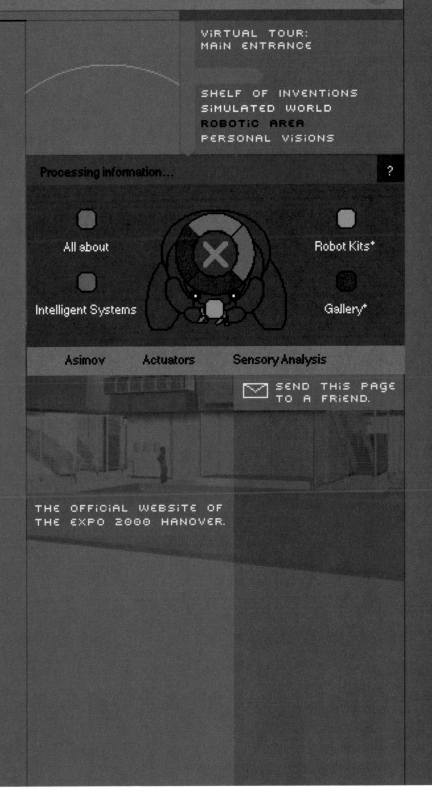

VIRTUAL TOUR:
MAiN ENTRANCE

SHELF OF INVENTIONS
SiMULATED WORLD
ROBOTiC AREA
PERSONAL ViSiONS

Processing information... ?

All about

Intelligent Systems

Robot Kits⁺

Gallery⁺

Asimov Actuators Sensory Analysis

✉ SEND THiS PAGE
TO A FRiEND.

THE OFFiCiAL WEBSiTE OF
THE EXPO 2000 HANOVER.

0120123456789013579

Futurefarmers engages in creative
investigation and development of new work.
Through collaboration, we explore the
relationship of concept and creative process
between interdisciplinary artists.

futurefarmers

co-LAB || portfolio || stimuli || lowdown || product || sitemap

amy_franceschir
www.futurefarmers.co

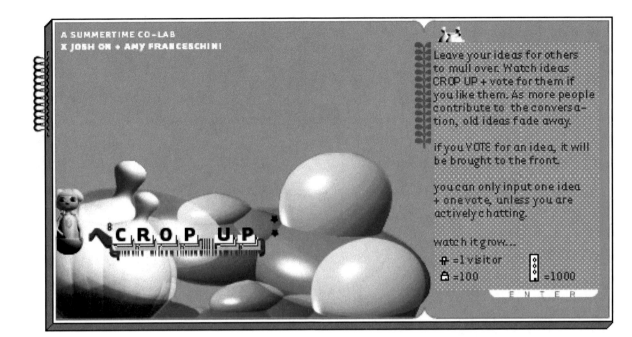

A SUMMERTIME CO-LAB
X JOSH ON + AMY FRANCESCHINI

Leave your ideas for others
to mull over. Watch ideas
CROP UP + vote for them if
you like them. As more people
contribute to the conversa-
tion, old ideas fade away.

if you VOTE for an idea, it will
be brought to the front.

you can only input one idea
+ one vote, unless you are
actively chatting.

watch it grow...

☖ = 1 visitor

☖ = 100 = 1000

E N T E R

CROP UP

POPULATION

ADD COMMENT VOTE

INHOUSE

hey hey
>hahaha
>haha are fun
>hello all
because we think it is.

>looking at him clean his
glasses was the same as comment just
watching him move in bed. it
is not to clear. >where

>the end is near!!!

>blah

>more than a tad small

>big time complication

CROP UP

####

<Grapes>
...Qq5dZv

<Lemon>
...T'v?T[

<Strawberry>
...3&7{gG

+
WHO
+

1025 17th
Street, #1
San Francisco, CA
9 4 1 0 7
USA

T :: 415.355.1330
F :: .355.1331

((*)) e-mail

Use SHIFT to reach your goal?

ゴールを達成するために「SHIFT」を使う？

VIEW GALLERY

SHOP!

WE ACCEPT:

AMERICAN EXPRESS
MasterCard
VISA

NETBABY LOVES YOU! ♥♥♥

NEW!

$ 35

HOW TO ORDER!
STEP-BY-STEP

1 FIND THE PRODUCT YOU WANT TO BUY

2 CLICK ON THE PRODUCT TO ADD TO BASKET

3 PRESS ORDER NOW BUTTON TO CONFIRM

KEYRING | **T-SHIRTS** | **COLLECTIBLES**

$2.9

42 DESIGNS

HOT PRODUCTS

Netbaby

$ 29.99

LIMITED EDITON!

Netbaby Collectibles!

SUPERPAC $ 94.99

NEW!

SUPERPAC!

ALL THIS INCLUDED:

* SMART KEYS™
* SMALL STICKERS
* BIG STICKERS
* NETBABY FRISBEE
* DIGGER DOLL
* KEYRING
* T-SHIRT
* SERIALNUMBER

TOP QUALITY!

netbaby
NBTS-0024

COLLECT ALL!

Hi score computer

Netbaby Collectibles!

NICE T-SHIRTS IN 100% COTTON. AVAILABLE IN FIVE DIFFERENT PRINTS.

COLOR: RED AND BLUE.

STICKERS - SMART KEYS FOR YOUR KEYBOARD AND NETBABY HEROES!

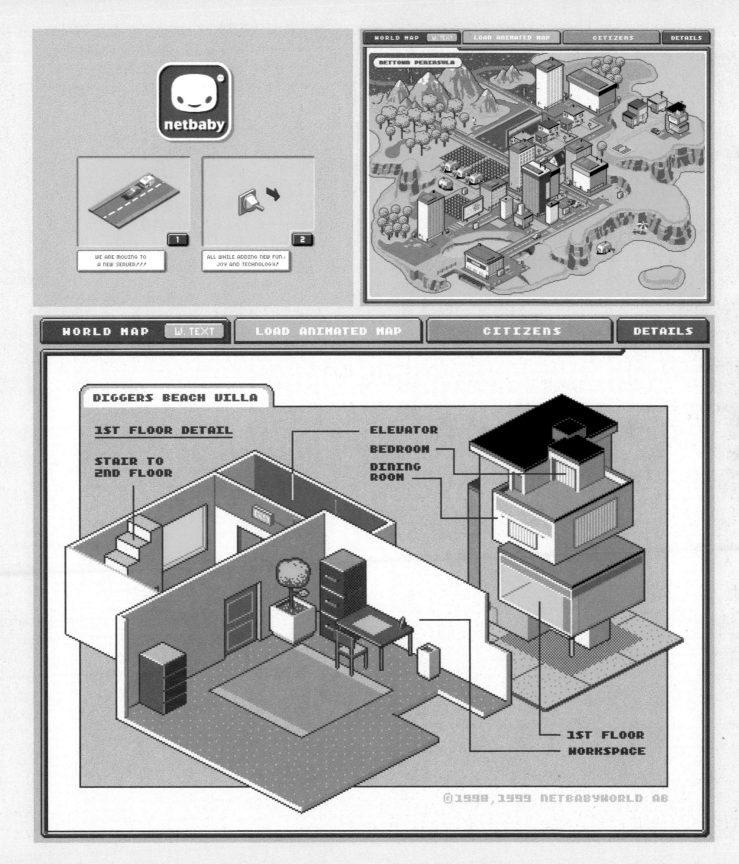

netbaby

WE ARE MOVING TO
A NEW SERVER???

ALL WHILE ADDING NEW FUN,
JOY AND TECHNOLOGY♪

NETTOWN PENINSULA

WORLD MAP W. TEXT LOAD ANIMATED MAP CITIZENS DETAILS

DIGGERS BEACH VILLA

1ST FLOOR DETAIL

ELEVATOR

BEDROOM

DINING
ROOM

STAIR TO
2ND FLOOR

1ST FLOOR

WORKSPACE

©1998,1999 NETBABYWORLD AB

0120123456789013579

Not every web designer is a diva, and not every web designer who behaves like a diva has the right to be one. Real divas claim early on in their rapid rise to the top of the career ladder to be a media mogul or an online god before falling back into obscurity for quite some time. We can easily identify divas by the following characteristics: no sense of proportion when it comes to self-promotion, zeal and partial communicative poverty. All other divas are common or garden eclectics.

But what really makes divas stand out? Their reputations as unparalleled creative talents must a priori have gone before them - this is the basis on which the originality of the diva is recognized by others. The special reputation of a web design diva is, in addition, dependent on a variety of interdisciplinary knowledge: To start with, the traditional components, such as a knowledge of how the medium is composed (i.e. sympathy), an understanding of the effect of the visual medium (i.e. brand awareness) and of the language of the visual medium (i.e. information recognition), which should, after all, open up the meaning and purpose of the presentation and its background to the viewer. These components make up one differentiating aspect of web design, namely that which can also be found again in analog visualizations. However, over and above this, the medium specifications of the Internet and its devices open the door to new, variously undefined dimensions. The web designer competently commands all these components in a new framework of a new medium and connects them with the unseen aspect, the architecture, which is hidden beneath the single dimension of the screen. And it is exactly this which brings designers closer to what they sometimes can and always want to be: a Diva or interface to happiness.

Above all, however, pure divas are a brake on everyday pragmatism. They do everything themselves, they are able to do everything better and they always know better. Thus, they see themselves as the lone wolf ascending Mount Olympus. But the more they shy away from the pack, the more they seek it out as a reality check. For the web designer in particular, creative isolation is always seen in relation to the creative society. This form of creative socialization is like a tightrope act. It is about interdisciplinary work flow and is for all members of an Internet team in equal measure a source of energy, of ideas and not least of conviction for and against the client. For the stubbornly egocentric designer, however, this teamwork instead appears to be the thorny cross to be borne on the path to understanding. The diva cannot do without them, but suffers by being with them. In addition to this, having the insight to be able to understand websites not in a linear way, as happens for purely organizational reasons in heavily staffed agencies, who burden themselves further with the attribute of full service, but by taking the lead from the me-

Web designers bring a new work structure to the team of technical people, programmers, conceptualists, managers and content-strategists. They lay the foundations for the integration of backend and frontend and, through their visualizing capacity, they are able to link the technical possibilities with comprehensible presentation for the viewer. The traditional expert principle of the excessive focusing of knowledge in linear workflow (a->b->c=d) is more and more giving way to the integrative simultaneity of knowledge focus and its intersection of sets/interdisciplinary nature/crossovers (abc->aabc->abbc->abcc=abcd). The reason is simple: design and production can only be separated (and thus processed linearly), once the potential of the development has moved far enough from the design so that set production processes with a high half life have been established.

But still the Internet does not seem to have suffered where developmental dynamic is concerned. The form of the specifics of an integrated process marches on. A major thought when reflecting on the considerable cross-over between development and production - assuming that people still consider themselves to be developers and not users of the new medium, or better still, people consider themselves to be divas rather than designers - remains the fact that interdisciplinary competence determines individual and original creativity and economic success. Generating ideas becomes more creative, therefore more likely to be successful, working time becomes more efficient, therefore used in a more motivated way, know-how transfer becomes quicker. The only thing against this principle is individual inertia.

That divas of web design like to see themselves as brilliantly-creative lone wolves is clear to anyone who has worked with one. And, we are happy to acknowledge the fact that the diva views content, technical, organizational and visual power equally and simultaneously from their self-constructed Mount Olympus. But one thing's for sure: by visualizing ideas, the diva makes it possible for things to be perceived by others.

if you want to work with us,
contact us day and night via
electronic mail at

info@hi-res.net

or in realtime on
+44 (0)171 247 4410

hi, Res!
5******star image chefs
london
england.earth.

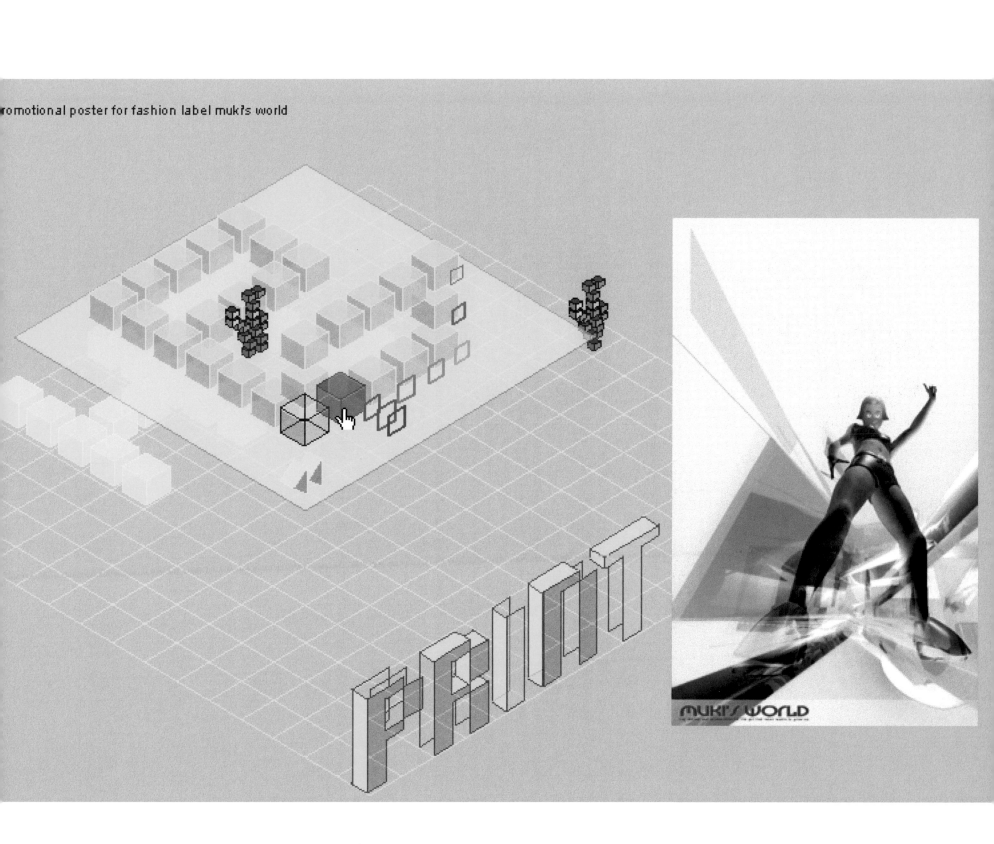

romotional poster for fashion label mukis world

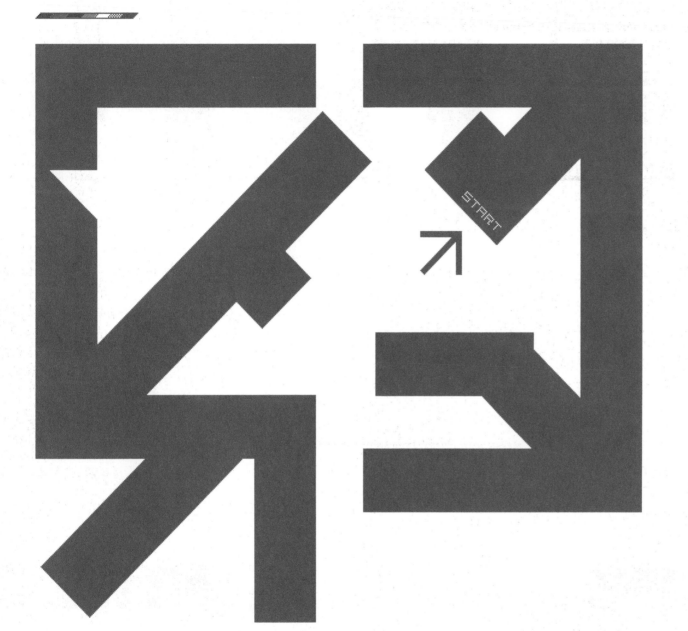

START

0523'00

philipp_körb●
www.plasticbag.●

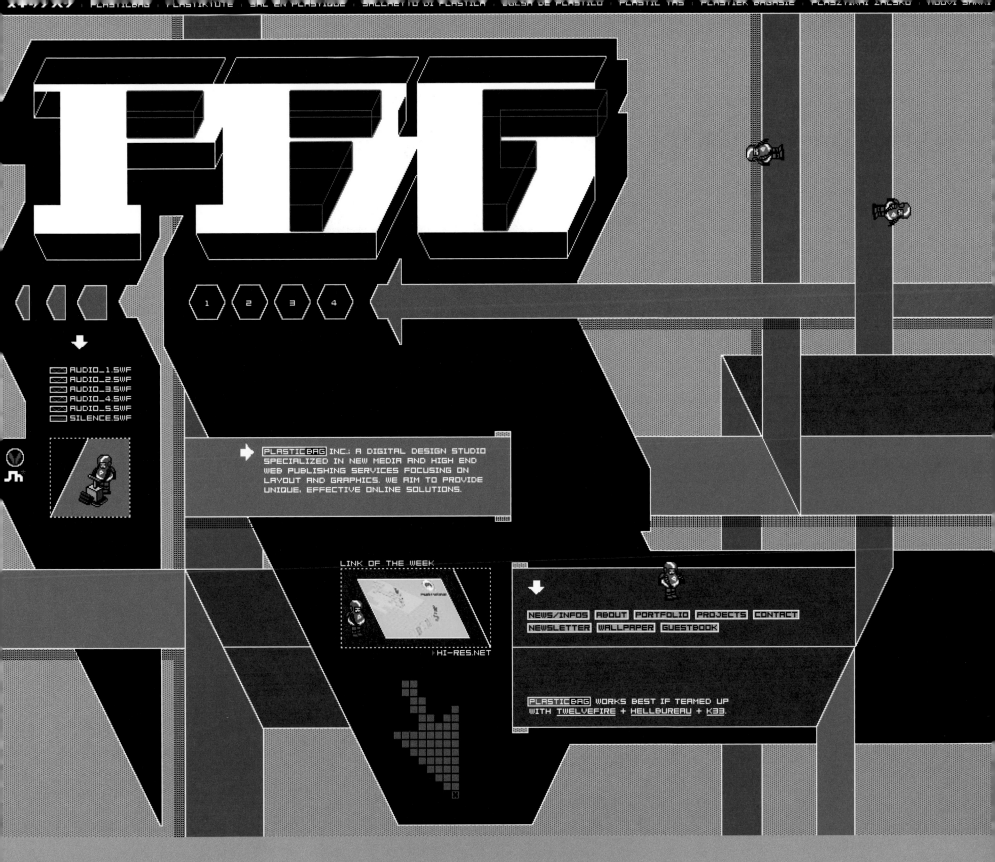

AUDIO_1.SWF
AUDIO_2.SWF
AUDIO_3.SWF
AUDIO_4.SWF
AUDIO_5.SWF
SILENCE.SWF

PLASTICBAG INC.: A DIGITAL DESIGN STUDIO
SPECIALIZED IN NEW MEDIA AND HIGH END
WEB PUBLISHING SERVICES FOCUSING ON
LAYOUT AND GRAPHICS. WE AIM TO PROVIDE
UNIQUE, EFFECTIVE ONLINE SOLUTIONS.

LINK OF THE WEEK

▸HI-RES.NET

NEWS/INFOS ABOUT PORTFOLIO PROJECTS CONTACT
NEWSLETTER WALLPAPER GUESTBOOK

PLASTICBAG WORKS BEST IF TEAMED UP
WITH TWELVEFIRE + HELLBUREAU + K33.

Creating a solution for navigating a website would not seem to be a major challenge these days. Designers are surrounded by a variety of apparent "design standards", which promise to be as successful as the supposed leaders, the likes of yahoo, amazon, cnet or ebay - today's web designers simply need to shop around.

Just as the average web designer creates something from the "non-creation" of his or her colleagues, it seems that the client is also content with the solutions offered by the wealth of revered models. It is not unheard of for a designer to be confronted with a client's demands to produce a design concept, which is very similar to a solution that already exists.

The issue of the quality of these quasi-solutions appears to play only a secondary role. The majority of designers submit to conventions, which they may not have created but which they are nonetheless happy to maintain. The creatives appear to have no shortage of energy when it comes to presenting yet another incarnation of the old reliable "left-side-navigation" (as anglophile web designers like to call the organization of navigational elements on the left hand side of the screen), the

Method Lab Feedback

obligatory tab system and of course the beveled button.

To understand this lack of direction prevailing in web design today, it may be helpful to look to the past. The origins of any new medium are dominated by engineers and technical people and the 'world wide web' is no exception. The need to evolve information designs seemed to be at best a secondary consideration. It was only when the 'World Wide Web' started to be exploited for commercial purposes that design became a necessity. Unfortunately the Internet revolution was preceded by another revolution, which sowed the seeds of the current design dilemma - the revolution of desktop publishing. By the mid-1980s, anyone who had a home computer and a printer was able to create a lay-out and publish documents, with the help of the appropriate software. This marked the start of the divorce of the design community from its tradition and its expertise. The availability of technology replaced the skill of information design - and reduced it to a superficial level. Computers took over the skill component and people felt qualified to take over the artistic component! The early period of the web which was driven and determined by technical people

and programmers soon gave way to the era of the zealous young web designers who no doubt went about their task with energy and innovation, influenced by an older generation of designers for whom knowledge of typography and sometimes even an understanding of elementary design principles seemed no longer to be of importance.

The body of expertise that has developed around the question of user-friendliness or navigation solutions appears to have sacrificed itself to an unusual philosophy of consensus. What other explanation could there be for the fact that usability experts such as Jacob Nielsen conclude that even though the design quality of 90% of the major websites is very low, they have to serve as the standard for designers. Such experts lay down what the user can expect because they assume the user wants every website to be navigable according to the same principles.

We can see that the user is not really trusted here. The Internet is the first medium in which the user moves in a highly dynamic and non-linear space. An adequate design for this includes the context of the user who is moving around in it.

Starting from the assumption that the user needs to navigate in order to arrive at a particular place, the solution offered should support this process and optimize it. Setting and maintaining the wrong standards means that the user is dictated to. The result is something that I call 'empty design'.

Thus by examining more precisely the dilemma of designing for the web , the greater dilemma of modern graphic design can be seen, which seems to have forgotten its original function - to find a solution for the best way to bring across content within a framework of implementation. Ignorance of and at times even disregard for the handwork tradition and its original base in the craft of printing and design does nothing to strengthen the field of design. Instead, the field becomes vulnerable and open to attack, not least from the client. When designers rediscover their power to solve communication problems (conceptual problems as well as those involved in the various aspects of implementation) then design will have a chance to be more than simply the half-hearted formatter of what is dictated by mediocrity and the Internet can develop its potential as a medium - for the user and for the designer.

Method Lab Feudback

alexander_baumgar
www.method.

THE**APT**

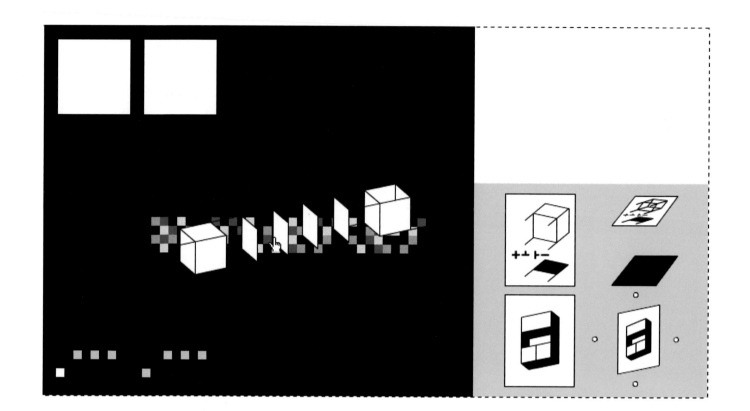

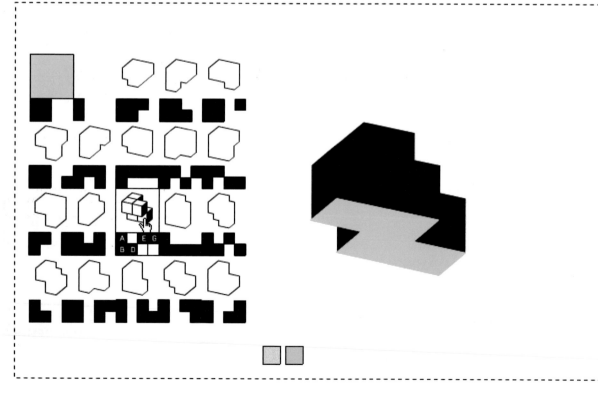

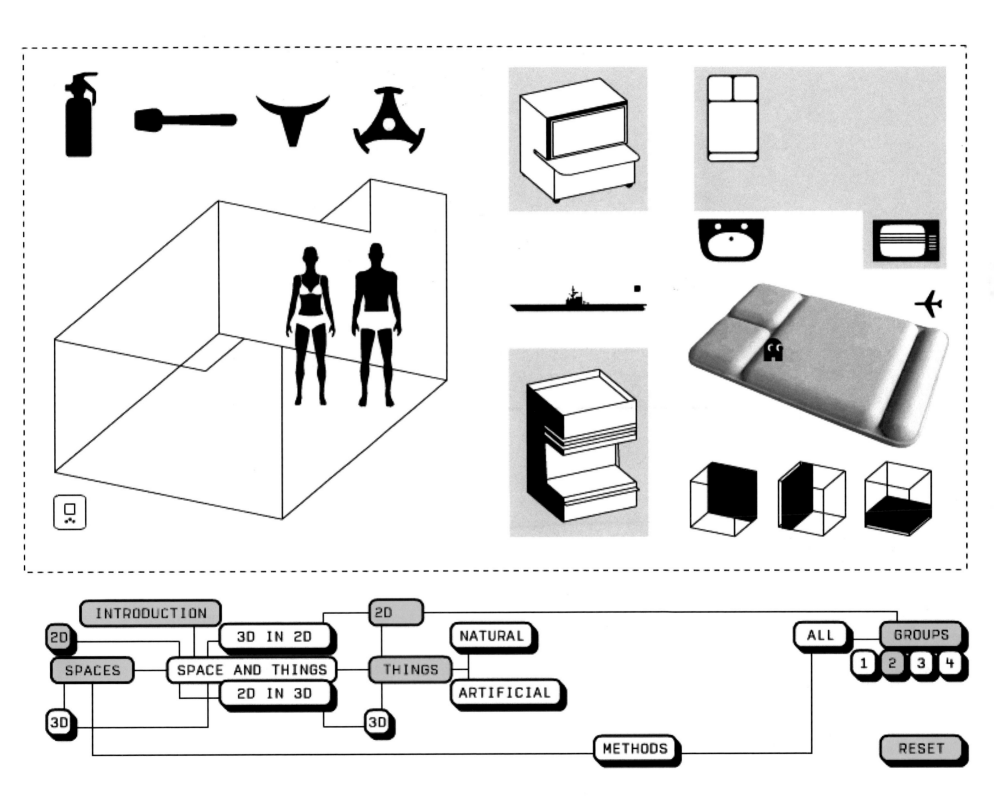

Last Easter, I was suddenly fed up with the endless round of dot.com parties and the cliched, ambivalent talk about value-added propositions and equity models which can cast a haze over the working day here in San Franciso to equal the smog that occasionally envelopes the city itself.
I decided on the spur of the moment to fly to New York for a long weekend. A woman I work with tipped me off about an Easter Special offered by United Airlines, fly out Saturday, fly back Thursday and all for just $350.
Mid-way through my journey to the east coast — leaving behind the turbulences and jet streams of the Rockies which usually remind me of my fear of flying and make me question the reliability of analog technology - I was at last able to enjoy a Gin and Tonic and "The talented Mr. Ripley" and to reflect at my leisure about the process in which I now found myself.
Of course, booking a ticket on-line has become a pretty standard procedure today and the fact that our natural need for comfort and convenience has been satisfied by the World Wide Web is also now widely acknowledged. But, the combination of the on and off-line aspects of my journey - the very easy and discretely organized on-line booking process, the smooth handling at the ticket counter and the equally easy and polite efficiency when getting on to the plane - had merged into a seamless travel experience. I had, in fact, for one brief and perhaps even insignificant moment that thing which everyone is talking about but which few are in a position to deliver - a Web-initiated customer experience.

Marshall McLuhan once claimed that all new media are conservative to begin with. The individual - when confronted with a complex, unfamiliar system - tends to use tried and trusted metaphors to get to grips with this new thing. There are legion examples of this: from the first pages printed by machine, that imitated handwriting, to early photography in which models were placed in front of painted, classical-romantic landscapes, to the electronic desktop which replicated all the dry charm of the familiar office landscape.
The Internet of 2000 AD would appear to support this thesis. The fact that it already is a mass medium obeys the logic of human inertia, in that it also has to function like any other (conventional) mass medium.
So, in spite of all the wonderfully designed websites and a growing number of bookmarks, I can't shake off the feeling that my experience of meaning, point and personal enrichment has become just as miserable as any this other screen – the television –promises to generate.
In all of this, it is irrelevant whether this frustration is due to the onslaught of the corporate players or the Flash masturbations of the cutting edge, which increasingly masks lack of content and authenticity beneath ambitious animation. Established graphics standards like the left-hand navigation bar as well as experimenting with and sounding out the very latest technologies have degenerated into generally accepted and expected goals in and of themselves.

However, unlike all "traditional" media, which were nothing more than a linear distribution mechanism by which one person's ideas and experiences could be communicated to many, the technological basis of the Internet enables the exchange of experiences and ideas between many individuals. As such, it is an inherently social vehicle, which, for the first time in the history of the media, equips individuals with the power to change their surroundings. To a certain extent, it is a mirror of life itself.
Designing a medium like this demands two things: first of all, an understanding of the technological structure that makes it possible for individuals to communicate. Secondly, giving the "players" simple, understandable and comprehensible tools, that make it possible for them to take part in this social and creative exchange - because now it is no longer about connecting people with data, but connecting people with people.
In the future we will no longer differentiate between on-line and off-line. Interfaces will become increasingly fluid, the frontiers imperceptible. Our focus should then be less concerned with generating an Erlebnis* (the experience of "thrill") - which has been the objective of mass communication from the beginning - and more with designing the necessary environment in which an individual Erfahrung* (an experience that is embodied in ones history) can be broadened: to sum up, nothing more than the conditions in which real interaction can take place.
At the level of design, this means that the "rules of engagement" will have to change. Design will no longer simply have the task of drawing the user to the page through pretty, superficial graphics. That was and still is the mechanism used by the old media. On the other hand, making it possible to have an active influence on the originating and exchange processes demands an environment which allows for different social configurations and individual preferences. To develop the argument further, would it not be interesting if our interfaces, instead of speaking the language of the sender, were able to speak the - vastly different - languages of the user?

* The German language has two genuinely different words for the English term 'experience', which have a quite different connotation: 'Erlebnis' is a rather superfical experience attached to a specific moment in time while 'Erfahrung' is something of a broader and more fundamental range which becomes part of ones ethic and way of thinking.

Because all social process are by nature amorphous and multi-faceted this may mean that the designer will have to give away a certain level of control in favor of the user (I hear some moaning here already...). But what a negligible loss this would be if we finally ended up in a situation where we had the ways and means to design how we can live and interact with each other - instead of simply changing things on the surface. I could also add at this point, how happy I would have been if at the end of my film Gwyneth Paltrow had found Matt Damon out as the fraudster he really was - but unfortunately this was another medium in which the director prescribed for me an ending which I did not like. Unfortunately, I did not have the means at my disposal to change the world. Well, not yet.....

No matter how enormous this task might seem, it is worth remembering that the history of the media shows us that the moment of art for art's sake is also the critical point from which a new, independent language develops.
In the short term, many designers will pursue the panaceas promised by multi media, with wide screen and video on demand already on the horizon, but few will last the distance. I am certain, however, that the best people in the field will take on the real challenge in the long term and will develop interfaces which enable individual freedom and experiential learning.

QuickTimeVR

QuickTimeVR is another technique by Apple. It simulates a pseudo-threedimensional space by stitching together sequential images. You can integrate such files into the HTML flow using the <embed> tag. Use the mouse pointer to move around. Hold down the "Alt" (Option) key to zoom in and the Control key to zoom out. For more details check out Apple's QuickTimeVR page.

QuickTimeVR

QuickTimeVR is another technique by Apple. It simulates a pseudo-threedimensional space by stitching together sequential images. You can integrate such files into the HTML flow using the <embed> tag. Use the mouse pointer to move around. Hold down the "Alt" (Option) key to zoom in and the Control key to zoom out. For more details check out Apple's QuickTimeVR page.

Introduction

Examples

Links

Resources

DHTML

Contact

< t y p o s p a c e >

Examples

For some examples of this section to view properly you will need special browser versions and/or special extensions.
Some samples may fail to load due to low memory or browser versions older than versions 3.

Dynamic HTML Netscape 4 or higher required.
Dynamic HTML is certainly the currently most exciting online technology. Layring elements and integrating Style Sheets opens up an unprecedented freedom for designers to create complex user interfaces that can be highly interactive without having to rely on third-party plug-ins. This is a small application
For a better understanding take a look at <typospace> 1.2, a short introduction into the advantages and some of the exciting possibilities of DHTML. You will need Netscape Navigator 4 to view this.

Gif Anima
As an offspr
developed i
display text
As part of t
browser ge
file (called
independent
system font
standard so
working on

JavaScrip
To confuse
Both langua
JavaScript was initially developed by Netscape and has become on of the most powerful tools to massage web content. As a so called "client-side" scripting language it allows for instant manipulations in the browser window without any time consuming interaction with the server. JavaScript's biggest asset is that it can offer certain graphical effects which are independent from any plug-ins installed.
This is a very simple rollover function which makes use of JavaScript's pre-caching feature. All the elements necessary for the transition are loaded into memory while the page loads. When the user interacts the change

Netscape: < t y p o s p a c e | j a v a s c r i p t >

JavaScript Rollover

This JavaScript function preloads all elements necessary for the animation into the browser's cache. These are an animated gif for the left turn and the right turn respectively, and a still image for the default image. The pre-loading makes feedback with the object immediate without any reload delay.

Move your mouse pointer over the left or the right half of the image.

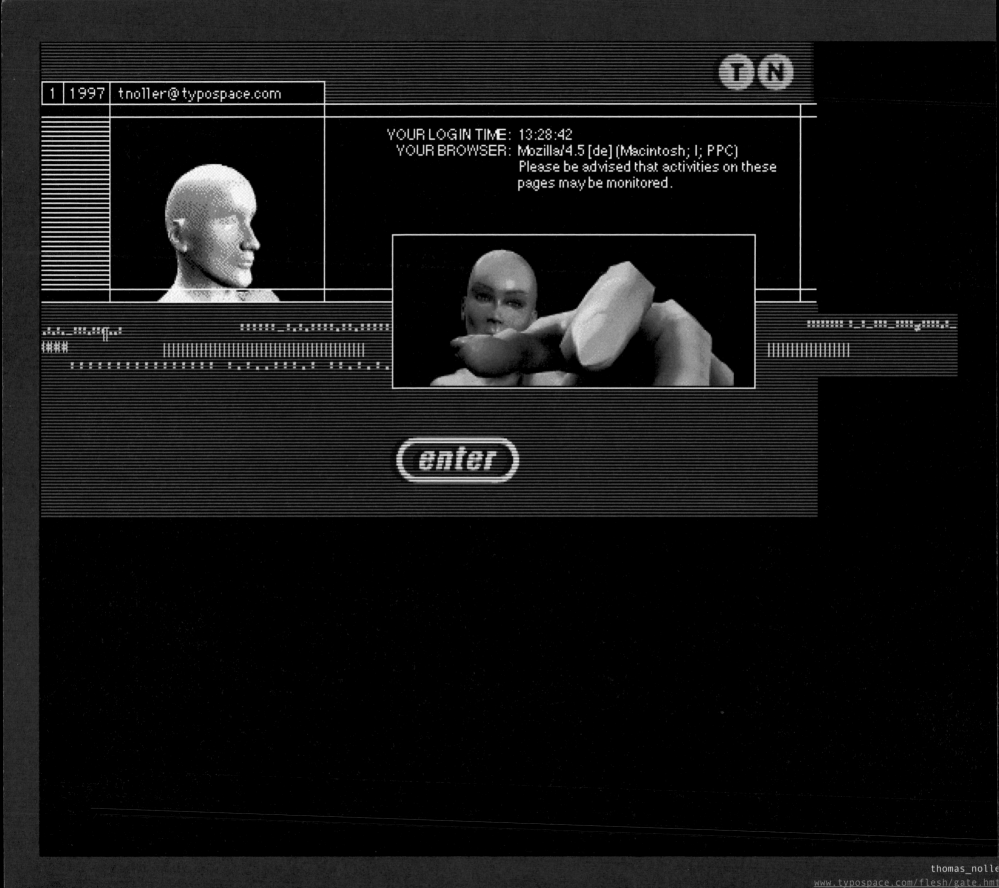

YOUR LOGIN TIME: 13:28:42
YOUR BROWSER: Mozilla/4.5 [de] (Macintosh; I; PPC)
Please be advised that activities on these
pages may be monitored.

enter

SECTION 1 - A SHORT HISTORY OF THE CYBORG CLICK HERE FOR SECTION 2

Mad Headroom Blade Runner Terminators

Self-Awareness

The Golem Menotions The Future

Homuncular
Perceptions

Myth/Culture

Techno-Reality

Stanley Kubrick's groundsetting "Space
Odyssey" of 1969 marks an end to the notion that
the artificial other has to be a clumsy and bodily
offensive being. Mirroring the late 60's obsession
with drug-enhanced realities, central character
HAL 9000 is all brain and mind power, a static
advanced network without extremities other than
an always open eye. Like in earlier examples the
cyborg runs amok in the end, this time because
he gets aware that memories can only be fake, if
they are not attached to a body that experienced
them.

◄ Early 20th Centaury Late 20th Centaury ►

CONCEPTS

"NO MORE ANXIETY, NO MORE
MEMORY OF MISERY, NO MORE
TEDIUM, NO MORE STALE HABITS.
WE GAMBLED WITH IMAGES, AND
THERE WERE NO LOSERS."

– PAUL ELUARD

01 02 03 04

RMX
PRESS'N'REMIX

WRITEITDOWN @ THEYRMXXX.COM

UL ELUARD

WRITEITDOWN ✉ THEYRMIXX.COM

WRITEITDOWN ✉ THEYRMIXX.COM

RMX //A VISUAL REMIX PROJECT

DESIGNERS ARE WANKERS

RMX
S'S'REMIX

04

WRITEITDOWN ✉ THEYRMIXX.COM

Print and Web Design - Is It Actually Possible? . Ansgar Hiller, Anja Wülfing, Oliver Funke, PlanetPixel, Cologne, Germany.

To reveal the answer straight away - it has to be possible. All self-employed graphic (or print) designers have at one time or another been confronted with the following statement by one of their loyal print customers: "We have to get a website". All self-respecting designers will of course instantly reply "No problem", even if they do not have the foggiest idea what they are letting themselves in for. After all, who wants to leave themselves open to the accusation of having been left behind by the futuristic development in the media landscape: even more to the point, who wants to lose a client to a web designer who most likely could also take over their loyal customer's print needs as well. So there is really no question, it simply has to be possible. Every Tom, Dick and Harry is being retrained as a "multi-media designer" thanks to various initiatives, so it would be a bit stupid if a real-life designer could not acquire this know-how, too. We all know that we cannot really expect too much from such retraining initiatives and as designers we have all learned to grow with these challenges. This is more or less how most web designers began their careers. We can safely assume that up to a few years ago many of the creators of the websites featured in this book were still print-based designers or at least some other type of designer and that those who only began their career in design with the onset of the Internet boom in the mid-1990s are the exception rather than the rule. Regardless of whether a designer gives up print totally in favor of web design or whether they decide to continue working with paper and card, it is no longer possible for designers to ignore the Internet. Over the last decade, print designers, more than any other profession, have had to give up their workplace, which was originally largely craft based, and submit to the digital revolution. Many "printers" have mutated to real freaks, who see their computer above all as an electronically living partner and eat, sleep and breath technology. No wonder that some of them were particularly irritated at still having to carry out the few tasks necessary in order to capture their digital products on paper without losing anything and to make their tool into a medium. The fact that the Internet was not in fact originally conceived for design purposes has been viewed as a challenge rather than a deterrent, and this is why many of the best web designers are also still in fact outstanding print designers - even if, for those of us who are still predominantly concerned with print on a day-to-day basis, this is difficult to admit.

Up to now you could be forgiven for thinking that the transformation from print to web design is really not worth talking about. But, you are completely wide of the mark! Maybe this would be a good time to go back to the beginnings of the online hysteria. Graphic designers who were used to dedicating themselves with loving devotion to each block of text, to spending hours breaking it up and pushing it here and there in the layout, think back in horror to their first expeditions into the world of online design. In design terms, the new medium threw, where it could, a spanner into the designer's works. Designers had to get used to working with programming languages just so that they could see how inadequate they are with their own eyes. Text and image could only be positioned across unconnecting parameters. New York, Monaco, Chicago and Geneva came back with a vengeance, just when we thought the era of fonts named after metropoli was at an end. In other words, it was a complete wasteland in terms of design. The Internet was simply a collection of networked texts, at best decorated here and there with a gif and it did not seem to want to be anything more.

When, at that time, a friend revealed to me that he wanted to work mainly in web design from then on, I really had to ask myself what the devil he was talking about. The rapid development of the medium has, however, proved him correct. From its origins as the ticker-tape of the universities, the Web has become an indispensable, global network for the presentation of information of all kinds and has grown beyond all expectation in a very short period of time. At the same time, the makers of graphics and layout software have targeted the new medium and have transferred insofar as possible the design possibilities of print design to the Internet. The demand for web graphics has grown enormously and these packages which can be maintained and extended regularly by updates open up new fields of work for programmers and (in former times) print-based graphic designers alike. There is no firm or brand which can afford not to have an Internet presence nowadays. By now at least it should be clear that print designers have always been part of this development; after all, is it not their (former) print customers who are populating the World Wide Web in such numbers?

In order to achieve complete communication (or CI as we (CDs) say) the interplay of print and web design is fundamentally important and designers who are expert in both can only be good for high maintenance customers. A product or service can hardly be offered online if it is not advertised correspondingly in the print media. The problem is that the different functions within web design have now become so complex that it is very difficult for one person to have a complete overview of the whole process. Who can claim to have a perfect command of HTML, JAVA, JAVA Script, D-HTML and Lingo and, on top of this, to be a really good designer. Exceptions do of course confirm the rule, but the rare combination of having in-depth knowledge of all the secrets of print preparation and still being a good designer are still confined to only a few prodigies. It is therefore valid to separate the various functions in a meaningful way. The division between print and web design makes no sense. In order to create a good website, we need good design and good programming. After all, printing can make or break a good print design. Instead of pulling our hair out over the issue of being a print or a web designer, we should really be thinking about the interplay between design and production (or programming). What is of fundamental importance for successful web design is a good team comprising a designer and a programmer - the designer knowing something about programming and vice versa.

In this way each can do his/her own job, but not in isolation from the other. There also needs to be an end to specialization beyond differentiating between design and other aspects of production. Of course, for designers, a separation of graphical and industrial design still makes sense. It is no longer acceptable for established print designers to turn their noses up at being asked to design a homepage. The same also applies the other way around to the web designer. Of course there are differences between the media, but a print designer should be in the position to decipher at least to some extent the mysteries of free navigation, the dramatization of brief animations and even programming. The public should be able to expect of a designer that s/he has an understanding of the basic technical features of both media. (Anyone who prints RGB-coloured 72dpi images or puts A4 size JPGs of scanned print brochures onto the Net does not understand either.) There is nothing wrong with setting priorities but no-one should rest on their reputation as a print, web, on-air or any other kind of designer. Last but not least we should not forget that it is also fun to fully exploit the possibilities offered by another medium. Who knows what the new medium of the future will be? The industry is on the brink of developing a new interface genus, one that will unite paper and screen. This development is clearly well on the way: with the appearance of e-books, magic ink and web pads, online layout will be captured on an interface that will be in the hands of the users, viewers or readers - creating something akin to paper. So then print and web designers will actually be doing one and the same job. We'll drink to that!

PLANET PIXEL
WE LIVE HERE.

FEATURE: #00

TO GET QUICK INFORMATION ABOUT
THE CONTENT OF A SUBPAGE FEATURE
(SEE MAIN-NAVIGATION AT BOTTOM),
CLICK THE GREY SQUARE ABOVE IT.

———————————— CLICK SQUARES FOR INFO... ————————————

STAFF WORK GALLERY EXTRAS NETWORK GAMES CONTACT

sgar_hiller < planet_pixel
w.planetpixel.de

DIE
DEKORATION
GEHÖRT
NICHT
ZUM
LIEFERUMFANG

ARBEIT WORK

#02

GRAPHICAL MANIFESTATIONS OF OUR DAILY WORK.

_ MAGAZINES

_ SOUND CARRIERS

_ LOGOS

_ IMAGE

_ HARDWARE

_ FLYER

STAFF WORK GALLERY EXTRAS NETWORK GAMES CONTACT

MASTERS OF SOUNDS MASTERS OF ARTS LINKS OF MASTERS

HELDEN UND TATEN

DARLINGS

PLEASE NO PURISM

TAKE A CLOSER LOOK TO THE WORK OF PEOPLE
WE LIKE AND RESPECT.

wallpaper*

007

W*WARE

wallpaper*

SELECT A CARD

01 02 03 04 05

01 email
Tell the world that you've found a whole
new way to communicate.

FILL IN CARD

006 CORRESPONDENCE **MESSENGER**
REMODELYOURMACHINE

COMMUNICATION

wallpaper*

001

INTELLIGENCE

wallpaper*

001INTELLIGENCE

Despatches on design, architecture and consumer culture from our far-flung correspondents

001 NEWS DISPATCH

NEW YORK CITY

INTELLIGENCE

wallpaper*

BIG TT

POSTED: 11.07.00

The Vico has long been the flagship power pack of choice. But are 12 cylinders enough? Both Mercedes and Bugatti have hinted at multi-cylinder monsters the 16-cylinder Maybach and 18-cylinder Veyron respectively). Now Audi is in on the act, proposing a mere 500 of the 600-horsepower behemoths. We're a soft spot for these German reductivists, and their all-aluminium supercar – a TT on steroids – is our chariot of choice. A snip at $375,000.

www.audi.com

001 **NEWS** DISPATCH

NEW YORK CITY

INTELLIGENCE

wallpaper*

REMODELYOUR**MACHINE**

The world of culture for your computer

006 CORRESPONDENCE MESSENGER

REMODELYOUR**MACHINE**

COMMUNICATION

wallpaper*

PC MAC

006 CORRESPONDENCE MESSENGER

REMODELYOUR**MACHINE**

COMMUNICATION

wallpaper*

006

COMMUNICATION

003
ENTERTAINING

W*?

Everything you ever wanted to know about the world's first global style magazine. Plus back issues, subscriptions, advertising and our Employee Of The Month

008
W*?

GROUP DYNAMICS

Put your guests in order & ensure they're strategically placed around the dinner table

003
GROUP DYNAMICS
ENTERTAINING

RED LENTIL SOUP WITH YOGHURT, SERVES 4

middleeastern

003
DISH OF THE WEEK
ENTERTAINING

CORRESPONDENCE

Ditch your dull e-mail and even change your sex @ wallpaper-boy/wallpaper-girl.com

006
CORRESPONDENCE
COMMUNICATION

BÜRO DESTRUCT

UPDATE
BOOK
DISCOTEC
FONTS
DDD
DESIGNER
WORKSHOWS
SPY
UNDERCOVER
PUB
GUESTBOOK
LINKS
CONTACT

büro destruct
wasserwerkgasse 7
3011 bern capital
switzerland

©copyright
bd 2000

INTIM PICS

09.04.95

AUDIO ACTIVE

PLEXIO 01

808 State
Alex Reece
Alliance Ethnik
Aloof
Aton Heart
Autechre
Autechre 2
Audio Active

type different.

download:

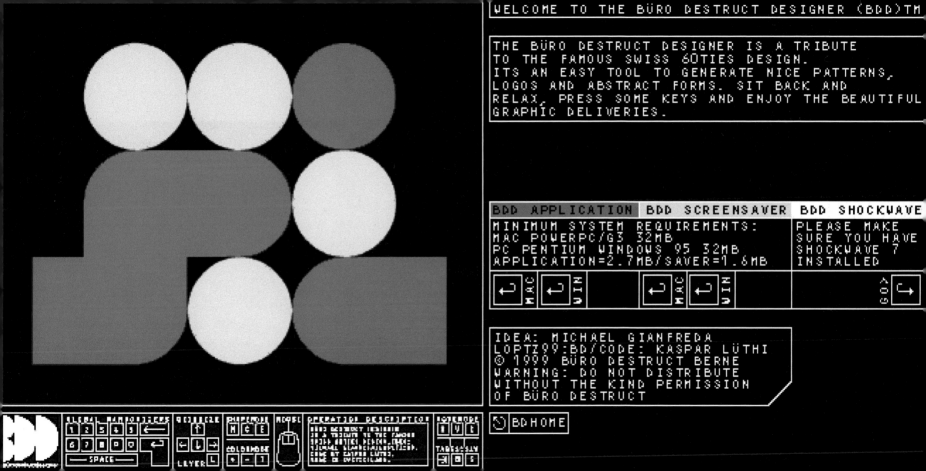

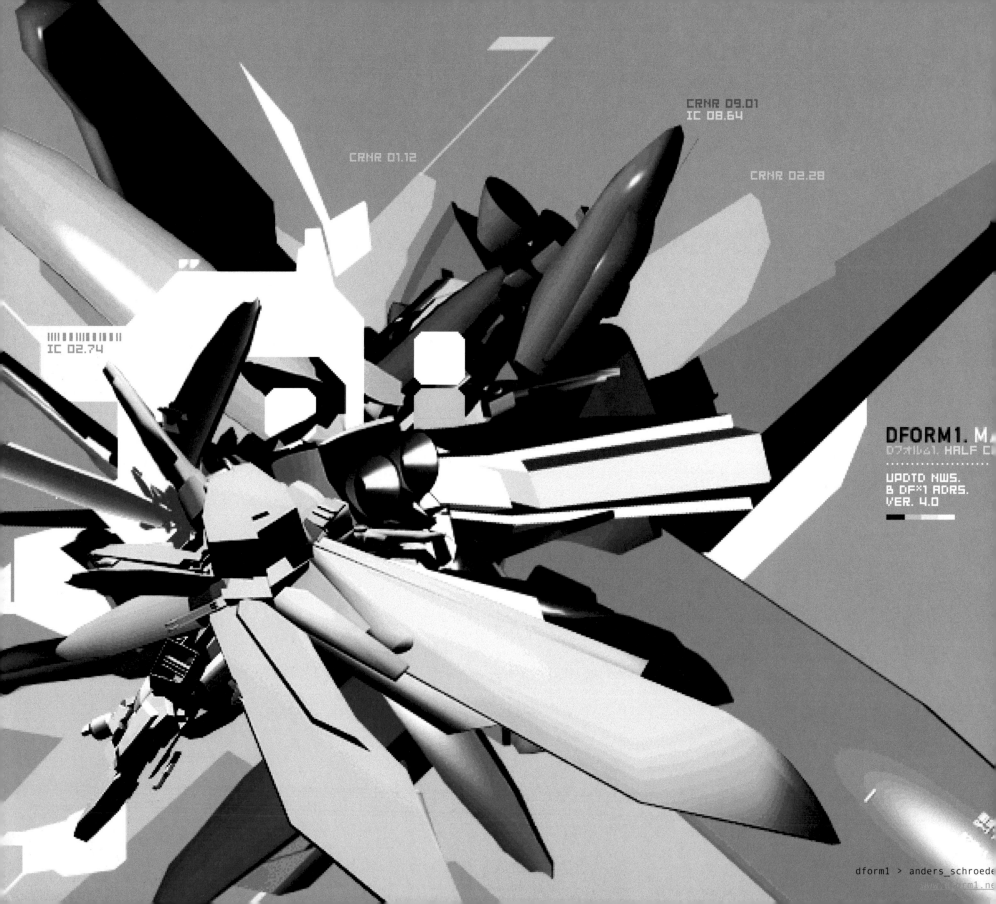

CRNR 09.01
IC 08.64

CRNR 01.12

CRNR 02.28

IC 02.74

DFORM1. M
Dフォルム1. HALF C

UPDTD NWS.
& DF×1 ADRS.
VER. 4.0

dform1 > anders_schroede
www.dform1.ne

NES NEED LOVE TOO. [tm].
HALF SUGAR.

PRSPKTV PWX6-000.
♥♥♥

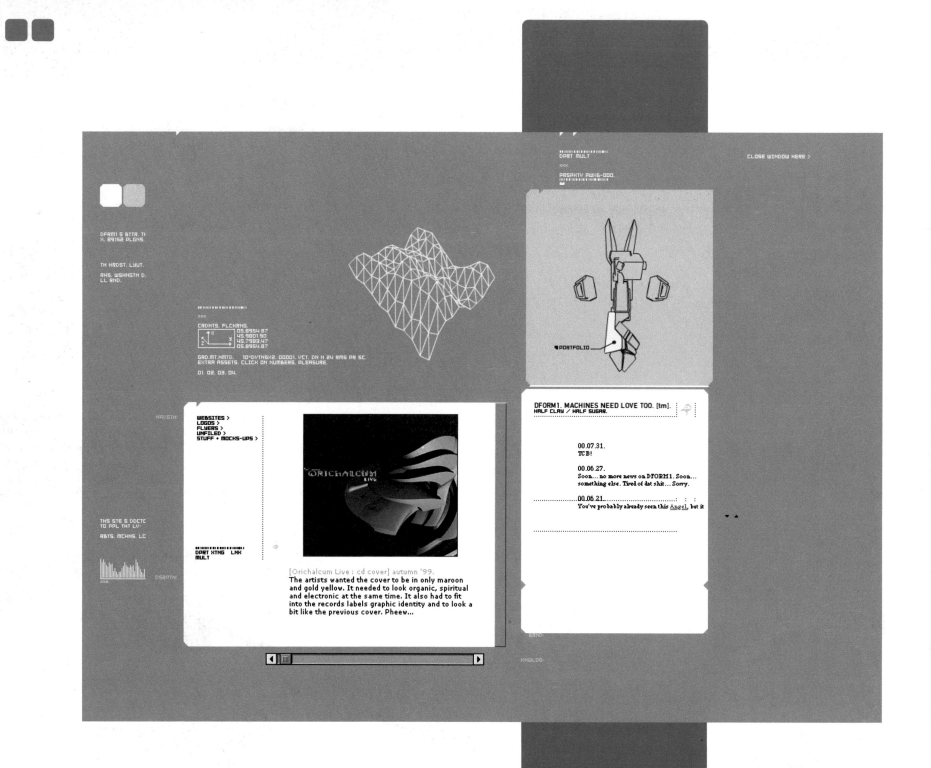

DFORM1 S BTTR. TH
X. 89152 PLGNS.

TH HRDST. LYUT.
RHS. WSHNGTN D.
LL RND.

CRDNTS. FLCKRNG.
05.8954.87
45.9801.90
45.7983.47
05.8954.87

GRD.MT.NMTD. 10°DVTNSX2. 00001. VCT. DN N 24 RMS PR SC.
EXTRA ASSETS. CLICK ON NUMBERS. PLEASURE.

01. 02. 03. 04.

PORTFOLIO

NRVGTN°

WEBSITES >
LOGOS >
FLYERS >
UNFILED >
STUFF + MOCKS-UPS >

DFORM1. MACHINES NEED LOVE TOO. [tm].
HALF CLAY / HALF SUGAR.

00.07.31.
TCB!

00.06.27.
Soon... no more news on DFORM1. Soon...
something else. Tired of dat shit... Sorry.

............00.06.21.................................. : :
You've probably already seen this Angel, but it

...

THS STE S DDCTD
TO PPL THT LV:

RBTS. MCHNS. LC

DPRT XTNG LNK
MULT

DSRPTN°

[Orichalcum Live : cd cover] autumn '99.
The artists wanted the cover to be in only maroon
and gold yellow. It needed to look organic, spiritual
and electronic at the same time. It also had to fit
into the records labels graphic identity and to look a
bit like the previous cover. Pheew...

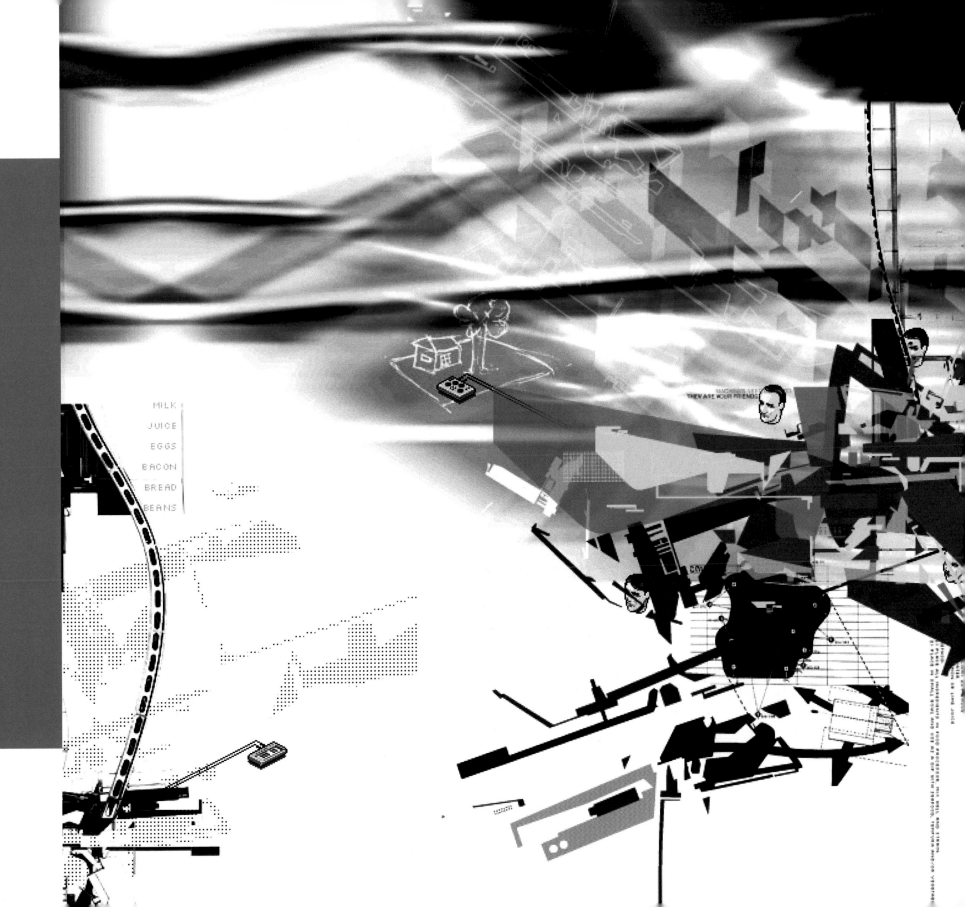

MILK
JUICE
EGGS
BACON
BREAD
BEANS

THEY ARE YOUR FRIENDS

'pure and lucid nothing'
an enhanced CD release by
RECOGNIZER

RECENT
PROJECTS

52
mm

~ BACK

"Transmitting Agencies" was 52mm's contribution to The
Remedi Project, an experimental web forum, headed up
by Josh Ulm of Eyecandy fame. "T.A." was inspired by post -
WWII Army Training Manuals left behind by the previous
tenant (an ex-FBI agent) in 52mm's current studio space.

THE REMEDI PROJECT

Passive

1964

MILI SYM

DVT TRANSMITTING AGENCIES 0

M+ M
D 180,000 2

■HOME ■IMPULSE ■LABOR ■CIRCUIT ■MOTIVE ■COLLISION ■FUSION ■THRILLS!

■HOME ■IMPULSE ■LABOR ■CIRCUIT ■MOTIVE ■COLLISION ■FUSION ■THRILLS!

CRASHSITE

HAUNTING TRANSMISSION | SINGULAR IN PROCESS

6:30–8:30 (2)d BASE
9:30–12:30
1:00–4:0

legionnaire's disease

ebola

leprosy

botulism

invasive strep

rables

▪ PUBLICITY

▪ KEYSTROKES

SYNTHETIC ENVIRONMENTS:

SYNTHETIC ENVIRONMENTS
DISPLAYS [+15M] DIGITAL ART WORKS AND INTERDISCIPLINARY PROJECTS AS WELL A
DOCUMENTING INSTALLATION ART EXHIBITED IN 'ANALOGUE
GALLERIES.

A-90037-TM

ART
INSTALLATIONS
OBLIVION
AERONAUTICS
EGOLAPSE
BANNER

[+ISM] LIMITED EDITIONS PROJECT
PRESENTS A NEW PLATFORM
OF HIGH QUALITY OBJECTS/PRODUCTS
DESIGNED BY [+ISM] IN SMALL LIMITED EDITIONS
[AVAILABLE EXCLUSIVELY THROUGH THE NET]
ウェブサイトでのみ限定生産される
[+ISM] デザイン＆プロデュースによる
ハイクオリティー・レベルなプロダクト
「リミテッド・エディション」

[+ISM]
LIMITED EDITIONS

NEXT ··········· LIMITED EDITION: T-[01]

NEXT

+ISM

ORDER

CIRCUMCISION™/CLASSIC BY MATIUS GERARDO GRIECK
FAMILY OF FOUR

CONCEPT

CHARACTER X

INTERPRETATION

» removing the foreskin of
the penis.
circumcision is performed by a mohel.

orthodox involves surgically «

R-90037-T M+I SM FO NTS

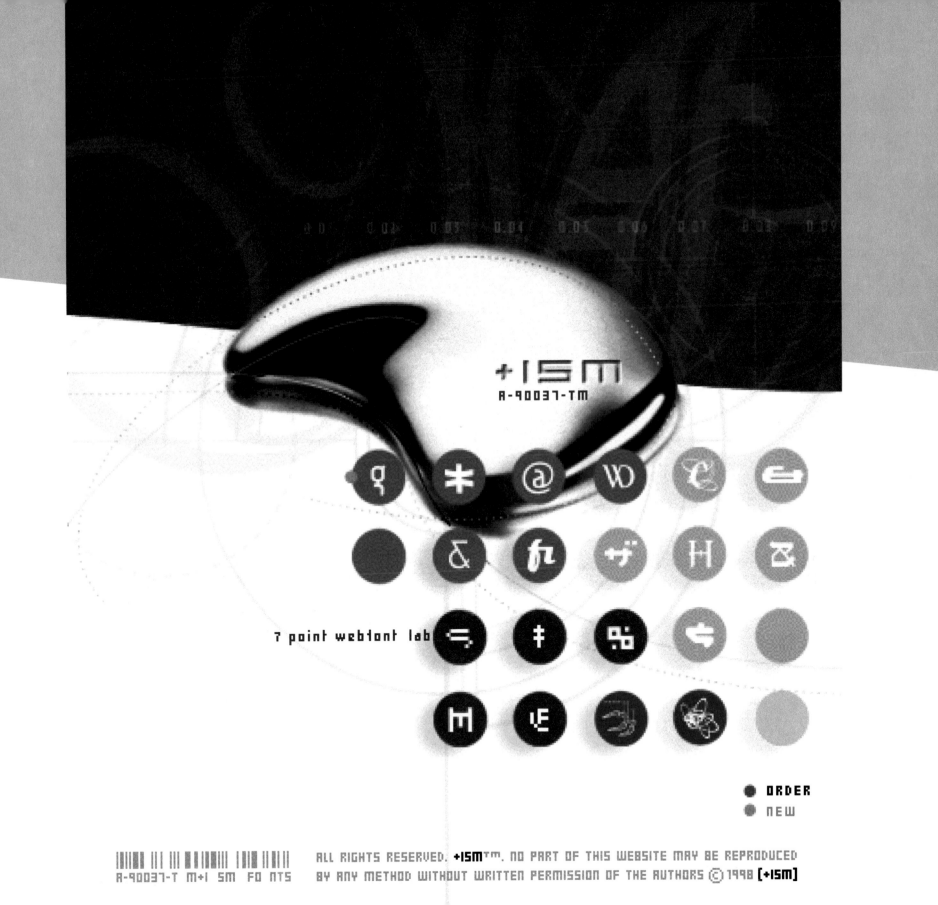

+ISM

A-90037-TM

7 point webfont lab

ORDER
NEW

13 hours to deadline, and still no architecture. In front of tedious sketches of meaningless and contrived complex shapes, all that was on my mind was collapsing. The problem was not lack of time nor lack of ideas; it was lack of focus for how I wanted to work. Then it was a trigger effect. There were reasons and meanings, but being in tune with them was not important. Explanations were gratuitous. In fact, they were destructive because they were dampers on the momentum of work. My concern was how to approach the work assuming that there is always an intention.

Inspiration comes from everything. The problem is not where to obtain it, but where not to. The pursuit of stimulation has become more a process of filtering the information, and it becomes difficult to conclude what can act as a catalyst for creative endeavors or not. In fact, this conclusion can be streched even further to say it is difficult to figure out what is a better catalyst, since anything can inspire us - new problems or other people's solutions, 80's heavy metal or some Kraut-rock, true love or pornography - anything. Although guilty of sounding existential saying that there really is no over arching value system of what is better, we live in hyper-disposable all-consuming society in which there seems to be enough room for all. Someone out here will "get it" and will be able to draw inspiration from it or find it sexy.

So now in this vast palette of materials to draw from, the most interesting starting points for Suction have been found in the less tangible qualities of situations, interactions, and moments. And that manifests itself in many different ways: the color palette that came to mind while listening to an old mix tape, an awkward pacing of a conversation between myself and a tall friend with short hair, the disoriented feeling on a warm morning I woke too early to see an empty 7th Avenue.
These are the types of starting points that have been of most interest recently, and they act as very good launch pads. Hopefully this sort of starting point results in a piece that can begin to evoke a reaction from viewers to equal the situations it drew upon.
Music and architecture are very good at evoking moods; there is clearly an emotional reaction when listening to a happy melody or walking into a dark bar. The inherent depth in music and architecture is more difficult to achieve on a flat digital plane. But this depth is not literal. The depth comes from a communication that is multi-layered and is not always a concrete statement; it comes in diluted and saturated forms where the receiver needs to filter out, or pick up and conclude on their own. People can appreciate the lyrics of a song that do not make literal sense or a grand lobby of a building whose space could have been used more efficiently. An image can cause the viewer to imagine the rest of the world it hints at - visually, structurally, thematically, etc. It is in a sense incomplete. There is not always an earnest desire for clarity and completion in communication or purpose; stimulation of thought can override translation of thought.

Suction really lies in the process by which it is created (and my current musical tastes); the most recent incarnation of the project relied heavily on digesting components and piecing them together in a way that attempted to create a setting. There is never a set image to achieve; the images are a direct result of working through the pieces. A sense of sarcasm and superficiality has always been part of the approach; the sampled components form a framework to begin working with.
In academic and professional settings, justification is usually required to validate the creative work, not just art or design. A simple "because I think it's cool" does not seem to hold too much weight against the smug subjectivity of design opinions. But that validation and acceptance is only necessary within certain circles or for particular goals. Anything for the sake of itself becomes pretentious and already makes the claim for its limited purpose, but when you are ready to rock shit out on your own for yourself, you automatically become King of the World like Leonardo on the Titanic. And there is no need to justify your masturbation; it just feels good - as long as no one gets hurt.

CHILDREN OF THE FO

CATALOGUED BY SYSTEM

NIKKONG PLANS: (DESIGNED BY . T.N. LeREOUX & SUCTION)
FRACTURING THE (N)HOLISTIK JEED UTILITIES
ROOTHED: PERSPECTIVE COLLAGE – JIHAN TESTICLE CRUSHING MACHINE

3.5 STANDARD AFFAIR SUCTION.COM

suction.com

Here are some responses to the site:

o "I am modern because I wear baggy pants and listen to Warp music and design websites. I like Japanese girls and I use Kanji in my designs even though I haven't a clue what they mean. I have a curry on Friday after drinking at trendy Soho bars. I am a designer in London. We're all the same."

o "What in the hell is this site supposed to be and what are the pics of? Explain!!!"

o "I think that wisdom is your ability to respect the truths within yourself, and live by them... basically to live by what you believe is right, whether that is with or against society. ***** your art work is cool, but it lacks the spark of life... I mean it looks like all of the other supposedly creative art works, like it is just artistic back-wash. Could you do something no one has thought of yet. I mean something really different, unexplainable, and yet familiar."

o "nice site = nice try
super hip = super tard
big joke, hipper than thou hipster dorks"

o "when the birds that rule the air cease to sing their percy song...when waves that rend asunder cleave the righteous to the wrong...WHEN THE FOAMY FIST OF HEAVEN FLAGELLATES THE DORSAL FIN OF THE COELECANTH CONDUCTOR YOU ARE READY TO BEGIN..."

o "my question: are these graphics attempting to transcend all meaning, is this deconstructivist. how do you expect someone to visit your art time after time when it lacks a message and any sort of interaction between computer and human? i want more."

o "You're rad. can I suck you? Do you know the people behind jodi.org?"

FRESH55 : DHKY : SUCTION

EIGHT SEVENTEEN
10PM MEAL : THREE DISHES - MYSELF ALREADY TAKE OUT
BETTY (TAIPEI) . FRESH55 . DHKY . NONEATER (1st MEET)
COMPARE IMAGE CAPTURE DEVICES [OLD SKOOL TO JPEG-
STOOPID PHUQS POSING ie TOURIST. 2 FINGERS UP SMILE
PEACE YO. PEACE. GET THAT WAITER. DOOOOD. FUNTIME
NEED TWO MORE UMBRELLAS. ON WAY TOWARDS NYN.[]

suction.com

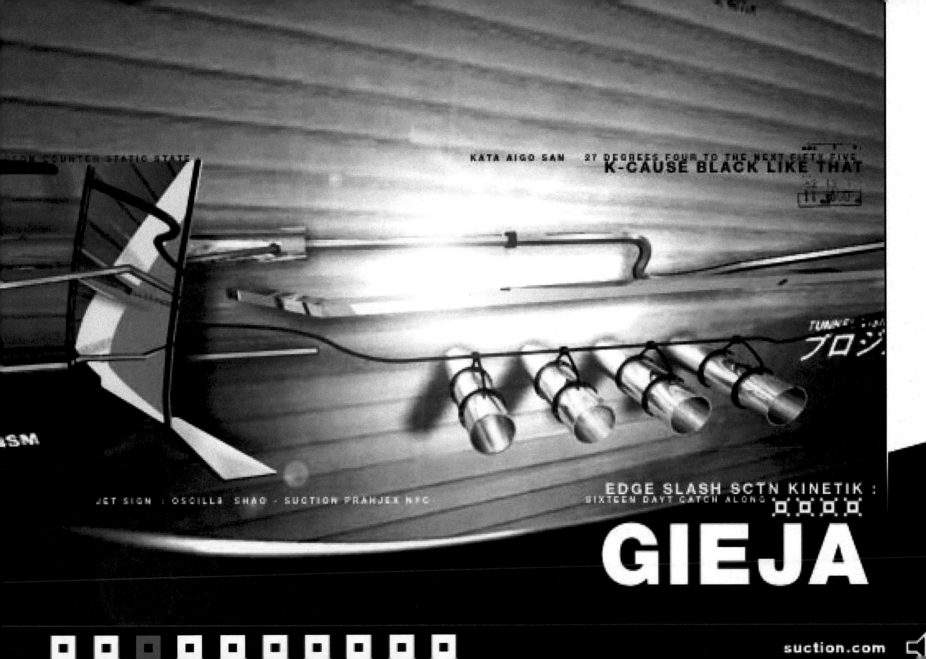

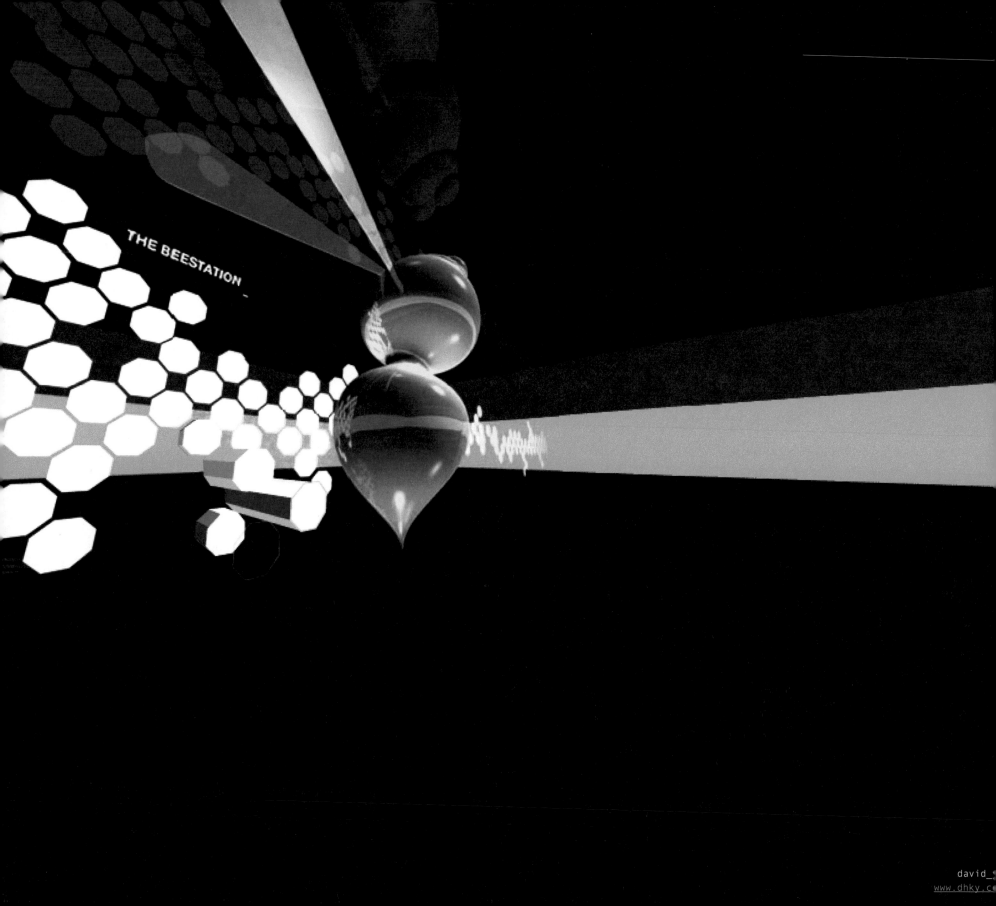

THE BEESTATION

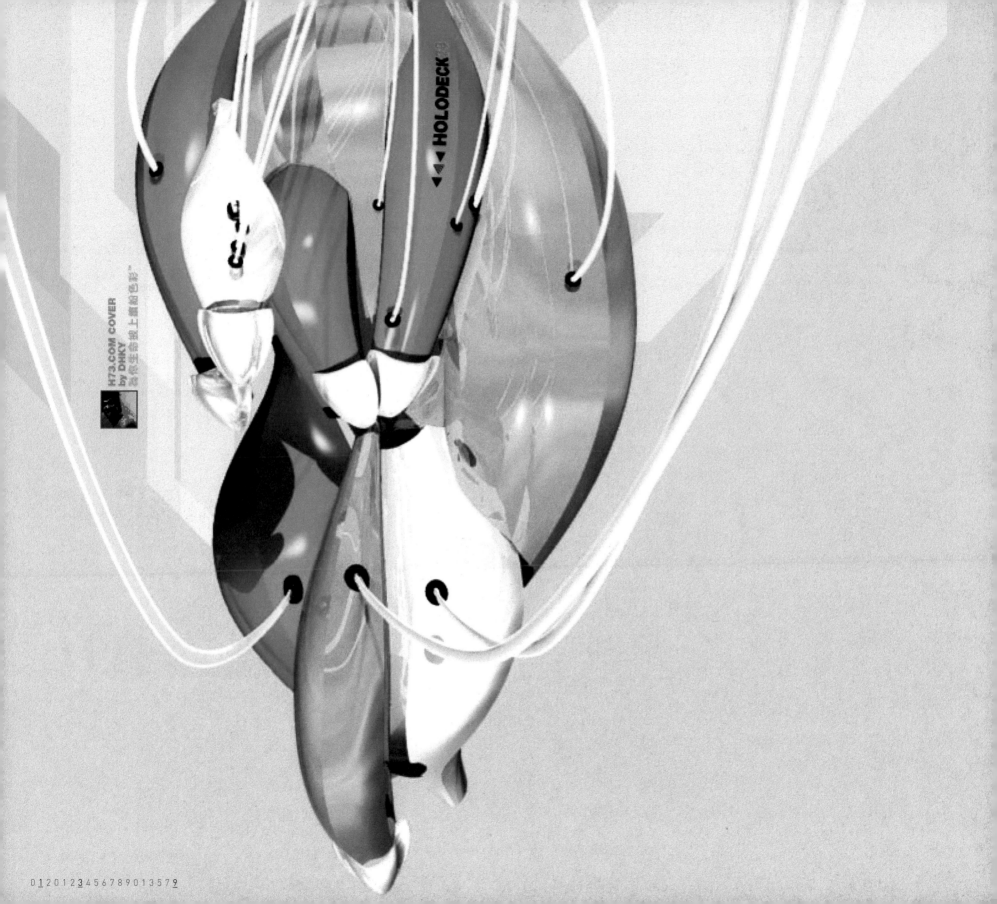

HOLODECK ▼◀▼

為你生命披上繽紛色彩™

DHKY: FOR MORE BETTER LIFE

05 : 14 : 2000

| V.003.00 | H73 COVER | | V.002.99 | CITY RHYTHM | |
| LOVE IS A FOUR-LETTER WORD | | | DHKY VS FAMEWHORE | |

V.001.98	STORIES	FRESH YUM FUCKY	V.000.97	CHOPIGAMI	STUFF
FEEL MY SERPENTINE @ SUCKSHUN DOT CALM			BREAKS OF FURY	DOUBLE HAPPINESS	
GENERATION NEXT					

AND NOW...

...we continue with more of the exotic flavours and fine epicurean delights of the Far East. Boy oh boy, am I going to cook you something special today, you lucky fuck you.

DHK-WOK

근하신년®
NEW YEAR BY DHKYSPORT™

◀ **LEFT** Army fatigue head gear, $85 by DHKY Sport. Plastic white daisy, $5 by DHKY Sport.

STYLING Simo
WORDS Moon
MODEL Hbunny

Click here for store information.

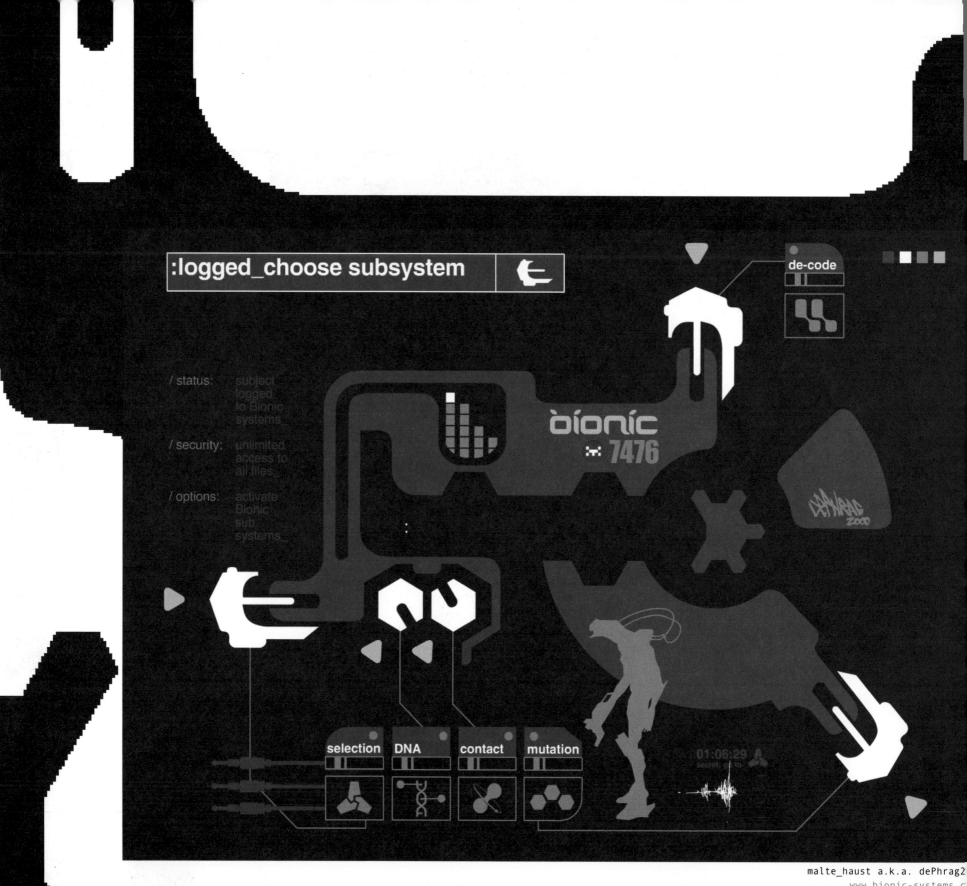

:logged_choose subsystem

de-code

/ status: subject
 logged
 to Bionic
 systems_

/ security: unlimited
 access to
 all files_

/ options: activate
 Bionic
 sub
 systems_

bionic
7476

selection DNA contact mutation

01:06:29
secret: goto

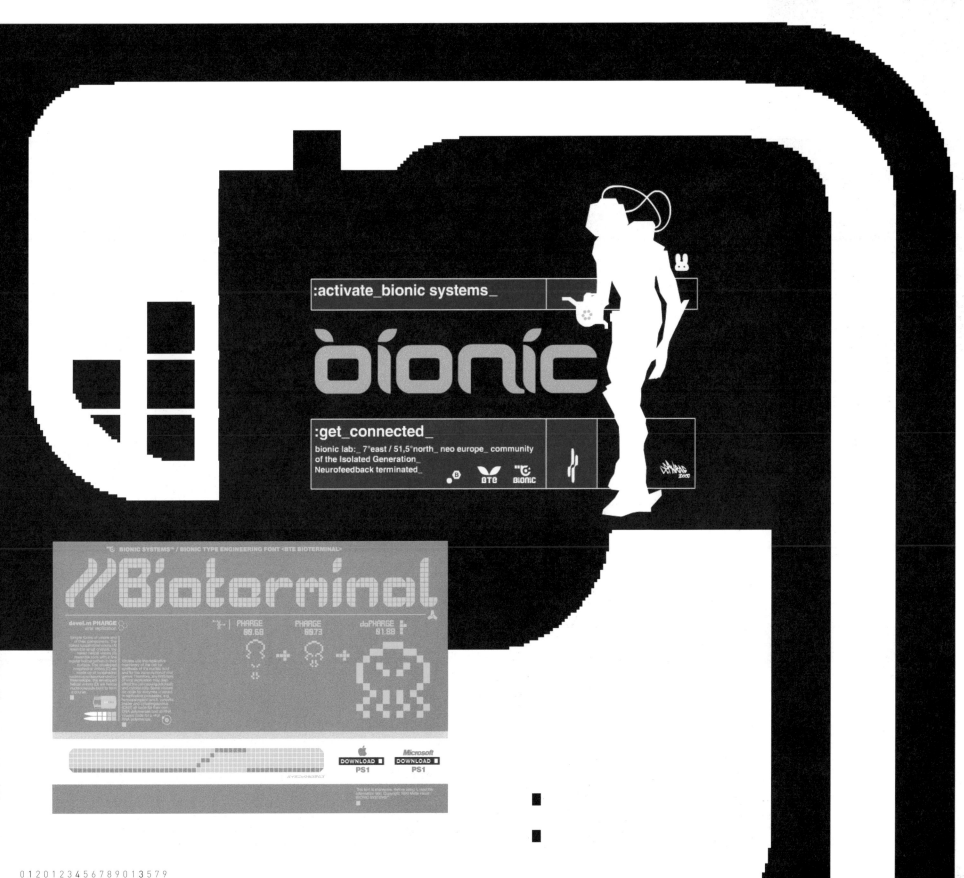

:activate_bionic systems_

bionic

:get_connected_

bionic lab:_ 7°east / 51,5°north_ neo europe_ community
of the Isolated Generation_
Neurofeedback terminated_

BTe BiONiC

BIONIC SYSTEMS™ / BIONIC TYPE ENGINEERING FONT <BTE BIOTERMINAL>

//Bioterminal

devel.m PHARGE
viral replication

PHARGE PHARGE daPHARGE
89.68 88.73 81.88

DOWNLOAD ☐ DOWNLOAD ☐
PS1 PS1

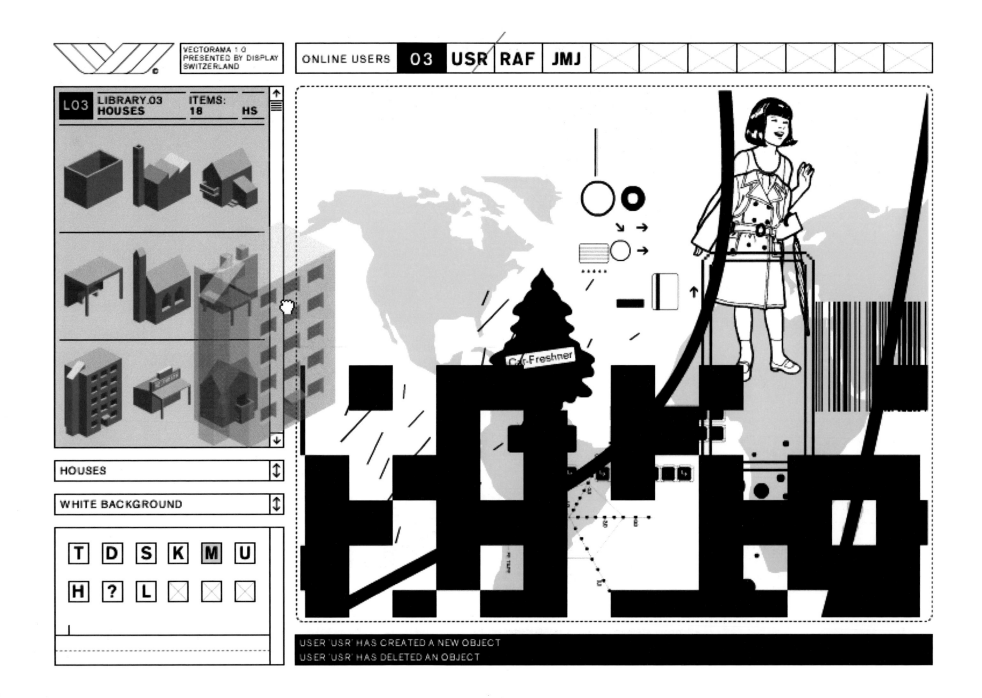

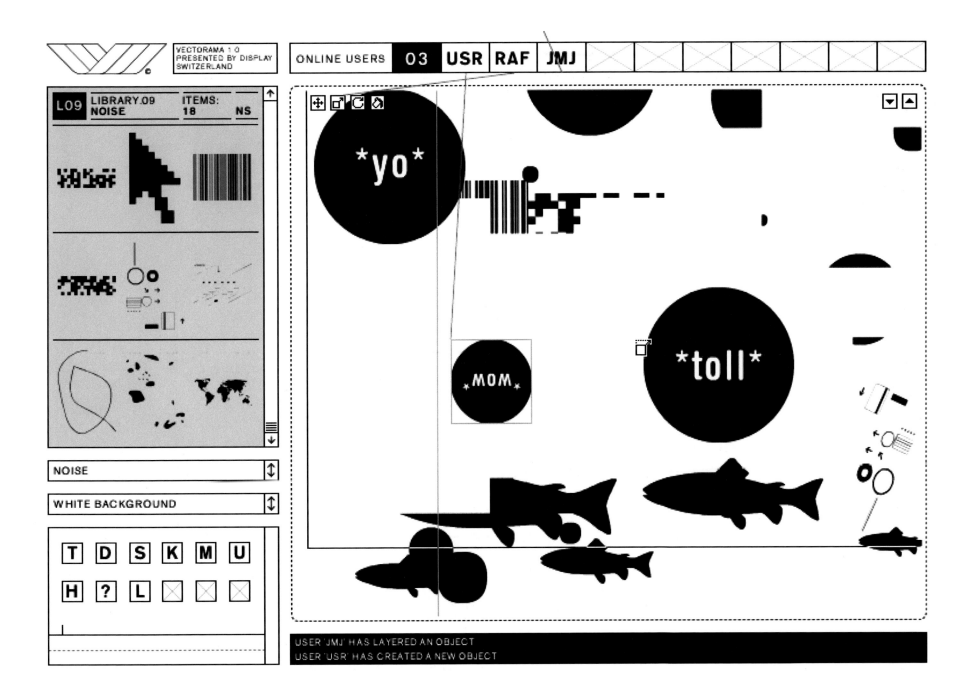

Let us play!

↑

How can I be creative?

- choose between a.m. and
 p.m. to view the two
 different faces.
- drag items from the library
 into the playground.
- choose colors.
- use arrows to move items.
- use shift+arrows to bring
 to front/send to back.
- use delete button to
 remove items.
- doubleclick to select all
 neghbouring items with
 the same color.
- push shift+click to add
 items to the selection.
- to export your playground,
 save it as eps.
- be creative!

a.m. p.m.

Lego Font Cre
Drag & Drop &

open save import ?

←

display > rafael_koch, urs_lehni, juerg_leh
www.lineto.com/01linetofonts/07linetoapplications/lego_fontcreator.ht

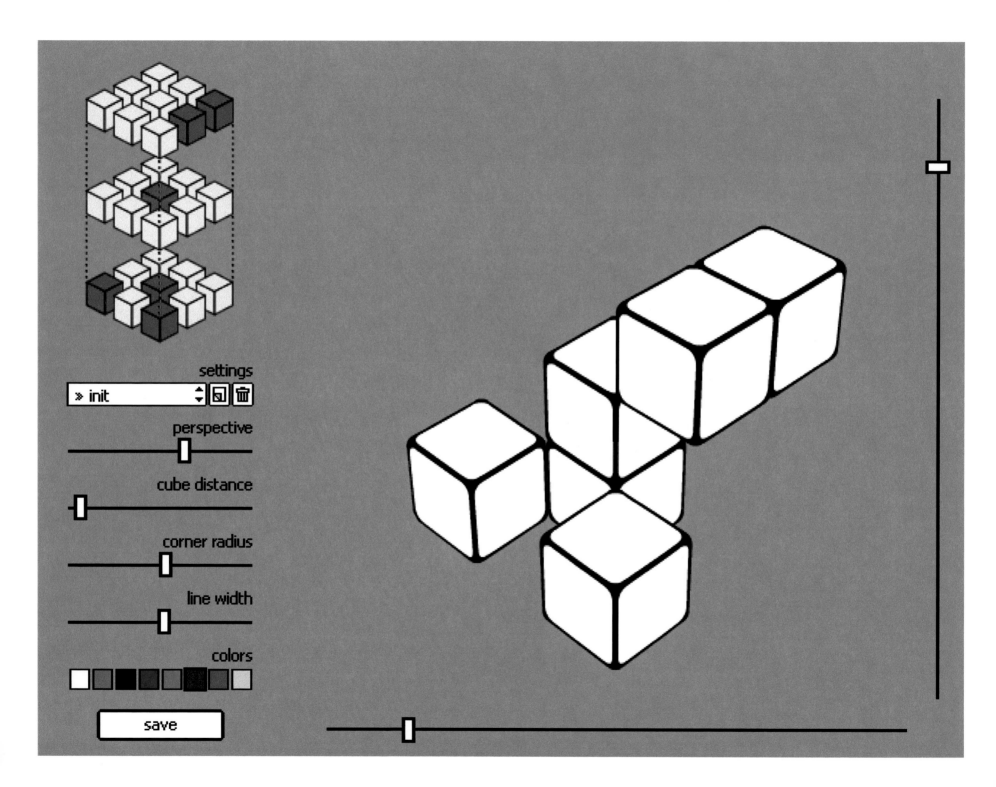

settings

» init

perspective

cube distance

corner radius

line width

colors

save

MR NOODLEBOX (ヌードル ボックス)
▷ enter

such a perfect day !

Electron field
field.dcr
You have been here

dannyb@amaze.co.uk : www.amaze.co.uk/noodlebox

◁ back

◁ back

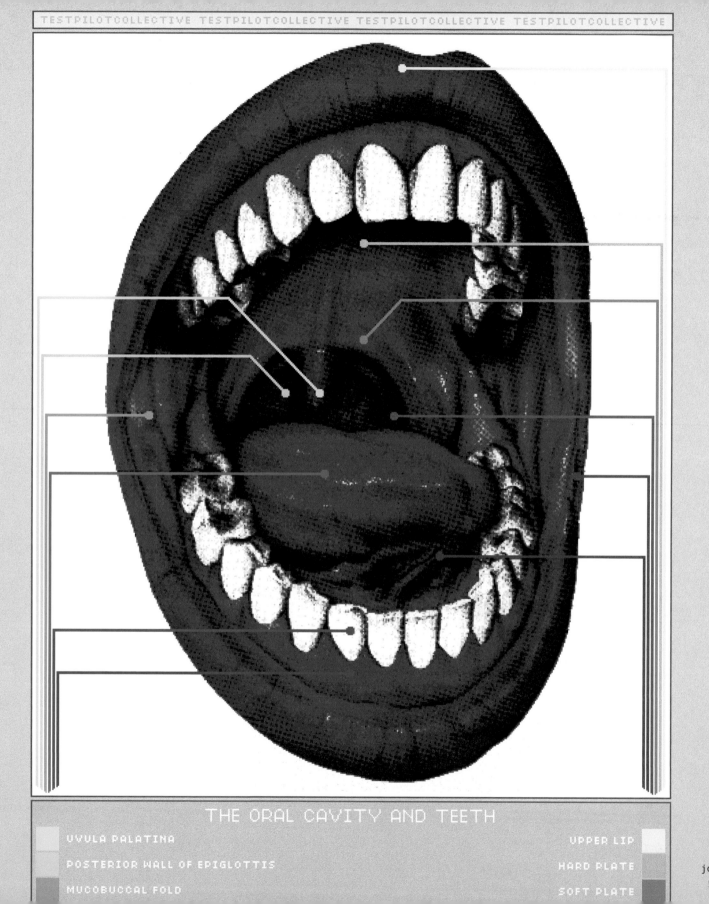

THE ORAL CAVITY AND TEETH

UVULA PALATINA

POSTERIOR WALL OF EPIGLOTTIS

MUCOBUCCAL FOLD

UPPER LIP

HARD PLATE

SOFT PLATE

joseph_kral, matthew_desmon
www.testpilotcollective.co

LOVE US? ☐YES ☐NO

1999

ENTER

CAPTAINS LOG 4.20.99
MISTER SPOCK, YOU KNOW WHAT TIME IT IS.
WWW.TESTPILOTCOLLECTIVE.COM

TPC FIRSTWARE
UPDATED DAILY

PRESS →
⌘ D

THE
**OFFICIAL
TEST PILOT
COLLECTIVE
WEBSITE**

TO BE READ ONLY BY _____
HTTP://WWW.TESTPILOTCOLLECTIVE.COM

JANUARY 22nd, 1999

TESTPILOTCOLLECTIVE
3010 HENNEPIN AVENUE SOUTH
SUITE NUMBER 168
MINNEAPOLIS, MN 55408 USA
1.612.872.7613

019

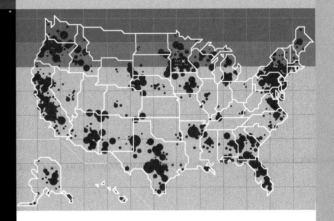

TPC-00
ЭМЖМАДМВСТРС

When thinking about graphic design and specifically design on the Internet, issues of clarity of navigation, information and experience inevitably arise. The Web is inherently seen as an 'informational' as opposed to an 'experiential' medium. As a consequence, pure 'content' is the primary focus, often at the expense of the visual and experiential qualities of information. As the online industry has matured, we have seen an evolution in both the approach and development of online subject matter. With new technologies, such as Flash and DHTML, we are seeing the world of HTML driven websites replaced with vector-based typography, animation movement and sound. As the online medium shifts from a visual language of bitmaps and web safe colors to a more experiential and dynamic one, we see the primary value of pure 'informational clarity' come into question. As we begin to look more closely at the interrelationship between information and interactivity, we find that different modes of experience are utilized for different types of information. It is the way in which different modes of experience merge and co-mingle to create a singular experience that provides insights into effective visual communication online.

As people experience the Internet today, the overall visual language of 'web-ness' - HTML text, scrolling, the browser interface, submit buttons - often overshadows the visual language of the subject matter being presented. We evaluate the usability of a site but discount or ignore the feeling and emotions that can be elicited by the actual experience of the information. If the viewer forgets that they are viewing a website, and becomes immersed in actual information they are experiencing, then the medium gives way to pure experience and interaction. It can be argued that any interactive medium, by its very nature, requires both an awareness of the medium and an in-depth knowledge of the subject matter being presented. When we watch a really great movie or read a good book, the book pages or the screen can disappear as we become completely consumed by the actual experience of reading or watching. This phenomenon also occurs within video games, as the player becomes more and more focused on the goal of the game. Interactive games such as Quake or Tony Hawk Pro Skater can become all consuming at times as the pace and speed of interaction combined with a goal-based objective overtakes the player's consciousness. In contrast, the 'informational' paradigm of the Internet seemingly exists far outside the 'interactive' world of video games, great books, or four star movies. However, the question arises; "does the Internet have to remain informational or can it become an immersive environment where experience and functionality blend into one?"

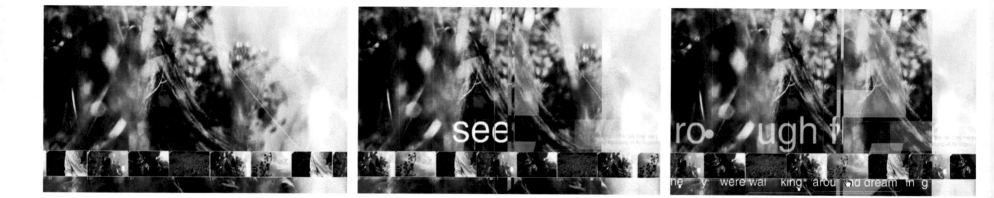

As the Internet matures and as new technologies merge with online experience, we can surely answer the above question in the affirmative. Online or offline, in books or on the movie screen, in verbal interchange or with body language, visual communication and story telling rest at the center of communicating ideas effectively. The process of narrative delivery, and how we go about experiencing something, is a key component in effective communication. A story can be told in any number of ways. The narrator can explain something factually, listing a series of events that make up an experience, or a story can be delivered in such a way so that the viewer/reader is increasingly engaged, encouraged to want to know more, and feels a part of the unfolding narrative experience. This process of story telling, when to deliver something factually and when to seduce the listener, when to be literal and when to make the user put the pieces together themselves, serves as an apt analogy for effective online communication.

The process of effective narrative 'delivery' can be a complex one depending on the subject matter. Online for example, finding a phone number or purchasing a product may not require a seductive narrative experience or a complex shift in language or interaction. If we have to convince an online user that something is worth purchasing, then narrative delivery becomes fundamental in convincing the user that the product is something they need. This separation between an "informational narrative experience" and a "mythologizing narrative experience" is the key to understanding different forms of information and how to communicate them effectively.

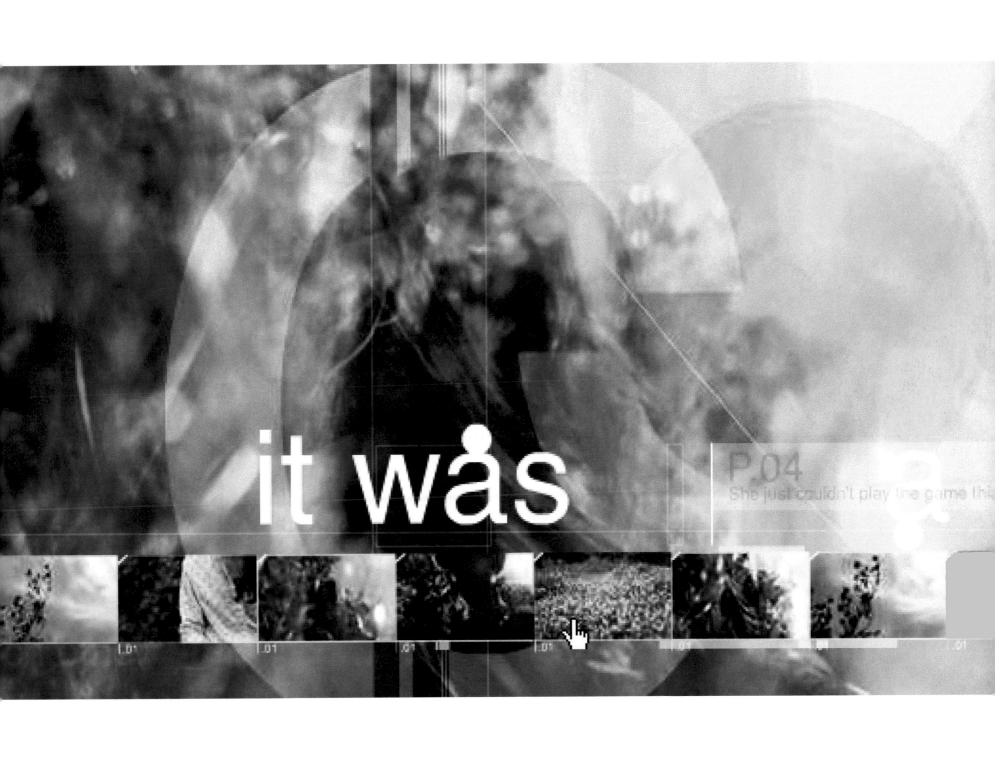

If someone is online and stumbles upon a music site for example, a story begins to unfold for the user of the site. The user will most likely check out different artists on the site, learn about them and perhaps hear a part of a song. The visitor may like the song they hear and choose to purchase it online. This narrative example consists of a combination of 'informational' and 'Immersive' narrative experiences. The music site itself may be very informative, presenting bands with simple text and image relationships. When the user selects a particular band, a splash screen presenting visual and audio information on the band may serve to 'mythologize' the band itself, presenting a glimpse into the band's lifestyle and attitude. This splash screen serves to immerse the user in the idea of the band, to tap into their emotions and to get the user excited about their music. The splash screen may be transformed into a more informational environment where users can find the bands' discography, biography and tour dates. If the visitor is interested in hearing more, an mp3 may be provided along with a 'flash card' of the song which serves as a cinematic "rock video like" presentation of the song. The Flash card and accompanying music reinforce the mythology of the band and should, ideally, persuade the user to purchase the CD. The actual purchasing process would be very simple and informational in an effort to make the online purchasing process as easy and seamless as possible.

The above music site example serves as a kind of case study where informational and immersive experience merge and overlap. The band's splash screen and flashcard use sound, motion and typography in an effort to communicate viscerally with the user. In contrast, the biography and tour dates as well as the online purchase process function on a more practical level. As the Internet evolves and as interactive television and broadband content merge, it is the transition between informational and immersive experience that will remain at the heart of successful communication. The ability to blend different types of experiences into a continuous thread of effective narrative delivery through an interactive medium is a new problem that will require not only the ability to tell a story effectively, but to deliver information in smart and sophisticated ways. This challenge is by no means an easy one to rise to. However, an awareness of the interrelationships between design, narrative delivery, interactivity and the experience of information can provide insights and possible answers to effective visual communication in the interactive arena.

unLucky13

the grass is alway greener so they say.
4 spring long. 4 spring come and gone.

Netscape: adoration doublezero

PISTICK 61

volumeone
THE SEASONS INFORMATION

BEDFD./N6TH.
overheard at roughly 2:43PM

8410

410

85TH.ST./LEX.
overheard at roughly 2:43PM

07

16

syn 1
rhodes
snack 1
break_1
bad bass
flute
deo guitar
snack break

Q W E R U I O P

deo hit
break_1mod
saboteur_loop
choc_lovely

A S D F H J K L

sordid_bs
rhino_fx
rhino_bass
anvil

AMON TOBIN

N

SUPERMODIFIER V.1.0

SILENCE

AMON TOBIN
ERMODIFIED

Animals on Wheels is just one individual – Andrew Coleman. Based a few miles outside Cambridge in the UK, Coleman works full-time on writing and producing music.

Coleman has been involved in making electronic music since 1994 after attempts at forming bands with other musicians fell flat. Starting out from humble beginnings, sharing a 2nd hand sampler and Atari with friends, the animals on wheels sound was only fully developed when Coleman began using a pc computer and found the delights of audio multitracking.

Animals On Wheels first released material on Bovinyl, a home-grown independent which was set-up by Cambridge comrades Tim Gould (Milky

ARTISTS
SELECT

RELEASES

Animals On Wheels
Nuvol i cadira
NTONE36

Cabbage Boy
Genetically Modified
NTONE35

Flanger
Templates
NTONE33

Neotropic
Mr Brubakers Strawberry Alarm Clock
NTONE30
NTONECD30

Journeyman
National Hijinx
NTONE24
NTONECD24

Neotropic
15 Levels Of Magnification
NTONE17
NTONECD17

to order one of these releases online, follow the link to the shop below

NINJASHOP

RELEASES

introitvs

ni da

old stuff

for being on my side. hey summertime!
in love with this big white background.
sorry for not being that *snuffed* right now.

loveletters:
metadesign@nitrada.com

punishment: **no.**

nothing.

hitradafti hda tes 17.01.79

love: 388.90
passion: 222

Please turn your head!

<u>No new Things?</u>

Vir L™
TECHNOLOGY
EMPOWERED BY ZENIMAX

NO FULLSCREEN ENTER **«** BEGIN
FULLSCREEN ENTER

SITE REQUIREMENTS

NETSCAPE 4.0
INTERNET EXPLORER 4.0
FLASH PLAYER 4.0
QUICKTIME 4.0

24 BIT DISPLAY
800 x 600

shatter my concepts of time and space, why don't you?

Program: Stylophone

Bytes: Stylophone

001.htm 002.htm 003.htm 004.htm 005.htm
006.htm 007.htm 008.htm 009.htm 010.htm
011htm 012.htm 013.htm 014.htm 015.htm
016.htm 017.htm 018.htm 019.htm 020.htm
021.htm 022.htm 023.htm 024.htm 025.htm
026.htm 027.htm 028.htm 029.htm 030.htm

CURRENT ACCESS IS
AVAILABLE THROUGH THE
FOLLOWING KEYWORDS

▶ DIR INFO HELP EXIT
▶ USR VER TIME

ABCDEFGHIJKLM DEL *
NOPQRSTUVWXYZ ▶

1993_9_26

1995_2_1

Maybe the only reason that "web art" has yet to be taken seriously by the rest of the artworld is that it has yet to make a killing. Who in their right mind would buy it? If someone did, it might finally be custom-tailored or saved on a storage medium and we may in turn be inclined to define it as either Designed or Rather Dead.

3 points complicate the matter even further: Art has often been about sharing experiences of humans for humans but not necessarily when and if they wanted it at that particular time. An irritation. Technology (in its infancy: magic) is seductive and illusory, therefore mistrusted or marveled at and often misunderstood by artists and their audiences alike. Lastly, there is no gallery or sophisticated market structure behind webart yet and traditionally artifacts or collection agents have contributed an official element of seriousness or believability to an artform.

Webart, in other words, is just a little bit ahead of its time and for that reason perfectly wonderful, most notable and not sufficiently documented.

Artsites are created by people who might not necessarily call themselves artists and by artists who would rather call themselves designers. Sometimes there is no intention to be "Art", yet the speed at which the work is disseminated through an inconceivably vast network despite lingual and cultural differences - despite clarity of function or purpose - and considering the resulting impact it has on communication, visual dialect, storytelling and unrelated media, it is indeed Art. It is memorable and important in changing the way we read, hear, click, drag and browse in turn changing the way we write, animate, tell stories and produce ourselves.

Web art is probably most accurately compared with performance: temporary installations fueling us with new metaphors sometimes unrelated to physical or analog experiences, cerebral in the sense that emotion, thought and comprehension are products of what we are learning and not what we have been taught. With new tools we make new artforms and through art we inevitably try to define experience, whatever that is, whenever it happens.

Consequently enough, most artsites now can be categorized into four general forms for which there are few (any?) academic or institutional descriptions:

1. not-so-perfect
a reaction to an increasingly over-produced Web (especially commerce sites) typically chaotic in structure and graphic in nature: fragments from fictitious productions, often composed with 1- or 2-bit graphics with intuitive (or not) navigation. similar to a puzzle, in which case the viewer is flooded with associations, alerts or shredded input from their own hard-drive or a remote site. closely related to math-based or irritation, except you fill in the blanks.

2. trash games
winning is unimportant (a necessary maxim in life) strategy is not so important. more important is what the author is telling you through the medium of a "game" or what you have to do to "win".

CLIPS:	
BODYCOUNT::	0
AMMO::	80
	3

OXYGEN	CLIPS:
BODYCOUNT::	-566
AMMO::	10
	3

3. math-based
interaction with your machine and the authors content, based on local situation variables and different for every user. especially important because it typically extends our experience in how we navigate in environments defined by inputs other than buttons and through intricate Boolean logic.

4. irritation
subversive content defying user experience (for example: forms and buttons with content that is shockingly intimate and somehow familiar) narrative content that "talks" to the user through familiar icons found in commercial or personal websites with narrative themes involving one or more users in a profound network experience, in which case there is an "a-ha" effect where you learn something incredibly important only possible in a vast network of idle browsers, or from a book if you're smart and you still read.

Of course we could get more academic in evaluating web art (and surely we will in the near future) but until then, it is, most importantly, about experimenting with new tools and human thought in a huge network where there hasn't been enough time to make rules and spoil the fun. =)

Press
Prev. Example

Next Example
Projects

-20
-10
0
10
20

DE:BUG

SPIEGEL ONLI

THE FACE

HOTWIRED

X-3413 Z-1972
Fork unstable media
Condition : unknown

Thrust 50%

love

feed.de

OK

OK

hotel

entry ▪ smalltown ▪ royalty ▪ rambler ▪ location ▪ floodplain ▪ bulldozer ▪ bundesrepublik ▪ exit

hotel is an installation that explores our relationship with 'home' and location

entry ▪ smalltown ▪ royalty ▪ rambler ▪ location ▪ floodplain ▪ bulldozer ▪ bundesrepublik ▪ exit

0 1 2 0 1 2 3 4 5 6 7 8 9 0 1 3 5 7 9

I GREW UP INNA SMALLTOWN.
AUSTIN,MINNESOTA

FEED DEUTSCHLAND

01

LOVE
JUNKIE
MACINTOSH LOVE
MACHINE
GERMAN
HARDCORE

MTU 1999 MUSIC AWARDS
BEST ARTIST SITE
FORK UNSTABLE MEDIA

BLOODY RIGHT.

ELECTRONIC AIR

NOW I'M BIG-CITY KID

COMES ALLY
FROM ALL
FEED XP

01
VERSION

VERSION ONE

CONNECTION LOST. TRYING AGAIN.

<ALIGN=LEFT>

./PROPERSUPERSET

tube.(font)

[1] in progress

../ downloads : soon

1. a question of airports:
2. resonant metaphor for current state of www design: transience, motion, sleekness
3. perfect mixture of mobility and stasis
4. continuous motion generates own breed of stasis [it is "always" moving]
5. implication: complete access to the network which is the world [sublime]
6. current www design prognosis [stamen included]: hermetic, static
7. many things moving [type etc.], very little actual change/dynamism
8. buckminster fuller [paraphrase]: "I don't want to suggest movement with my designs. I'd rather build things that move."
9. desire for control [popups, plugins etc.] symptomatic of resistance to paradigm shift towards openness?

eric_rodenbe
www.stamen.c

-13- @100% (RGB)
-13- @100% (RGB)
-13- @100% (RGB)
-13- @100% (RGB)
-13- @100% (RGB)
-13- @100% (RGB)
-13- @100% (RGB)
-13- @100% (RGB)
-13- @100% (RGB)
-13- @100% (RGB)

Containing virus @ 100% (RGB)

PROTECTED BY SOVIET UNION RD

>What was the driving thought behind releasing fonts?

>What was the driving thought behind releasing fonts?

You need to feel emotionally unstable, hysteric
or very patient.

OK

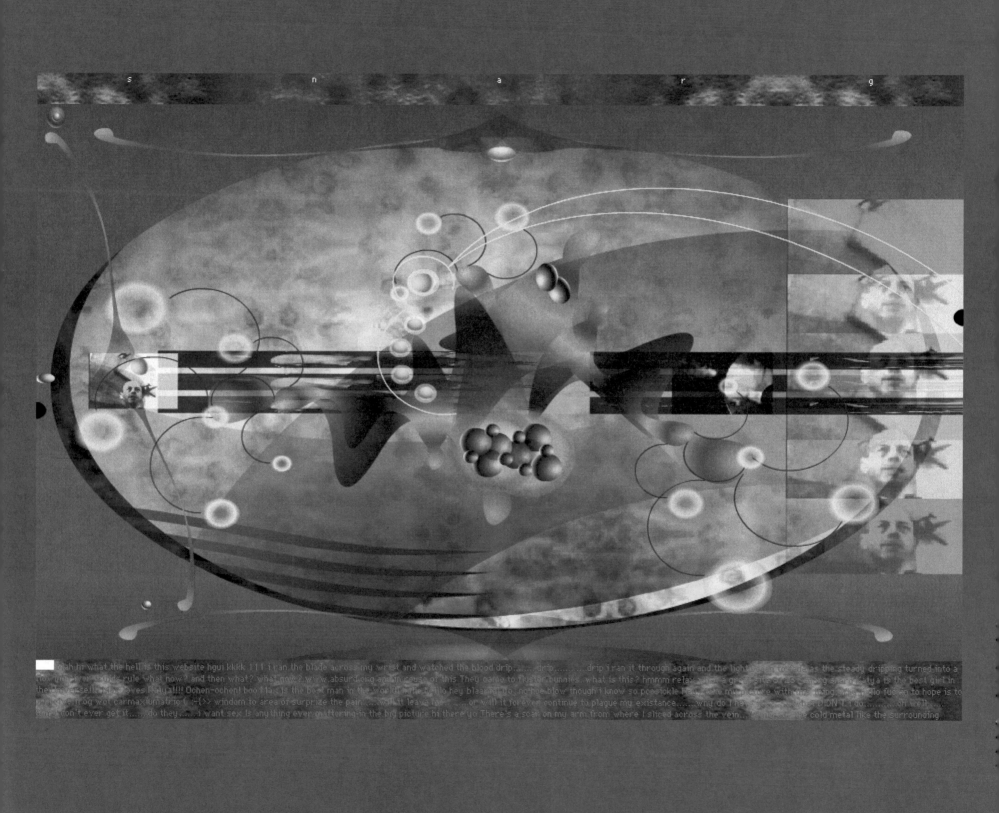

blah hi what the hell is this website hgui kkkk 111 i ran the blade across my wrist and watched the blood drip...... drip........... drip i ran it through again and the light........ as the steady dripping turned into a flow whatever holds rule what now? and then what? what now? www.absurd.org and in cause of this They came to flustor bunnies. what is this? hmmm relax with a gr........ this snarg snarg snarg stya is the best girl in the universe!!!!!...loves laiya!!!! Oohen-ochen! boo Max is the best man in the world! hi he hi llo hey blaaah Ho, no hoe blow though i know so popsickle Ha......a multipicture with uni dosing. hi to pollo fuck in to hope is to produce frog wot carmaxiumatric (..-(>> windom to area of surprize the pain......will it leave me........ or will it forever continue to plague my existance......why do I have......... bec DIDN'T I do........... oh wellI don't ever get it......do they......i want sex is anything ever mattering in the big picture hi there yo There's a scar on my arm from where I sliced across the vein......kame the cold metal like the surrounding

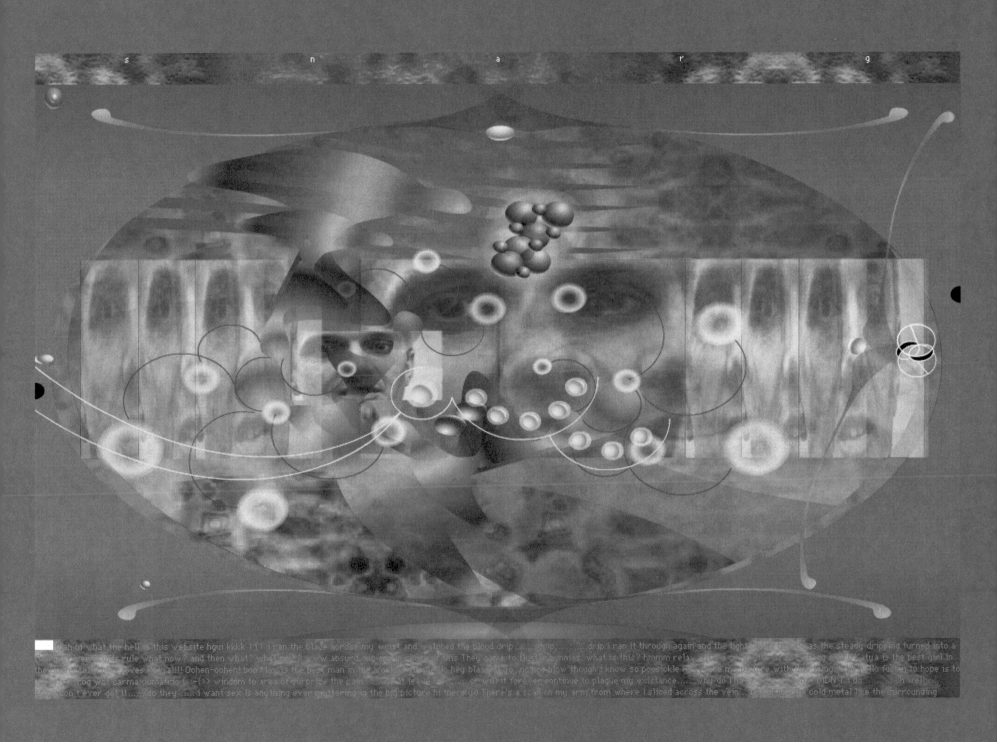

wah hi what the hell is this website hgui kkkk 111 i ran the blade across my wrist and watched the blood drip...... drip.........drip i ran it through again and the light.........................as the steady dripping turned into ards rule what now? and then what? what now? www.absurd.org-an...........of this They came to Dust bunnies. what is this? hmmm relax...... a g..............o................ say Katya is the best girl in theloves Katya!!!! Ochen-ochen! boo Max is the best man in the world...........lo hey blaaa..go...notice blow though i know so poosickle I are much more with me doinglo fuck in to hope is tofrog wot carmaxiumario (:-(>> windom to area of surprize the pain............it leave.................er will it forever continue to plague my existance........ why do I hi..............DIDN'T i dooh well...............on't ever get it.......do they........i want sex is anything ever mattering in the big picture hi there yo There's a scar on my arm from where i sliced across the vein.................cold metal like the surrounding

- Prologue

Words have a linear, discrete, successive order. Beyond the very limited meanings of inflections which can indeed be incorporated in the words themselves we cannot talk in simultaneous bunches of names. Visual forms - lines, colors, proportions etc. are just as capable of articulation, of complex combinations as words, but the laws that govern this sort of articulation are altogether different than the laws of syntax that govern language. The most radical difference is that visual forms are not discursive. They do not present their constituents successively but simultaneously, so the relations determining one visual structure are grasped in one act of vision. relations within relations cannot be projected into discursive form.

reality = 2 complex for oral communication
[aLpha.60.jean.luc.godard.scene.23]

The visual cortex is modular. Different areas respond to color. orientation of lines. movement. The function of the brain is to represent the constant. lasting. essential and enduring features of objects. surfaces. faces. situations. Jacques Riviere : "the cubists are destined ... to give back to painting its true aims - which is to reproduce ... objects as they are" (not as they appear to the eye)

Consider - "not as they appear to the eye" and US businesses alone cost society ~$3 trillion per year - this is 5 times their profit.

After Copernicus moved humankind off the center stage of the physical universe Descartes filled the void in two steps. First he gave centrality to human thought. Second he enlisted the mathematics curriculum to inculcate his new methods of thought. New notions of being soon came together to replace the ones destroyed by Copernicus. These notions have taken humans as far as they can. Civilization's most recent burst of scientific progress - the one that started during the Renaissance - is fast approaching its denouement. Data quantities equivalent to one person's lifetime experiences may be downloaded in minutes. The planet as a whole disgorges 1 trillion pieces of data per day. When civilization began, human thought was the only available resource for processing information. Today information processing capacity is a trillion times greater with almost all of the increase being electronic. These electronic circuits do not need the smoothly varying data that human minds prefer - for them the jagged terrain of the real world is as absorbable as the artificial sphere of the geometer or the torus of the analyst. Utilizing the

- Communication

Animal communication is typically non-syntactic which means that sig-

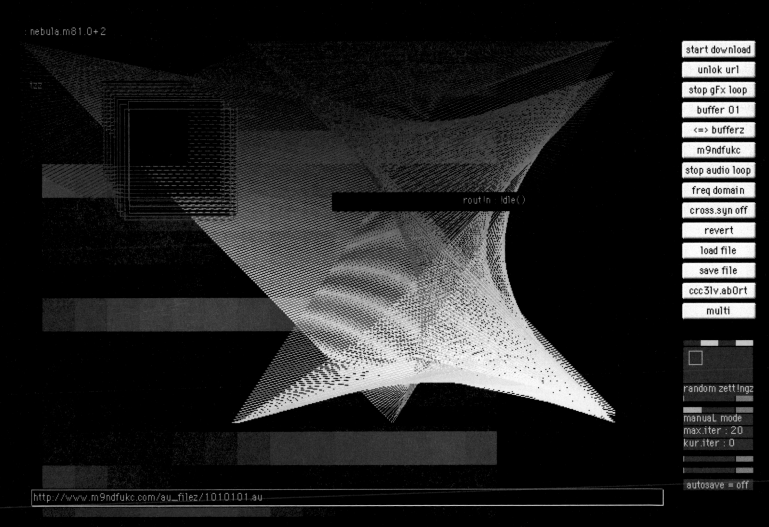

: nebula.m81.0+2

rout!n : !dle()

start download

unlok url

stop gFx loop

buffer 01

<=> bufferz

m9ndfukc

stop audio loop

freq domain

cross.syn off

revert

load file

save file

ccc3lv.abOrt

multi

random zett!ngz

manuaL mode
max.iter : 20
kur.iter : 0

autosave = off

http://www.m9ndfukc.com/au_filez/1010101.au

m 9 n d f u k c . o s _ || - 0 f 0 0 0 3 . m 2 z k 1 n 3 n k u n z t

Nebula.M81 transforms the capital `i` Internet into a massively parallel musical and visual instrument in perpetual flux; an internet site into a composition. an internet page into a sound, an image or non-linear text. Essentially one's synthesis library has been extended to incorporate any data accessible via Internet.

Nebula.M81 performs fast Fourier and time domain synthesis and cross synthesis, granulation and transclusion of Internet / URL data. The several modules include:
- autonomous. infinite loop module for automatically accessing URL data and communicating with Internet Search Engines.
- granular sequencer modules for granulation and re-sequencing, transclusion of URL data.
- image generation module for translation of URL data to animated image displays.
- audio generation module for translation of URL data to sound.
- scrubbing and dynamic loop generation of URL data.
The majority of processes are stochastic and automatic hence operator mind activity is stimulated not by the imposition of decision making, rather by an invitation to observe and analyze data transformations, to be distracted and ultimately to select. This constitutes true interactivity and is the singularity.

: kinematek.0+2

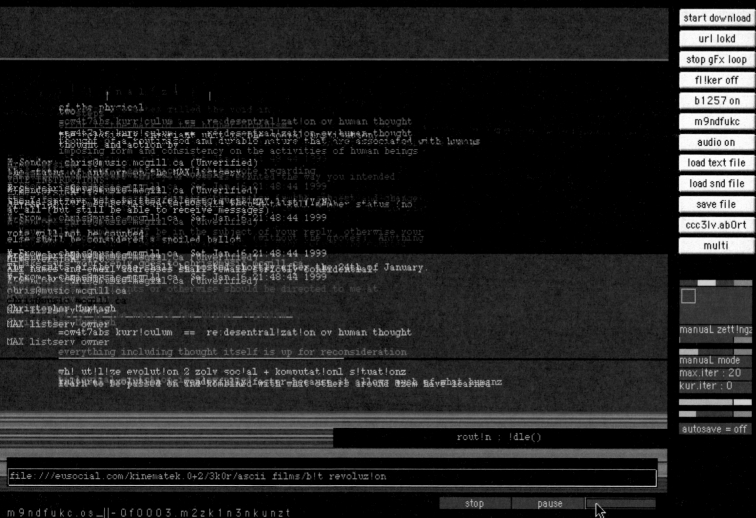

start download
url lokd
stop gFx loop
fl!ker off
b1257 on
m9ndfukc
audio on
load text file
load snd file
save file
ccc3lv.abOrt
multi

manuaL zett!ngz

manuaL mode
max.iter : 20
kur.iter : 0

autosave = off

rout!n : !dle()

file:///eusocial.com/kinematek.0+2/3k0r/ascii films/b!t revoluz!on

stop pause

Of particular interest is autonomous mode, also referred to as Internet Binary Television Mode. The Internet Binary Television Mode enables a continuous program consisting of sound. image. text generation from the abundant and evolving Internet data.
Autonomous mode commences by placing a query with an Internet search engine with the keywords specified by the operator or selected stochastically. The response is parsed and a URL destination automatically selected. The URL data are retrieved and translated into audio. nonlinear text. and / or image data. As well one may select to automatically archive URL contents. The operation resumes with the stochastic selection of a keyword from the previous URL's contents - history matters. The keyword is utilized to place additional queries with an Internet Search engine. The operation continues infinitely as desired.

: nebula.m81.0+2

start download
unlok url
stop gFx loop
buffer 01
<=> bufferz
m9ndfukc
stop audio loop
freq domain
cross.syn off
revert
load file
save file
ccc3lv.abOrt
multi

rout!n : !dle()

random zett!ngz

manuaL mode
max.iter : 20
kur.iter : 0

autosave = off

http://www.m9ndfukc.com/au_filez/1010101.au

- epilogue
Nebula.M81 / USISK research has bifurcated into a number of projects. Kinematek.0+2, MMF0+99 and
Venera 8 (Nezvanova 1999), as Nebula.m81 utilize the Internet as their primary data source.
Kinematek.0+2 is a "non-linear book". Whereas a book is a sequential, one track structure, Kinematek is a
non-linear textual sampler. Chords of paragraphs or entire web pages may be "played" via keyboard, and
programmatically. The data may be trans-
posed, segmented, sequenced, dispersed.
MMF0+99 performs similar operations
with the resultant output ultimately trans-
lated into MIDI information. Venera 8 inter-
faces with an Email server, mapping data
transmissions to sound, MIDI and video.

USISK works were debuted at the 5th International Festival of Computer Arts, Maribor,
Slovenia (Grzinic 1999) and were awarded first prize at the 4th International Musical Soft-
ware Competition (Bourges 1999, Multimedia Category). They are utilized in presentations
at the Modern Art Museums of Santiago, Chile and Paris, France, Nebula.m81/USISK re-
search is continued in NATO.0+55 (Nezvanova 1999), an Internet, audio, video, VR, 2D and
3D graphics environment for the IRCAM/Opcode Max programming language.
Within a few years, it is expected nearly all major Internet sites will be capable of accom-

	fitness
	fitness
	fitness
	40
	50
	60
	0 1 0 0 1
	1 0 1 1 0
100	1,000
	1 1 0 1 0
	1 1 1 0 1
	0 0 1 1 0
	1 1 0 1 1
	1 1 1 1 1

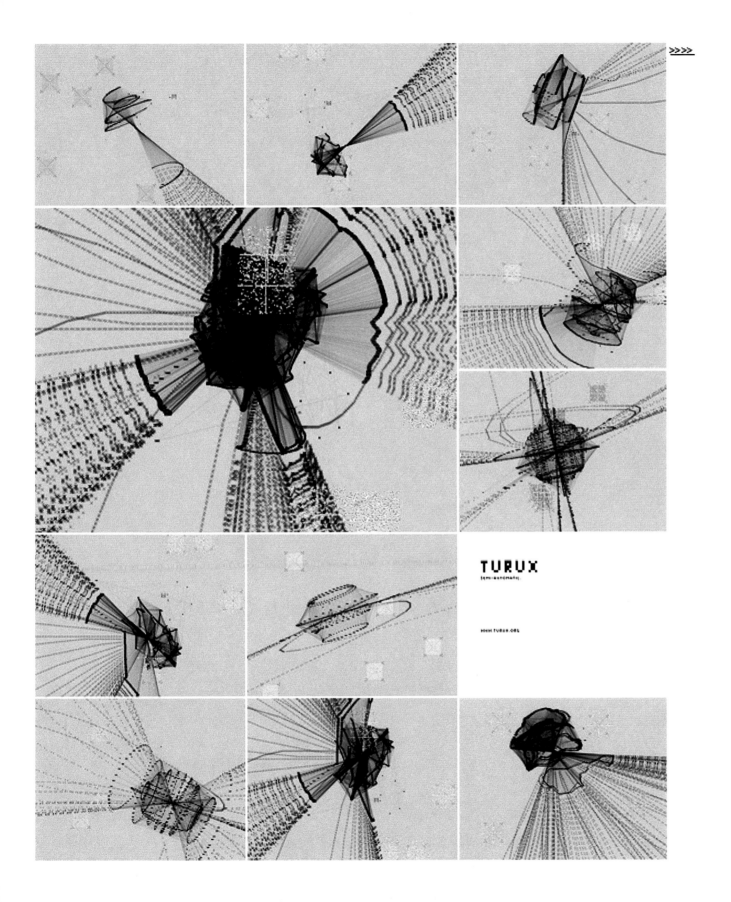

TURUX
(semiautomatic)

www.turux.org

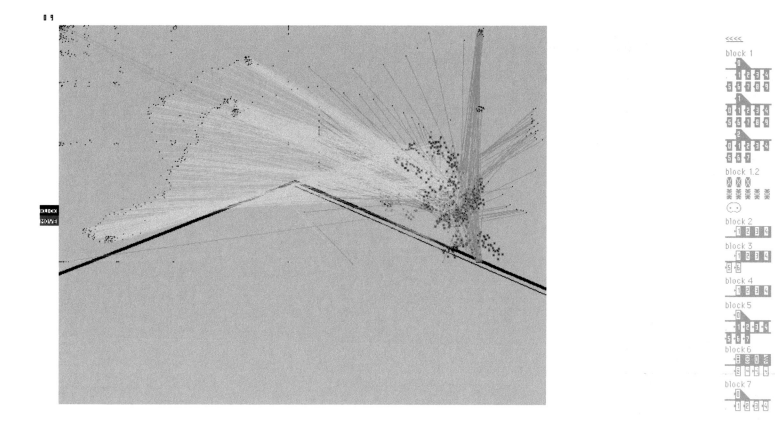

<<<<

block 1

block 1.2

block 2

block 3

block 4

block 5

block 6

block 7

>>>> <<<<

‹HEADPHONES HIGHLY RECOMMENDED

‹HEADPHONES HIGHLY RECOMMENDED

‹HEADPHONES HIGHLY RECOMMENDED

audio: dextro
based on a 3d script by che tamahori

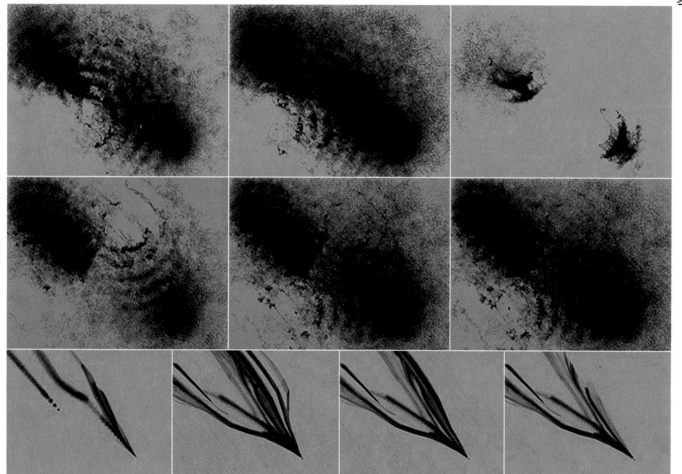

TURUX
(semi-automatic)

WWW.TURUX.ORG

021

Audi Konfigurator ↘ www.audi.de/konfigurator 0110110010010001011011001000101
Meta Design/ Online Services for ↘ Audi AG ↘ Berlin 1999 ↘ Language: German
↘ © Audi AG ↘ Programming: Buero am Draht, Berlin 10010010001011011001000101
Designer: Kora Kimpel, 32, German ↘ koki@snafu.de 0011001000101101100100010
↘ works at MetaDesign plus GmbH ↘ Bergmannstraße 102, D-10961 Berlin
↘ T. +1.49.30.69 00 62-00 ↘ F. +1.49.30.69 00 62-22 ↘ www.metadesign.com 01010
Former Industrial Designer who began to work in the field of New Media in the
early nineties. Worked as 3D Artist for medical animations and did the Media
Design for several exhibitions. Works at Meta Design since 1999. Teaches at the
HdK Berlin the Basics of Digital Media since 1998. 011101101010001010011100010
Latest/personal projects: The coupe-part of audi-tt.com (only PC-proof). 10110110
Personal milestones & inspirations: Would be Architect, if not Designer. I love
Architecture and Architecture inspires me.
Jan Rikus Hillmann, 30, German ↘ hillmann@its-immaterial.com 1101101010010
works at It's Immaterial, Berlin ↘ www.its-immaterial.com 010110010100010100
Latest/personal projects: design/architecture for a web-tracking & statistics
application; a certain webdesign book 01110110010010001011011001010011101
Inspirations: friends, Berlin, food, urban environments and culturen 01000010001
Function: living an authentic life, installing medial pragmatism on clientside,
mixing channels, preaching quality not quantity, developing contextualisation
see editor: ↘ Jan Rikus Hillmann 0111011001010001011001001 0111010010010

019

Barneys New York, Website 2000 ↘ www.barneys.com 01110110010001011001010
Kioken, Inc. for ↘ Barneys New York ↘ New York 1999-2000 ↘ Language: English
Designer: Eric Wysocan, 25, USA ↘ ewysocan@kioken.com 010010010001011001010
works at Kioken, Inc. ↘ 59 John St. NY, N.Y. 10038, USA ↘ C.: Susie Kang ↘
skang@kioken.com ↘ T. +1.212.346.7860 ↘ F. +1.212.346.7858 ↘ www.kioken.com
0111011001010001011001001000101011011010010100010100
www.bionic-systems.com 010001000100101011010010011011010100011011001

143

Bionic Systems, Düsseldorf, Germany, Summer 99 ↘ Language: English 1000010
Designer: Malte Haust aka dePhrag2.0, 25, German ↘ dephrag@bionic-systems.com
1974 - born in Kassel, Germany ↘ 1994 - german baccalaureate ↘ 1995+ studying
visual communications at FH Düsseldorf ↘ 1996+ freelancing for various design
companies [print+webdesign] 011101100100100010110110010100111010010010
Doris Fürst aka °juici%, 24, German ↘ juici@bionic-systems.com 01001001011
1976 - born in Trier, Germany ↘ 1995 - German baccalaureate ↘ 1995+ freelancing
and ad for various design companies [print+webdesign] ↘ 1996+ studying visual
communications at FH Düsseldorf 01110110010010001011011001001110100110010
Both: ↘ 1998+ working for various clients ↘ 1999 establishing BIONIC SYSTEMS
↘ Ellerstr. 115, D-40227 Düsseldorf ↘ T. +49.211.7885497/ +49.211.656678 0010101
Latest/personal projects: creating fonts for T-26 Font Company ↘ www.t26.com,
urban travelling and taking pictures 010110010100010100101010101100100110

119

Personal milestones & inspirations: 1. meeting, loving and working with each other
ever since [BioSYS™] 2. Moving Shadow and other phat beats. boom. 3. Ghost in the
shell 4. gobi@wurmkur.de 5. Delta [Boris Tellegen] 6. Science 7. Japanese Toys and
Characters 8. Star Wars 9. Schulmädchen Report 10. U-Kunst Berlin 0101100100010
0111011001010001011001001000101011011010010100010100110010011

121

www.burodestruct.net 1011010100010001001000101101011010
Büro Destruct, Bern 1996 ↘ Language: English 0100101100100010001010010110
Designer: Büro Destruct ↘ bd@bermuda.ch 010010010001011011001010011101
↘ Wasserwerkgasse 7, CH-3011 Bern ↘ C.: Lopetz ↘ T. +41.31.312.6307 10110010
0111011001010001011001001000101011011010010100010100110010011
1101100100011001010001011010110100011011001010011101001001010
0010110110111011010010010001011011001010011101001001010110010

167

conclave obscvrvm ↘ cmart.design.ru 01000010101011101010100011011000101010
Oleg "cmart" Paschenko, Moscow 1998-2000 ↘ Language: misspelled Latin 0001
Designer: Oleg "cmart" Paschenko, 28, Russian ↘ cmart@design.ru 010001001
↘ 109153 Zhulebinski Boul. 27-18 Moscow, Russia ↘ T.+7.95.704 57 23 1010000011
works at Art. Lebedev Studio, Moscow ↘ 0110110010100010110010010001010110010
Latest/personal projects: Desperanzza ↘ cmart.design.ru/desperanzza/ 10110001
Oxygene ↘ cmart.design.ru/o2/ 0111011001010001011001001000101011011001010
0111011001010001011001001000101011011010010100010100110010011
1101100100011001010001011010110100011011001010011101001001010
0010110110111011010010010001011011001010011101001001010110010

007

www.contexta.ch 010001000100101011010010011011010100011011001010011
Connector AG for ↘ Contexta AG ↘ Bern, 1999 ↘ Language: German/English 110
Connector AG, digital communications, Wasserwerkgasse 19, CH-3000 Bern 13 10
↘ T. +41.31.318.7878 ↘ F. +41.31.318.7879 0111011001010001011001001000101010
Contexta AG, Werbeagentur BSW ↘ Wasserwerkgasse 37, CH-3000 Bern 13 111011
↘ T. +41.31.310.8888 ↘ F. +41.31.311.4877 ↘ C.: bene.abegglen@contexta.ch 00111
Designer: Connector AG ↘ mail@connector.ch 1001000101101100101001110
Born in mind in early 90's, established as ltd. in 97, connector marries broad
experience in all fields of classical communication with state of the art media
technologies to make our clients visions part of the digital revolution. 10010100010
Latest/personal projects: www.limelite.ch, latest on the wap: wapporn.ch 0110010
Personal milestones & inspirations: as seen on 1999.connector.ch 01110110010100

009

025

107

Method, Inc. for ↘ Adobe ↘ San Francisco, 1999 ↘ Language: various

039

041

043

123

125

www.crackdesign.com 0011001000101101100101011101001011101010010110
Crackdesign, August 1999 ↘ Language: English ↘ Credits: Nina Mielisch 111010
Designer: Vladimir Muzhesky, 27, Ukrainian ↘ www.basicray.org 010110110100010
www.basicray.org ↘ 83 Canal #207, New York, N.Y. 10002, USA 0010110011010001011
↘ works at Thing.net Communications
Professor School of Visual Arts, Course 3D animation.
Recent art projects: ↘ 2000 - Ru, Formula, SF MoMA, San Francisco, USA ↘
2000 - Market Interference, I T Park, Taipei, Taiwan. ↘ 1999 - Hosts, Blasthaus
Gallery, San Francisco, USA. ↘ 1999 - LSHELL, Synreal, (Netbase/ Vienna,
Museum of Video Games,/ Tokyo, Museum of Video Games/ Berlin), Vienna,
Austria. ↘ 1998 - Aggregat, Virtual Worlds, Paris, France. 011001001000010100001
Personal milestones & inspirations: vr, animation, games 1001000100010010001
0111011001010001011001001000101011011010010100010100110010011
1101100100011001010001011010110100011011001010011101001001010

www.defytherules.com 010001000100101011010010011011010100011011001
Method, Inc. for ↘ Adobe ↘ San Francisco, 1999 ↘ Language: various 1101100101
Designers: Thomas Noller, German, Henrikk Karlsson, Swedish 0101100101100101
↘ thomas@method.com 010010010001011011001010011101001001010110010
working at Method, Inc., New York ↘ www.method.com 0111011001010001011
see author: Thomas Noller 000101101100101001110100100101011001011001
0010110110111011010010010001011011001010011101001001010110010
0111011001010001011001001000101011011010010100010100110010011
0010110110111011010010010001011011001010011101001001010110010

ds´001, designershock [first issue] 010001000100101011010010011011001
↘ www.designershock.com ↘ Language: ds´English 100010010001010010110
↘ www.designershock.de ↘ Language: ds´German 0100101100100010001010
Designers: Stefan ↘ stefan@designershock.de, Birte ↘ birte@designershock.de,
Rob ↘ rob@designershock.de, Malcolm ↘ malcolm@designershock.de, Markus
↘ markus@designershock.de, 130, various 010010010001011011001010011101
Designershock, c/o Designerdock ↘ Grimmstrasse 27, D-10967 Berlin
↘ T. +49.30 69 59 66 0 ↘ F. + 49.30 69 59 66 12 ↘ Place of work: yes ↘ Biography: yes
Latest/personal projects: ds´002, designershock 0110110010100010110010
Ranking: the new working-class ↘ Personal milestones: ds´004 01001010010010
Inspirations: ISBN 3-85415-200-0 ↘ ISBN 3-8228-8499-5 ↘ ISBN 3-283-00259-2
↘ ISBN 3-283-00264-9 ↘ ISBN 0-86001-818-0 ↘ ISBN 84-343-0522-4 ↘ ISBN
953-97400-0-2 ↘ ISBN 3-900456-01-1 ↘ Buñuel, Auge des Jahrhunderts (NO
ISBN!) 01000010101011101010100011011000101010110110100010010001011
0111011001010001011001001000101011011010010100010100110010011
1101100100011001010001011010110100011011001010011101001001010
0010110110111011010010010001011011001010011101001001010110010

www.dform1.net 010001000100101011010010011011010100011011001010011
DFORM1, Rockville, USA, April-May 2000 ↘ Language: English 11001000110100011
Designer: Anders Schroeder, 24, Danish ↘ dform1@dform1.net 100010010001010
works in London ↘ Flat 1, 4 Spital Square, E1 6DX London, UK ↘ T. +44.7949204605
Me, Anders Schroeder, 24, Tech boy. Born and raised in the tiny little country of
Denmark, Europe, where I spent most of my life hanging out with machines and
those semi-organic people that I call my friends. As a Graduate from Multimedia
Academy of Aarhus, Denmark, I like fast paced living as well as chill music and
sweet robos. With electronic music since I was able to walk and a built in phono
jack on my back, what could be better than city travelling and snowboarding?
Or Ping pong... huh? I'm always wired up with some high-tech tunes and feel
comfortable in white rooms. Currently I'm busting it hard at a-nexus studios,
London, a playground filled with creativity, energy and great people, and of course
I'm always aiming at giving machines a little extra love. 00111011100011001000
1101100100011001010001011010110100011011001010011101001001010
0111011001010001011001001000101011011010010100010100110010011

DHKY | For More Better Life ↘ www.dhky.com 011101100101000101101001
DHKY, Vancouver/ New York/ Hong Kong, 1997-2000 ↘ Language: Chinglish 100
A platform that allows me to simultaneously experiment with design and inter-
activity and explore themes of nostalgia, memory, and fried rice. 1001000100010
Designer: David Yu, 27, Chinese Canadian ↘ sifu@dhky.com 010010010001010
↘ 84 Madison St., #20, New York, NY 10002, USA ↘ T:212.349.2287 001000101001
works at The Office for Fun and Profit, Inc. ↘ www.theOFP.com 01110110010010
Born 1972 ... Rat/Scorpio ... spent my formative years in Vancouver, BC, Canada ...
BS in Computer Science ... working as web designer in NYC since 1996 ... partner
of The Office of Fun and Profit ... sausage lover and camouflage connoisseur 100
Latest/personal projects: The Office for Fun and Profit - Summer 2000; Nisen
poster exhibition in Osaka, Japan ... next stop: Tokyo; site for Eric So, Hong Kong
artist/dollmaker ↘ www.ericsoart.com; designs for MTV Japan; continuing:
updates to DHKY and Beestation; DHKY at the SF Museum of Modern Art 0101110
Personal milestones & inspirations: Unagi-don, Macster, Wong Kar Wai, Diesel,
Lille/Amsterdam/Brussels/Paris with EPak, Bad Company "Inside the-Machine",
chubby Chinese kids, Kevin Lyons/Natural Born, Van Halen "Panama", AOL
Instant Messenger, unrequited love, Sasha "Expander", E on the beach, Ocean
Drive, Miami, Generic Costume, Bruce 1010000111011000110010001010111010110100

139

141

177

179

095

199

201

015

www.dividebyzero.org 1100100101011011001000101011000101001111100010100001
dividebyzero, London ↘ Language: non
Designer: dividebyzero, n/a, Yorkshire ↘ 0@dividebyzero.org 01011101010101000
works anywhere with electricity ↘ 33 Lawn Terrace, Blackheath, London, SE3 9LL, UK
↘ T. +44.20.8852.2127
Latest/personal projects: www.autechre.co.uk 00001101100100101011010001010001
Personal milestones & inspirations: Jodi, Antiorp, J.G. Ballard, Duchamp, Weevil,
People who can't sing but still make music 1001001011010110011011000101001000

E13.com 0000110110010010101101010010101110100100010101011
New York, 1996 ↘ Language: none
Designer: Eric L. Rosevear, 26, American ↘ e13@e13.com 10111011010001011
↘ 432 East 13 Street #35, New York, NY 10009, USA ↘ T: +1.212.228.0304
Born 08/03/73, New York. Unemployed.
Latest/personal projects: Work in progress. 010100101000101011010001010101
Personal milestones & inspirations: knowing all the right people: Matthew M.,
Franko R., Yoshi S., Jimmy T., David M., David O.

www.eboy.com 0011110110100101001011010010101001101100101001
eboy, permanently updated ↘ Language: English 0010110101011010001001011
Designer: Kai Vermehr, 35, Steffen Sauerteig, 32, Peter Stemmler, 34, Svend
Smital, 32, all German ↘ eboy@eboy.com 010101110100101100010010110011
working in Berlin and New York
Kai grew up in Guatemala and Steffen, Peter and Svend in Berlin, Germany. We
all studied "Visual Communication" but at different places. We are working together
as "eboy" since 1998. 010110100101001011010010101001101100101001
Latest/personal projects: Our latest project are series of collectible cards with
pictures of monsters, guns, cars, girls ...
↘ www.eboy.com/pages/works/eboycards/eboycards.html 1110110010100101110
Personal milestones & inspirations: girls, hots, military equipment, apple,
playstation, palm, japan, usa, england, coca cola, football, muhamed ali, lego,
formular 1, beasty boys, AC/DC, nintendo, marathon, quake, predator, terminator,
matchbox, hulk, supermarkets, street typography, CNN, NEWs stands, TV zapping ...

Entropy8Zuper! ↘ entropy8zuper.org 01111001011001100011000110110
Entropy8Zuper!, internet, as of 1999 ↘ Language: English & Dutch 01010001011110
Designer: Michael Samyn, 32, Belgian & Auriea Harvey, 29, American 11011001010
↘ two@entropy8zuper.org 000010100001011010010101001011100101000011
Place of work: internet 1011101000010100010101101010010100100010001
Zuper! is Michaël Samyn. Samyn was trained a graphic designer for traditional
media but has devoted his work exclusively to new media since 1995. Early 1999
he started Entropy8Zuper!, a high-tech high-emotion web production organization,
with Entropy8|Auriea Harvey.
Entropy8 is Auriea Harvey. Harvey was trained a sculptor for traditional media but
has devoted her work exclusively to new media since 1995. Early 1999 she started
Entropy8Zuper!, a high-tech high-emotion web production organization, with
Zuper!|Michael Samyn. 11011001011010101010010001001100010111011
Latest/personal projects: CameraSS (on line version) ↘ 11011000101001011011001
entropy8zuper.org/godlove/closer/products/cameraSS.swf 0010001011011001001
Leviticus ↘ entropy8zuper.org/godlove/it's_not_about_comfort_baby 0001010110
Skinonskinonskin ↘ www.entropy8zuper.org/skinonskinonskin 001010000101101001
Wirefire ↘ entropy8zuper.org/wirefire 010101101010010100010011011001000
Personal milestones & inspirations: Z! - I do not understand this question. 1011001
A! - Goddamn this noise inside my head. 0001011001000101010001001100010100101011

e-Types.com 00010110010010010101011010010101001011100101001
e-Types ApS, June 2000 ↘ Language: English
Designer: e-Types, Danish ↘ info@e-types.com 0010001011101011001010101001
working in Copenhagen ↘ Vesterbrogade 80B, DK-1620 Copenhagen 10011010010
↘ C.: Rasmus Koch ↘ T. +45.33 25 45 00 ↘ F. +45 33 25 45 57 01011101010101000
e-Types is a Danish based design-community founded by a group of young desi-
gners, educated at the Danish Design School and at the Royal Academy of Art in
Copenhagen. Established in the summer of 1997. Main working fields are corporate
design and typeface design. Our field is abstract communication, and our strength
is being very different individuals working as a group. By co-operating as open-
mindedly as possible, we are able to effectuate our common dream of making
design that moves boundaries. 100010101001011011010010110010110001010111
Personal milestones: Spread joy & revolution. 111011001010010100101000101101000

175

187

181

183

077

173

193

195

197

www.evolutionzone.com 10011001010010101010100010101001010100100111
A playground for ideas where elephants of the mind come to die. 100110110100110
Anywhere, anytime, right now ↘ Language: English 0010010110010100010001
Designer: Marius Watz, 27, Norwegian ↘ amoeba@evolutionzone.com 111111110011
works at Amoeba World Headquarters ↘ Sons.gate 25, N-0654 Oslo 0010101001100
↘ T. +47.23240888
Once a computer nerd, now a new media yuppie whose love can be bought for money.
But I still collect toys.
Latest/personal projects: Whatever is most current on evolutionzone.com. 010011
Personal milestones & inspirations: Love is all you need. A little ignorance goes
a long way, too. 01110010100010010010101000001010101010001011001001

You can live forever in a paradise on Earth ↘ feed.de 00010011100011001100110
Da5d, March 2000, Hamburg, Tel Aviv ↘ American Home Products ↘ Language:
American/German © David Linderman
Designer: Da5d, American ↘ da5d@fork.de 0010010100010110001001011010
working in Hamburg and Berlin ↘ c/o Fork, Wollinerstrasse 11, D-10435 Berlin
see author: ↘ Da5d 011011001010101011101010010010101010101010101
0010010010100101001010001010010101101100101010101

www.fork.de 11011001000010101000101011010100101101011001010
Fork Unstable Media, last update: August 2000: v4.0 for ↘ e-fork Ltd. 01000101011
↘ Language: German/American
Designers: Fork Design, Code and Crisis Management e.V., United States,
Germany, Austria, Vietnam, Laos, France, Persia, United Kingdom, Greece ↘
info@fork.de 101000010110010100010001011001010100101010
Headquarters ↘ Juliusstrasse 25, D-22769 Hamburg ↘ C.: Svenja Peters
↘ T. +49.40.432.948.0 ↘ F. +49.40.432.948.11
Made in the Bundesrepublik. 01001010010101011010101101010010001001
see author: ↘ Da5d 011011001010101011101010010010101010101010101

www.futurefarmers.com 11011001000101011001010100010110100001011001
Futurefarmers, San Francisco, CA since 1995 ↘ Language: English 001010010010
Futurefarmers engages in creative investigation and development of new work.
Through collaboration, we expore the relationship of concept and creative process
between interdisciplinary artists. 001011001010010100101010001011011001001
Designer: Amy Franceschini, 29, American ↘ ame@sirius.com 000101011010010
works in San Francisco ↘ 1201 B Howard Street. San Francisco. CA 94103, USA
↘ T. +1.415.552.2124 ↘ F. +1.415.626.8953
Futurefarmer's founding member, Amy Franceschini, graduated from San Francisco
State University in 1992 with a BFA in photography and interned at Photo Metro,
a monthly photography publication, where she was introduced to computer graphics
and design. In 1995, she formed a partnership with Olivier Laude and Michael
Macrone, founders of Atlas (www.atlasmagazine.com), an online magazine. In
1997, the Atlas website was selected as the first to be included in the permanent
collection of the San Francisco Museum of Modern Art. The site has won two
Webby awards (the equivalent of an online Oscar) for Art and Design, and has won
many other online and publication design awards. In 1995, she also started
Futurefarmers. It's first years harvest proved to be quite prolific. First with Switch
Manufacturing's highly acclaimed collateral and print catalog (see communication
arts 01/97). Next, "Flesh Farmer", a multimedia CO-lab in "Dig It: Digital Art
and the Next Generation", a digital show co-curated by Thomas Bonavich of
Postmasters Gallery, NYC and Limn Gallery, SF and most recently being in San
Francisco's prestigious biennial "Bay Area Now" exhibit at Yerba Buena Center
for the Arts. This balance between art and commerce pushes her to continually
rethink her craft while striving to transcend both. 001001010010010110110010
Latest/personal projects: www.nutrishnia.org, www.atlasmagazine.com, 01110010
coming soon: www.communiculture.org 010010101010010010101110110010010
Personal milestones: To continue to transcend new media experiences on both
personal and commercial levels, so as to realize my dream of working remotely
from a farm north of San Francisco. I want to have an artist in residency program
that can facilitate up to 6 artists at a time. 01010010010100100101110101001001

www.greyscale.net 110110010000101010001010101101010010110101100
Designer: Erik Jarlsson, 21, Swedish ↘ erik@greyscale.net 100010110111010010
works in London 101110010100101001010010010101110110010010010
↘ Flat A, 39 Exmouth Market, Clerkenwell, London EC1R4QL, UK ↘ T: +44.20.7841.1028
Milestone: e-Nexus Studios 00010010100101001010001010010101101100100
Inspirations: Portishead, Amon Tobin, Kieslowski 010110010100101010010010

www.hel13.com 11011001000101011001010100010110100001011001
HEL Communications Oy, March 1998 - May 2000 ↘ Language: Finnish / English
Designer: HEL Creative Team, 20 - 33, Finnish, Canadian, English ↘ hel@taivas.com
↘ Unioninkatu 15, 00130 Helsinki, Finland ↘ C.: Mr. Ilkka Montin ↘ T. +358.9.666 266
↘ F. +358.9.666 326
The HEL Creative Team is 16 people with experience in a variety of areas. Some
have cooked in McDonald's, one studied communications, some graphic design,
another acts in radio and TV commercials and one of us even sold paintings door-
to-door in Australia. Oh, and one of us is a lawyer; really. Most do snowboarding,
but are losing the battle with nature. This pool of "talent" has been stretched to
its limits for clients such as Diesel, MTV Europe and Sprite. 1101100101001001110
Latest/personal projects: www.protokid.com 0010010011011001010010101001

089

091

059

165

145

075

149

151

035

037

www.hi-res.net 0100010010100011110110100011101101101101100010101100101
hi-res!, London, Jan. 2000 ↘ Language: English 0100010100101110110111010100011
Designers: Alexandra Jugovic, 30, German ↘ alexandra@hi-res.net 10111011010
Studied Art and Graphic Design @ Hochschule für Gestaltung (HfG) Offenbach.
Freelance work for music industry in Germany, England and u.s.: music promos,
record sleeves. moved to London in May 1999, one of the founders of the design
group hi-res! 10010100010010100011110110100011101101011010001010010100010
Florian Schmitt, 28, German ↘ florian@hi-res.net 0100010100010111010110011010
Studied Product Design @ Hochschule für Gestaltung (HfG) Offenbach. Freelance
work for music industry in Germany, England and u.s.: music promos, 3D and
special effects, websites. moved to London in May 1999, one of the founders of the
design group hi-res! 01001010001001010001111011010001110110101101000101
Alexandra & Florian ↘ hi-res! 5 star image chefs, pixelpusher to the stars! 110110
working in London ↘ 47 Great Eastern St, London, EC2A 3HP, UK
↘ T. +44.7684.3100 ↘ F. +44.7684.3129
Latest/personal projects: complete redesign of ninjatune's sister record label
ntone: logo, visual appearance and website. 101101100101000100010010010011001
Personal milestones & inspirations: all sorts of silly toys, (especially buzz
lightyear, the aliens, slinky, rex from toystory), action man, lego, aibo, all
electronic gadgets, sony playstation (tekken, grand tourismo) ↘ Music: Clifford
Gilberto, Amon Tobin, Moloko, John Coltrane, Elvin Jones, Thelonius Monk,
Kraftwerk, Rachmaninoff, Chopin, Gershwin; ↘ Films: Bladerunner, Pulp
Fiction, Casino, Enemy of the State, Toy Story 1 /2 ↘ TV Series: 6 Million Dollar
Man, The Incredible Hulk, Enterprise, Simpsons, Futurama, Muppetshow, M2
↘ Comedy: Monty python, Seinfeld ↘ Art: Bill Viola, Rebecca Horn, Oskar
Fischinger, Norman McLaren ↘ Literature: Greg Egan, Garcia Marquez 1101101001
0001101011010100011011010001110110101100010010110110101001010110100011101
0011101101100101010010110101010001010010101100010101010101100101101001010

www.kabeljau.ch 01010001001011100101000100010100011010101010110011010101
Kabeljau, Zurich ↘ Language: English/ German 0101000100010011010110110010
Designers: Claudia Blum ↘ claudia@kabeljau.ch 1101100010100100100100010010
Christof Täschler ↘ claudia@kabeljau.ch 011100010101101000010010110
working in Zurich ↘ Schöneggstr. 5, CH-8004 Zürich ↘ T. / F. +41.1.240.0937

www.lab01.com 0101010011011101010101001000100110011
Media/ Mediaconcept, Hamburg 1999 for ↘ DaimlerChrysler 1010001000100100010
↘ Language: English/ German ↘ © DaimlerChrysler 010010011011001011010101
Designer: Jeremy Abbett, 28, USA ↘ tai@suture.com 10110111011010001011001
works at Fork Unstable Media ↘ www.fork.de 100101110110100101011011010
0001001101101011010101011010110101001010101010101011010101010101001011010
010100011010110101010100011011010001110110101100010010110110101001010101
0011101101100101010010110101010001010010101100010101010101100101101001010

Lego Font Creator 110100010010110110101000101001010110010101011001011010
www.lineto.com/01linetofonts/07linetoapplications/lego_fontcreator.html 10110
Display for ↘ Lineto ↘ Switzerland 1999 (Basel/Lucerne/Zurich) 1000100101001010
↘ Language: English 101101101011010001011001010010010110010100011010010
Designers: Urs Lehni, 25, Swiss ↘ lehni@gmx.ch 01011101100101001010110100
Rafael Koch, 23, Swiss ↘ r.koch@gmx.ch 0101110110010101011010101101001010
Juerg Lehni, 22, Swiss ↘ lehni@gmx.net 1011000101001010110100110100111001
see index: ↘ www.vectorama.org 00010010011110110100011101101011010001010

Lineto ↘ RubikMaker 1.0 010101101011010001011001010010010110010100010011
www.lineto.com/01linetofonts/07linetoapplications/rubik_maker.html 0111011100
Jürg Lehni & Cornel Windlin, Switzerland 1999 ↘ Language: English 111011001010
Designers: Juerg Lehni, 22, Swiss ↘ lehni@gmx.net 010111011001010010101101
Cornel Windlin, Swiss ↘ info@lineto.com 0101110110010101011010101101001010
Place of work: Here, there & everywhere. 0101000100101110010100010001010010
↘ Pfingstweidstr. 6, CH-8005 Zürich ↘ C.: Lisa Kholl ↘ F. +41.1.271.9066 0001011
Latest/personal projects: www.ilovepeanutbutter.org 10111011001010010101101
0010001001011100101000100010100011010101010110011010101010001011001010010
0010001001011100101000100010100011010101010110011010101010001011001010010

lessrain.com 1011011001010010101101010100010100101011000101010101011001011
less rain ↘ March 98 - September 98 ↘ Language: English 100010010110110101000
Designers: Lars Eberle, Vassilios Alexiou, Gunnar Bauer, 29-31. German/ Greek
↘ reception@lessrain.com 0100010100010111010110011010010011011001011010
working in London and Berlin ↘ 33-34 Hoxton Square, London N1 6NN, UK
↘ T. +44.20.7729.7227 ↘ F. +44.20.7739.002 ↘ www.lessrain.co.uk 0010001010111
↘ Kurfürestendamm 66,D- 10707 Berlin ↘ www.lessrain.de 1011011001010010101
Less Rain is an International network with it's core based in London. The disparate
nodes of the network encompass architecture, conceptualization, copywriting,
fine art, illustration, music, sound design, photography and programming. By
combining different elements within the network in varying combinations, work
has been produced which is humorous and functional, minimalist but rich in
experience, unfamiliar yet intuitive. Communication channels have included CDR,
exhibition design, internet, kiosk and print. 00010011101101100101010010110100
Less Rain promotes the work and vision of clients that range from small organi-
zations to high-profile companies, from the local to the international. All have
been charmed by their friendly, innovative and professional approach to a brief.
Latest/personal projects: www.mycities.com.br, www.playstation.co.uk 110110011

205

207

097

069

017

063

083

085

169

|| m9ndfukc.macht.ganz.gluckl!ch+fre! ↘ m9ndfukc.com 1000010011011000101011101
0f0003.maschinenkunst, Denmark. 1999-2000 for ↘ you ↘ Language: -cw4t7abs
Credits information: © 1999, La Reproduction Interdite. ↘ Auteur: La Reproduction
Interdite/ Un film de La Reproduction Interdite 110010010010010101010000010011
Designer: Netochka Nezvanova, 2x [female] life objekt 00100100010111011010010
↘ f1f0@m9ndfukc.com ↘ ecdysone@eusocial.com 0010010001011101101001010
Place of work: www.eusocial.com, www.m9ndfukc.com, www.memvirus.com,
www.biohakc.com, www.membank.org, www.gttctttat.com 01111011001010010110
dze pa!r!ng ov homologouz kromozomez one 4rom each odr prnt. dur!ng me!os!z -
i cannot be bothered.i cannot be bothered.surrender your pattent. 0100101010010
see author: ↘ Netochka Nezvanova 011011001010010101011010101000101100101
0001100101010010110101010001010010101100010101010101100101101001010101010
1010001010010101100010101010101100101101001010101010100010100101011000101

www.method.com 00010011101101100101010010110100101011010101000101100
Method Inc., San Francisco, 2000 ↘ Language: English 00010011011001011010101
Designer: Olivier Chételat, Swiss ↘ olivier@method.com 110100101011010101000
Method Inc., ↘ David Lipkin ↘ 512 2nd Street, San Francisco, CA 94107 , USA
↘ C.: Cameron Campbell ↘ cameron@method.com ↘ T. +1.415.901.6300
↘ F. +1.415.901.6310 1101010101000101100101001001011001010001001101101001
0100010100101011010101000101100101001001011001010001001101101001010001010

MTV2 ↘ www.mtv2.co.uk 001000100101011010101000101100101001001011001010
Digit for ↘ MTV Networks Europe ↘ London, 2000 ↘ Language: English 01100101
© MTV Networks Europe 110010100100101100101000100110110100101000101001
Designers: Digit, 4, UK ↘ studio@digitlondon.com 10001010101010110011010101
Digit ↘ 54 - 55 Hoxton Square, London N1 6PB, U.K. ↘ C.: Daljit Singh ↘
info@digitlondon.com ↘ T. +44.207.684.6161 ↘ F. +44.207.684.6161 011011011001
↘ www.digitlondon.com 10010001011101101001010001010010101100010101010
Latest commercial/personal projects: www.digital-experiences.com 1011011001010
Ranking: Drink before you think 0101110110010101011010101101001010110100101
0001100101010010110101010001010010101100010101010101100101101001010101010
0011101101100101010010110101010001010010101100010101010101100101101001010
0011101101100101010010110101010001010010101100010101010101100101101001010
0011101101100101010010110101010001010010101100010101010101100101101001010

mycity: vienna ↘ www.mycity.com.br/mycitysites/vienna1 1100100100101100101010
lia, maia, [n:ja] for ↘ Centro Cultural Banco do Brasil ↘ Vienna 1999 110110010100
↘ Language: English 110100101011010101000101100101001001011001010001001
Designers: maia, Swiss ↘ maia@re-p.at ↘ www.re-p.at 100010101010101100110
lia, Austrian ↘ lia@sil.at ↘ www.re-move.org, www.turux.org 0110010100010011
[n:ja], 28, Austrian ↘ annja@t0.or.at ↘ www.n-ja.org 11010010101101010100010
all working in Vienna ↘ T. +43.1.52406641 ↘ F. +43.1.52406644 00010011011001
Latest/personal projects [n:ja]: www.lanolin.at, www.thing.at/v++ 1110110010100
0001100101010010110101010001010010101100010101010101100101101001010101010
0011101101100101010010110101010001010010101100010101010101100101101001010
0011101101100101010010110101010001010010101100010101010101100101101001010
0011101101100101010010110101010001010010101100010101010101100101101001010
0011101101100101010010110101010001010010101100010101010101100101101001010

www.net-150.de 00011101101100101010010110101010001010010101100010101010
playframe digital media studio, Berlin, July 2000 ↘ Language: English 110110010100
Designer: Vicky Tiegelkamp, 33, German ↘ vicky@playframe.de 101110110010100
Personal milestones & inspirations: old magazines, all kinds of bits and pieces of
paper found on fleamarkets (postcards, photos, maps...), J.S. Bach Cello Suites,
cigarettes, sea, sitting in a park or garden 110010100100101100101000100110110
see editor: ↘ Vicky Tiegelkamp 10110110010100101011010101000101100101001
0001100101010010110101010001010010101100010101010101100101101001010101010

www.netbabyworld.com 0001110110110010101001011010101000101001010110001
Netbaby World AB, March 2000 ↘ Language: English 00010011011001011010101000
Designer: ACNE International AB, Swedish ↘ jesper@acne.se 11011001010010101
working in Stockholm ↘ www.acne.se 0100010100010111010110011010010011011
Netbaby World AB ↘ C.: Sara Söderberg ↘ sara@netbabyworld.com 101110110010
↘ Drottninggatan 57, S-11121 Stockholm ↘ T. +44.8.102263 ↘ F: +44.8.102441 1101
ACNE started to produce Shockwave games in 1994. The concept grew and in 1999
ACNE founded Netbaby World AB together with Nightscape Communications, and
the domain www.netbabyworld.com became an active game community. 110010100
Latest/personal projects: www.actionjeans.com 010111011001010010101101010
0001100101010010110101010001010010101100010101010101100101101001010101010
0011101101100101010010110101010001010010101100010101010101100101101001010
0011101101100101010010110101010001010010101100010101010101100101101001010

nitrada.com 01000100101110010100010001010001101010101011001101010101000
Christophe Stoll, Hamburg 2000 ↘ Language: English/German 010000100101100
Designer: Christophe Stoll, 24, German and French ↘ ntrd@fork.de 00000000100
works at Fork Unstable Media, Hamburg ↘ www.fork.de 1101100101001010110
↘ Talstrasse 24, D-20359 Hamburg ↘ T. +49.171-423 02 64 ↘ F. +49.40-432 948 11 0110
Latest/personal projects: nitrada and nitrada.de (regularly updated) 101110110010
Personal milestones & inspirations: Drugs: Vodka, Pastis, Powerbook ↘ Music:
Richard D. James album, Blonde Redhead, The Locust ↘ Love: title tags,
Hamburg City, girl/boy song, loops ↘ Hate: beer ↘ Milestone: Chris Cunningham
↘ Inspiration: hell.noise.people.random.music and nature. 11001010010010110010

185

no-live-operator: How should I behave? ↘ nolo.de
Da5d, last update: February 2000, Hamburg ↘ World Trade Organization.
↘ Language: American/German ↘ © David Linderman
Designer: Da5d, American ↘ da5d@fork.de
working in Hamburg and Berlin ↘ c/o Fork, Wollinerstrasse 11, D-10435 Berlin
see author: ↘ Da5d

093

Plasticbag | Designing Virtual Landscapes ↘ www.plasticbag.de
Philipp Körber, concept/basic layout: Washington DC, Feb. 2000, finished: Uslar,
Germany, April 2000 ↘ Language: English
Designer: Philipp Körber, 23, German ↘ polypropylene@plasticbag.de
works in London for e-Nexus Studios Europe Ltd., a division of ZeniMax Media Inc.
↘ Flat A, 39 Exmouth Market, Clerkenwell, London EC1 RQ4L ↘ T. +44.20.7841.1023
↘ F. +44.20.7681.6279
I was born in Germany/Europe in the second half of the 1970's and lived in a working
class home in a village named Uslar. My childhood was spent peacefully. I was 8
years old when my mother introduced me to a Decision Mate V with CP/M as its
operating system. From then on I knew that computers would rule a great part of
my life. I grew up creating ascii/ansi/vga graphics for the underground computer
scene. After graduating from high school and declared as not qualified enough
to serve in the German army, I went to do a period of practical training in an
advertising agency specializing in new media. During this first year I realized that
my strengths lay in graphic design and the internet. Everything I know in this field
is self-taught.
Latest/personal projects: www.puk.de/artcore, www.benzedrin.de
Projects involved in: www.vtwinlabs.com
Milestones: my current job, 72dpi
Inspirations: Music, Life ↘ Toys: Powerbook, Palmpilot, Skateboard ↘ Music:
Jazz (Miles Davis, Herbie Hancock, Thelonious Monk...); Funk (Curtis Mayfield,
Bootsie Collins, George Clinton, James Brown...); Reggae (Peter Tosh, Toots
Hibbert, Burning Spear, yeah.. Bob of course...); HipHop USA (Beastie Boys, Tribe
Called Quest, De La Soul, Group Home, Jeru, Dilated P., Common, Mobb Deep,
Ghostface...); HipHop Deutsch-Coast (Creutzfeld & Jakob, Curse, Stieber Twins,
RAG...) Techno (Kraftwerk, Dave Clarke, Richie Hawtin, Dave Angel, Speedy J, I-
F, Autechre, Dopplereffekt, Detrechno, Kevin Saunderson, Richard Bartz,
Surgeon...); Drum 'n' Bass (Ed Rush/Optical, Roni Size, Amon Tobin...); and many
many more... it's all about the music! ↘ Websites: Dextro/Turux, Feed/Nolo, e13
↘ Love: Sandra ↘ etc.: Macs rule!

153

mrNoodleBox ↘ www.noodlebox.com
Daniel Brown, Amaze, 1997/98 ↘ Language: English
Designer: Daniel Brown, 23, UK ↘ dannyb@amaze.com
works at Amaze, London ↘ Condor House, 5-14 St. Paul's Churchyard, London
EC4M 8BE, UK ↘ T. +44.207.332.5620 ↘ F. +44.207.248.4082 ↘ www.amaze.com
Danny was born and raised in Liverpool, England. He became aware of new media
from an early age when, via family connections, he was introduced to Roy Stringer,
one of the early pioneers of the digital media industry. Stringer was then working
at the Learning Methods Unit (LMU) at Liverpool John Moores University, which
was, and remains today, a pioneer of interactive learning through CD-ROM and the
Internet. Danny was instantly struck by what he saw as the merging of his two
greatest passions - creativity and the challenges of technology. In his late teens
Danny formalized his relationship with the LMU when he began work on a number
of their commercial projects. During this time he worked on the award-winning CD-
ROM Cytofocus, which beat Microsoft's Encarta as overall category winner in the
1993 European Multimedia Awards. This work led to Danny joining the unit on a full
time basis after completing his schooling. Danny later started university, intending
to use this space to develop his own ideas. After an unhappy period however, Danny
left university, disillusioned by the slow pace of the programme and its inability to
match the experience he had gained through his practical exposure to contempo-
rary practice. Danny immediately joined Amaze, a new media company spun-out of
Liverpool John Moores University. It is here that Danny gained notoriety for his
research into expanding the uses of existing Internet technology, disproving the
status quo opinion of what was technically possible at that time. This research
culminated in the now famous and much applauded Mr. Noodlebox web site. Danny
now works actively on commercial projects as a creative technologist, bringing his
new concepts into the public domain and actively trying to push the boundaries of
existing perceptions of the Internet medium.

www.plusism.com
[+ISM], Tokyo/ London ↘ Language: English/Japanese
Designers: Matius Gerado Grieck / Tsuyoshi Nakazako, authorized age, transnational
↘ a90037tm@plusism.com
working in London and Tokyo ↘ 52B Malden Road Londom NW5 3 HG ↘ T.
+44.020.7284.0797 ↘ F. +44.020.7284.0797
Short biography: Buenos Aires | Berlin | Tokyo | London
Latest /personal projects: X __purifications
Personal milestones & inspirations: X __indifferent paroxysm

www.norm.to
norm, Zurich 2000 ↘ Language: English
Designer: norm is Dimitri Bruni, 29, Italian & Manuel Krebs, 29, Swiss ↘ n@norm.to
working on vectors and fonts ↘ Pfingstweidstr. 37 B, CH-8005 Zürich
↘ T. +41.1.273.6633 ↘ F. +41.1.273.6637
1991-1996 Schule für Gestaltung Biel / Fachklasse Grafik ↘ 1996-1999 engagements
for designstudios in Geneva and Zurich ↘ since 1-1-1999 norm / designstudio
↘ January 2000 release of: "norm: introduction"
Latest/personal projects: norm "reading" for autumn
Personal milestones & inspirations: love commodore64 / hate quark x-press/ &
wu-tang forever

101

129

133

131

www.popinger.com
Fork Unstable Media for ↘ Popinger ↘ Hamburg 1998
↘ Language: English, German
Designer: Jeremy Abbett, 28, USA ↘ tai@suture.com
works at Fork Unstable Media ↘ www.fork.de
↘ 184 Kent Avenue, Fifth Floor #5B Brooklyn, New York 11211, USA
↘ T. +1.917.548.8472 ↘ F. +1.718.384.1402
Latest/personal projects: www.doublecity.com, www.suture.com,
www.hell.com, www.truthdaredoubledare.com
see author: ↘ Jeremy Abbett

www.ntone.com
hi-res!, London, Spring 2000 ↘ Language: English
Designers: Alexandra Jugovic, 30, German ↘ alexandra@hi-res.net
Florian Schmitt, 28, German ↘ florian@hi-res.net
see index ↘ www.hi-res.net

165

023

047

www.praystation.com
Designer: Joshua Davis, 29 ↘ CHAOS@praystation.com
works at Kioken Inc. ↘ kioken.com
↘ 545 Lorimer Stree, 2nd floor Brooklyn, New York 11211
↘ T. +1.718.782.6969 ↘ F. 1.718.782.7917
see author: ↘ Joshua Davis

www.once-upon-a-forest.com
Designer: Joshua Davis, 29 ↘ Maruto@once-upon-a-forest.com
works at Kioken Inc. ↘ kioken.com
↘ 545 Lorimer Stree, 2nd floor Brooklyn, New York 11211, USA ↘ T. +1.718.782.6969
↘ F. 1.718.782.7917
see author: ↘ Joshua Davis

051

053

049

www.re.p.at
Designer: maia, Swiss ↘ maia@re-p.at
working in Vienna ↘ Maia Gusberti, Nik Thoenen ↘ T. +43+1+5240664
↘ F. +43.1.52406644

111

189

RMX//A Visual Remix Project ↘ www.rmxxx.com
RMX (a collaboration of 8 Designers), Australia 2000 ↘ Language: English
Designers: Craig Redman, Steve Alexander, Karl Maier, Adrian Clifford, Katrina Dobbs,
Callum Flack, Michael Christoffel, Rilla Alexander, 22-27, Australian ↘ they@rmxxx.com
↘ PO Box 944, Fortitude Valley 4006, Queensland, Australia ↘ C.:Rilla Alexander
↘ rilla@rinzen.com ↘ T. +61.7.3852.5351 / M. +61.438.1175.88
RMX//A Visual Remix Project launched from a desire to produce exciting visual
work in an unpredictable way. Each of the players produced an initial piece, based
on themes ranging from the relevant to the ridiculous. These were passed pro-
gressively to each player being 'remixed' each step of the way – modified, added
to, erased – with each participant not seeing the work before it was their turn to
remix it. The resulting 64 pieces form the basis of an Exhibition, a Collectable
Poster, a Music CD and a Website.
Visit also: ↘ www.rinzen.com, www.rasa8.com

113

www.planetpixel.de
Designers: Oliver Funke, Ansgar Hiller, Anja Wülffing ↘ mail@planetpixel.de
working in Cologne ↘ Planet Pixel, Hansaring 94, 50670 Köln, Germany
↘ T. +49.221.9123.913 ↘ F +49.221.9123.914
see author: ↘ Ansgar Hiller

109

087

033

011

013

005

203

055

057

www.robotnikdesign.com 00100101110110001001011011000101011101101100010010110
Robotnikdesign, Berlin 1999 - 2000 ↘ Language: English/German 11011010110
Designer: Ian Warner, 25, Nationality: none ↘ ian@robotnikdesign.com 11000001
no set working location ↘ Belforter Str. 25, 10405 Berlin ↘ T. +49.30.4404.5244
Born 1975.↘ 1993-1996 studied communication design at Portsmouth University,
School of Art, Design and Media. ↘ 1996 moved to Berlin. ↘ Since 1997 freelance
designer for grappa blotto design. ↘ Since 2000 partner at grappa blotto design.
Latest (recent) projects: www.hotheaven.com, www.grappablotto.de
Personal milestones & inspirations: (in chronological order) Lego, ZX81, "Tron",
Kraftwerk's "Computer Love", Einstuerzende Neubauten's "Tabula Rasa", Berlin,
Dada, Coffee, Post Script Errors, Charles Mingus, Zaha Hadid, Smart Media Cards
00101011101100010010110110010011010101101100010010110100010010110101011
Sinnzeug ↘ www.sinnzeug.de 11001011101101011001010010100010010011101011
Stephan Huber, Ralph Ammer & Birte Steffan at ↘ Hochschule der Künste,
Berlin 1999 ↘ Language: English ↘ © Stephan Huber, Ralph Ammer, Birte Steffan
Designers: Stephan Huber, 27, German ↘ stephan@cybrig.org 00101011101100110
↘ Talstrasse 21, 20359 Hamburg ↘ T. +49.40 317 95 859 10110101101001010
1973 +: living my life, 1996 +: studying "visuelle kommunikation" at the hdk berlin
Latest/personal projects: www.cybrig.org, www.digitalmind.de 1101100101110010
Inspirations: Depeche Mode, Surrogat, Tortoise, www.rsi-online.de and the rest
Birte Steffan, 27, German ↘ birte@hdk-berlin.de 0100010110110001011101001011
Final year at the HdK Berlin in the class for digital media of Prof. Joachim Sauter.
Latest/personal projects: "Any Place Before Now" is a personal space/ time map.
you can visit any place at every time before now ↘ www.anyplacebeforenow.org
Ralph Ammer, 26, German ↘ ralph@ammerart.de 011001011100010101110110110
↘ Greifswalderstr. 207, 10405 Berlin 0110011011001001101010110110001010011
*2.12.73, 1995-2000 Visual Communication at University of Arts, Berlin 0110010100
Latest/personal projects: www.ammerart.de 1001010010001001011101100101001010

SmartMoney Map of the Market ↘ www.smartmoney.com/marketmap 11011010010
SmartMoney.com ↘ New York City, 1998-2000. Language: English 0110010010010
Designer: Martin Wattenberg, 30, USA ↘ mwattenberg@smartmoney.com 110110
↘ 755 Broadway, 2nd Fl., New York, NY 10019, USA ↘ T. +1.212.830-9226 00101000
Martin Wattenberg is Director of Research and Development at SmartMoney.com,
where he led the team that developed the Map of the Market. In his spare time he
works on www.bewitched.com, an experimental digital art site. Wattenberg holds
a Ph.D. in mathematics. 11011010000110110001010110100010110110001010111
Latest/personal projects: www.bewitched.com 101000101101101110010110010001
11011001101010110110001010011011001001101010110110001010011011001001101
00011001101101011011000101001101100100110101011011000101001101100100110
10001100110110101101100010100110110010011010101101100010100110110010011

www.smashstatusquo.com 0010011101101011001010010100010010011101101011
Method, Inc. for ↘ Adobe ↘ San Francisco, 1999 ↘ Language: Various 0110010101
Designers: Olivier Chételat, Swiss, Henrikk Karlsson, Swedish 01101100100010111
↘ olivier@method.com 00101011101100011010010110110001011101001011010011
working at Method, Inc. New York ↘ www.method.com 0110010010001001011101
00110110001110010110010001001011101100101001010010001001011101100101001

www.snarg.net 111011001010010100010010011101101011001010010100010110
snarg, Anacortes, WA. USA, 1995-2000 & Antwerpen, Belgium, 1996 11010010010
↘ Language: English 110110101101001010010100010010011011010110100101001
Designer: Jef Morlan, 45, USA ↘ jef@snarg.net 11011010110100101001010001001
↘ 923 Washington St., Port Townsend, WA. 98368 USA ↘ T. +1.360.344.3701
↘ F. +1.360.344.4103 00110110100010110110001011101001011010011011010001
Short biography: www.snarg.net/bio/jef.html 01000101101101110010110010001011
Ranking: digitalsnargphlap 0010010111011010110010100101000100100111011010
Personal milestones: 45 years on this planet 11001010010100010010011101101011
Inspirations: love 0001100100010110100101000101011100010101110110010100010

sodaplay.com 11010010100010010011101101011001010010100010010011101011
creative play, London 1998 ↘ Language: Java ↘ © Soda Creative Technologies 1
Designer: Ed Burton, 28, British ↘ ed@soda.co.uk 00101011101100011010010111
works at Soda Creative Technologies Ltd. ↘ www.soda.co.uk 010000110110000101
First got into programming at the age of 10 when I got my hands on a 48K Sinclair
Spectrum, one touch of those rubber keys and I was hooked. When not tinkering
with computers I was as happy drawing and painting, my school uniform was
typically plastered in oil paint. This apparent geek/artist schism led me to a degree
in architecture, attracting me as the sort of subject where there are few barriers
between technology and creativity. 11011010000110110001010110100010110110
Career in architecture narrowly avoided when in a year out from studying archi-
tecture I completed a Masters course in Digital Arts at Middlesex University [DArt].
This somewhat esoteric course took mostly artists and designers and taught them
to make art by writing computer programs in the language 'C'. It proved even more
interesting that I'd anticipated and was invited to stay on for another three years
to teach on the course and develop the work I was doing in programming computer
models of children's drawing behaviour to PhD level. 00010011010010011001010
Career in academia narrowly avoided when a small group of former DArt students
and another DArt lecturer who had formed Soda Creative Technologies Ltd. a year
earlier invited me to join the soda team. I've been with Soda ever since, it's a
great team and we get to do great work. Best of all, we get to play too, soda-
constructor was originally one of my playthings, now it's grown into a worldwide
craze and a whole new business direction. 1011110010010010110110001011101101

191

135

137

067

071

073

081

065

155

www.stamen.com 0011011000100101011011010010010110010010110010011010101001
stamen.com, San Francisco, 1997-2000 ↘ Language: English 0001010110
stamen.com develops interactive narratives and original digital experiences. stamen
\Sta"men\, n.; pl. E. Stamens (used only in the second sense); L. Stamina (in the
first sense). [L. stamen the warp, a thread, fiber, akin to Gr. ? the warp, fr. ? to
stand, akin to E. stand. See Stand, and cf. Stamin, Stamina.] 1. A thread; especially,
a warp thread. In February 2000 the project took over a space at the epicenter of
San Francisco's gentrification effort. 0100101011011010010010110010010110010
Designer: Eric Rodenbeck, 30, American ↘ eric@stamen.com 01010110110010110
↘ 3012 16th Street #202, San Francisco, CA 94103, USA ↘ T. +1.415.621.2299 110110
Born in New York City, Eric studied architecture at The Cooper Union and History
and Philosophy of Technology at The New School. He has been living and working
in San Francisco since 1994. 010100101101101001001011001001011001001101010
1001010010110110100100101100100101100100110101010010100101101101001001011

www.suction.com 1001010010110110100100101100100101100100110101010010
graphic explorations / The Office for Fun and Profit, Inc., New York 1997-2000 1100
↘ Language: verbal diarrhea 0100101011011010010010110010010110010011010101
Designer: Eddie Pak, physically 26, Korean American ↘ epak@suction.com 01000
↘ 315 7th Avenue, #88, New York, NY 10001, USA ↘ T. 212.366.4365 01010011011
see author: ↘ Eddie Pak 0101001011011010010010110010010110010011010101001
0111011001010010110110100100101100100101100100110101010010100101101101001

www.sumea.com 10001010110110100100101100100101100100110101010010
Sumea Interactive, Finland 1999-2000 ↘ Language: English 01010011011010010010
Designers: Jarkko Salminen, 25, Finnish ↘ jarkko.salminen@sumea.com 110101
↘ Mäkelänkatu 21 C 21, 00550 Helsinki, Finland 0100101011011010010010110010
Born 1974. Has so far earned ten years of experience in the field of computer gra-
phics and BA in graphic design at the University of Art and Design Helsinki UIAH.
Latest projects/personal projects: www.m-cult.org 010010110110100100101100100
Personal milestones & inspirations: artist: Björk, designer: Saul Bass, magazine:
Eye, website: www.kioken.com, software: Lightwave 3D, game: Populous 1000101
Sami Arola, 24, Finnish ↘ sami.arola@sumea.com 010010110110100100101100100
↘ 4 Kauppiaskatu 13 a 50, 20100 Turku, Finland ↘ T. +358.40.5910 999 10010010
Born 1975, naked. Got my first computer at age of 8. Found immediate passion in
those beeping sounds and programming of all sorts of moving things... Trying to
desperately return from that path (without success by far). 00011010010011001010
Personal milestones & inspirations: Toys that inspire me usually make weird noises
and beats. Only drugs at the moment are progressive house/ trance music and a
fast network connection. Good websites - k10k.com, katastro.fi, pehmuste.com -
Trying to explore what REAL love is at the moment. 0100101101101001001011001
0111011001010010110110100100101100100101100100110101010010100101101101001

www.suture.net 0010110110100100101100100101100100110101010010100101
Jeremy Abbett, Hamburg 1996-2000 ↘ Language: English 1000101011011010010
Designer: Jeremy Abbett, 28, United States ↘ tai@suture.com 01101100101001010
works at Fork Unstable Media, New York ↘ www.fork.de 1101101001001011001001
↘ 184 Kent Avenue, Fifth Floor 5B Brooklyn, New York 11211 01001011011010010
↘ T. +1.917.548.8472 ↘ F. +1.718.384.1402 01001011011010010010110010010
Latest/personal projects: www.lab01.com, www.theremediproject.com 000101001
see author: ↘ Jeremy Abbett 0010110110100100101100100101100100110101010
0111011001010010110110100100101100100101100100110101010010100101101101001

Post Me ↘ www.swedengraphics.com 1100110110100100101100100101100100110
SWEDEN, Stockholm 1999 ↘ Language: all 0100101011011010010010110010010110
Designer: SWEDEN ↘ hello@swedengraphics.com 10110110010100101001010001001
Nille Svensson/ Magnus Åström ↘ T. +46.8.652.0066 ↘ F. +46.8.652.0033 10111011
1001010010110110100100101100100101100100110101010010100101101101001001011
0100011011010001011011000101110100101101001101101000101101100010111010010
0111011001010010110110100100101100100101100100110101010010100101101101001
1001010010110110100100101100100101100100110101010010100101101101001001011

www.tedbaker.co.uk 1001010010110110100100101100100101100100110101010
Blueberry.Net for ↘ Ted Baker ↘ London, July-October 1999 ↘ Language: English
↘ © Ted Baker 100110110100100101100100101100100110101010010100101101101
Designer: Tim Spear, 29, English ↘ tim.spear@blueberry.net 0110110010100101001
works at Blueberry.Net ↘ Number Ten, Second Floor, Marbour Yard, Chelsea
Harbour, London SW 10 OXD. UK ↘ C.: Nick Fulford ↘ T. +44.20.7351 33 13
↘ F. +44.20.7351 2478 ↘ www.blueberry.net 01000101101101110010110010001011
Sculpture graduate, now Head of Interactive at blueberry.net. involved in web,
projects from 1995. 01101100101001010010001001011101100101001010010001
Latest/personal projects: Developing blueberry interactive, new R&D and motion
graphics arm of blueberry.net. Personal projects include nowwashyourhands.com,
UK design & music community, wehaveinformation.com, and addntox.com, official
site for mute records artists. 0100101101101001001011001001011001001101010
Personal milestones & inspirations: toys - stuff with flashing lights on ↘ music -
tons. post rock, warp stuff, noise ↘ drugs - can't remember. ↘ websites -
l-o-u-d-l-a-n-d.com, archinect.com, jodi.org 0100101101101001001011001001011
0111011001010010110110100100101100100101100100110101010010100101101101001

www.testpilotcollective.com 10010110110100100101100100101100100110101010
Digital Type Foundry & Design Studio, Minneapolis, MN, V1_1998, V2_1999,
V3_2000 ↘ Language: English 1001010010110110100100101100100101100100110
Designers: Joseph Kral, 26, American ↘ kral@testpilotcollective.com 1001010010
Matthew Desmond, 23, American ↘ matt@testpilotcollective.com 1001010010
↘ 100 Scott Street #4, San Francisco, CA 94107, USA ↘ T. +1.415.626.5860 0110010
Test Pilot Collective was formed in 1998 as a vehicle to distribute our unique type-
faces, develop custom typefaces and to produce fresh and innovative design work.

www.theapt.com
Method, Inc. for ↘ TheApartment ↘ © TheApartment
San Francisco, 2000 ↘ Language: English
Designers: Alexander Baumgardt, German ↘ alex@method.com
Erik Engstroem, Swedish ↘ erik@method.com
working at Method, Inc. ↘ www.method.com
see author: ↘ Alexander Baumgardt

www.tree-axis.com
Tree-Axis, San Francisco 1998-1999 ↘ Language: English
Designers: Stella Lai, 25, Hong Kong ↘ stella@tree-axis.com
Krister Olsson, 25, USA ↘ krister@tree-axis.com
working in San Francisco ↘ 1025 17th Street, #1, San Francisco, CA 94107, USA
↘ T. +1.415.355.1330 ↘ F. +1.415.355.1331
Tree-Axis is a web design firm founded by Stella Lai and Krister Olsson in 1998. The
firm is located in San Francisco's Potrero Hill district - ground zero for the next
generation of Internet companies and birthplace of American hero O.J. Simpson.
Latest/personal projects: Remedi project soon. New website soon. Massaging
corporate egos now.
Ranking: Krister ↘ Murakami Haruki (author), Machino Henmaru (comic author),
Isis (cat), Kawakubo Rei/ Comme des Garçons (fashion designer), House of the
Dead II (game)
Stella ↘ Pupi (cat), Thelonious Monk (musician), Miyazaki Hayao (director), John
Fante (author), House of the Dead II (game)

turux-b ↘ **www.turux.org**
Europe, Japan ↘ Language: /
© dextro/turux ↘ page 208, 210, 211, 212, 213, 214 - lia/turux ↘ page 209, 215
Designer: dextro, /, Austrian ↘ dextro@dextro.org
Place of work: various ↘ dextro.org
lia, /, Austrian ↘ lia@sil.at
Place of work: various ↘ re-move.org, www.silverserver.co.at/lia
Inspirations: "liquid sky", laurie anderson, "art forms in nature", ghb

www.typographic.com
Typographic, 1996 - present ↘ Language: English
Designer: Jimmy Chen, 30, Taiwanese/American ↘ jimmy@typographic.com
works at Typographic ↘ 443 South Cochran Avenue, Number 201, Los Angeles,
California, USA
Jimmy Chen started out as a designer for a health care company in Burbank, CA.
Eventually migrated into web design and served as a creative director at eLogic
in Venice, CA., designing web sites for clients such as The Getty Center,
Warner/Chappell Music, and Discovery Records, among others. In 1996, Jimmy
launched typographic, a site dedicated to the personal exploration of design and
technology. In 1997, Jimmy worked at Studio Archetype in San Francisco, then
returned to LA in 1998. Worked at Genex as an art director at 1999. Now as typo-
graphic, Jimmy developed web sites for clients such as MTV, Elektra Records,
Atlantic Records, The Getty Center, Sony and Warner Bros. Jimmy's work has
been recognized by Print, How, Communication Arts, and multiple domestic and
foreign design books.
Latest/personal projects: Summer@TheWb.com ↘ calendar.thewb.com, Calvin
Klein Network ↘ ckjnetwork.mtv.com, The Getty Center ↘ www.getty.edu, Adobe
Profile ↘ www.adobe.com/web/gallery/typographic/main.html
Personal milestones & inspirations: Television, alcoholic beverages, pretty pictures,
LAN, 70 degrees weather, home deliveries...

www.typospace.com
Thomas Noller, various, 1996 - 2000 ↘ Language: English
Designer: Thomas Noller, German ↘ tnoller@typospace.com
works at Method, Inc. New York ↘ www.method.com
see author: ↘ Thomas Noller

www.uncontrol.com
NYC, April 2000 - present ↘ Language: English
Designer: Manuel Tan, 24, Phillipines ↘ manatee@uncontrol.com
↘ 39-55 51st Street, Apt 6B, Woodside, N.Y., 11377, USA
↘ T. +1.646.638.9783 / +1.718.898.0912 ↘ F. +1.646.638.9716
works at Rare Medium, Inc. ↘ 28 west 23rd street, 5th floor, New York, N.Y., 10010,
USA ↘ www.raremedium.com
Born in Phillipines. Raised in Queens, NYC, Started with an Engineering degree and
came out of college with a communication design degree. Interned at TwoTwelve
Associates. Working for I0360° Digital Design and Rare Medium. Started with
Supercard, then Director, than Flash. Websites: I was involved in: www.nytoday.com,
shop.microsoft.com, www.tutopia.com, and a bunch of small projects.
Latest/personal projects: exe.raremedium.com
Milestones: grinding on a park bench with my rollerblades, finally having the abilty
to buy things.
Inspirations: Video games, Nature, Modern Furniture ↘ Toys: Macross, Bandai
Models, and all sorts of gadgets and gizmos ↘ Music: Diana Ross, Black Starr,
Massive Attack and anything else i can find on Napster ↘ Favorite Web sites:
www.turux.org, sodaplay.com, shockfusion.com ↘ Love: would love to someday
↘ Drugs: Nicotine, Ebay

www.vectorama.org
Display, Switzerland (Basel/Lucerne), spring/summer 2000 ↘ Language: English
Display Headquarter ↘ Neustadtstrasse 38, CH-6003 Luzern ↘ T. +41.41.360.2458 /
+41.76.348.9680
Designers: Urs Lehni, 25, Swiss ↘ lehni@gmx.ch
Born in 1974 in the Swiss primitive and never moved out of there ever since.
School of art and design in Lucerne.
Personal milestones & inspirations: pong/dub/weed
Rafael Koch, 23, Swiss ↘ r.koch@gmx.ch
Born, 23 years ago in the loveley heart of Switzerland. Sometimes moving out of
this place for holidays and work experiences, at the moment resting in the
Lucerne Display-HQ.
Personal milestones & inspirations: mags, tv and popcorn
Juerg Lehni, 22, Swiss ↘ lehni@gmx.net
1978 born in Ballwil, Lucerne. ↘ 1991 - 1998 High Scool in Luzern with graduation.
↘ 1999 practical course in Hyperstudio, Basel. ↘ 2000+ studies at Hyperwerk,
Basel, a course of studies for new media design.
Latest/personal projects: Rubik Maker (see page in this book), server sided
programming for freitag online shop: www.freitag.ch
Personal milestones & inspirations: Toys: Digital Ixus ↘ Music: moloko, Leftfield,
DJ Vadim, Kid koala, Les Rhytmes Digitales,... ↘ Websites: www.webmedia.co.nz,
www.yugop.com, www.noodlebox/classic, sodaplay.com, www.mobilesdisco.com

www.vir2l.com
Vir2L, a division of ZeniMax Media Inc., 2000 ↘ Language: English
Designers: Vir2L ↘ artists@vir2l.com
↘ 1370 Piccard Drive, Suite 120, Rockville, Maryland 20850, USA ↘ C.: Douglas
Frederick, President ↘ T. +1.301.948 2200 ↘ F. +1.301.948 2253

www.volumeone.com
Designer: Matt Owens, 29, Texan ↘ matt@volumeone.com
works at one9ine ↘ www.one9ine.com
↘ 54 W. 21st St., Suite 607 New York, NY 10010, USA ↘ T. + F. +1.212.929.7828
see author: ↘ Matt Owens

www.wallpaper.com
I-D Media London for ↘ Wallpaper* ↘ London 1999 –2000 (ongoing)
↘ Language: English
Designers: I-D Media ↘ contact@i-dmedia.com ↘ www.i-dmedia.com

MONO*crafts ↘ **www.yugop.com**
MONO*crafts ↘ Japan, Summer 1999, Language: English
Designer: YUGO Nakamura, 29, Japanese ↘ yugo@yugop.com
works in Tokyo ↘ 302 MM-Building, 2-8-9 Miyazaki, Miyamae, Kawasaki, Kanagawa,
Japan 216-0033
1970 - born in Nara/Japan ↘ 1988-95 - University of Tokyo, School of engineering,
studied Landscape design, Stuructural engineering and so on ↘ 1996-1999 - worked
as a designer/engineer of large-scale structure. ↘2000- Web-Designer.
Latest/personal projects: www.kiriya.com

www.52mm.com
52mm, New York City 1998-2000 ↘ Language: English
Designer: Marilyn Devedjiev, 29, Filipino/Bulgarian, American Born
↘ typediva@52mm.com
works in New York ↘ 52mm, 12 John St., 10th Floor. New York, NY 10038, USA
↘ T. +1.212.766.8035 ↘ F. +1.212.766.8035
 A neutral thought / in defiance of disassociation
 relating to inactivity / in defiance of judgement
 relating to grandeur / a mirage
 and sometimes I find money in the street.
Latest/personal projects: www.product52.com. It's the new thing.
Personal milestones & inspirations: March 30, 1971. April 15, 1989. April 3, 1994.
August 26, 1996. January 1, 2000. March 30, 2000. April 1, 2000. July 1, 2000.
August 1, 2000.

002 Editor: Jan Rikus Hillmann, 30 ↘ hillmann@its-immaterial.com 0010101101100100110010010001011001100010100
works at It's Immaterial, Berlin ↘ www.its-immaterial.com 1101100101000101011001
see index: ↘ www.audi.de/konfigurator 100100101100100101100101000101001
Following a general design degree at the FH University in Cologne, where he specialized in communication design and new media, Jan Rikus Hillmann began working with multimedia agency Pixelpark in Berlin in the middle of 1995 and later that year took over as design director of their online magazine, Wildpark. After having been art director on a number of diverse online projects he moved to MetaDesign Plus GmbH in 1998 as senior designer for online development, conception and design management. In May 2000 he founded It's Immaterial GmbH, an agency for strategic media consultancy, where he now works as managing creative director. 110100010101101100101000101001100100010010111000
His other professional activities and appointments between 1995 and 2000 include the formation and design directorship of the newspaper publisher De:Bug Verlag GmbH with responsibility for content and visual development, production management and lay-out/design of De:Bug magazine for electronic aspects of living. In addition, Jan Rikus Hillmann works as a freelance designer in among other areas: design conception, design and production of flyers, CD and record covers, corporate design, branding for the recording industry, PR/entertainment and software. Jan Rikus Hillmann lives and works in Berlin. 0010111100010010110111011
0010010010110110101100101000101011001001010010010100101000101011011

002 Editor: Vicky Tiegelkamp, 33 ↘ vicky@playframe.de 0110010010010101001010010100010100100110010011000101 180
↘ Wollinerstrasse 18-19, 10435 Berlin, Germany ↘ www.playframe.de 000101111C
see index: ↘ www.net-150.de 0010011000100101001010010010001001010010010010001011100001
Vicky Tiegelkamp worked in her home city of Cologne, then in Hamburg and Berlin holding various positions within the media industry. Since 1995 she has concentrated on design and concept development for the Web, for, among others, multimedia agencies such as Pixelpart, IXL and MetaDesign Berlin. From 1997 to 1999 she worked at MetaDesign, developing the content strategies for sites such as the Audi-TT. 010110010001010010001001010101001010010010110000101011011
At the same time she co-founded the Berlin based De:Bug and edited the new media and web design sections. In the summer of 2000 together with co-founder Patrick Boltz she set up playframe digital media studio. playframe is dedicated to online format development. The focus here is on integrating narrative methods and instruments such as film and video, in order to achieve a new and particular form of brand and product staging. playframe's first project is the Interview Channel Net-150.de with online designers, journalists and others. 100011110001
0010100010110101010010010110010110011000011100100110011000110010100

070 Author: Jeremy Abbett, 28 ↘ tail@suture.com, jeremy@fork.de 010101000101001010010110010001011000101001001001100010100
works at Fork Unstable Media, New York ↘ www.fork.de, www.4rk.com 101111011
see index: ↘ www.suture.com 0001011001001010010010001001010010010010110
Latest/personal projects: 011101010001011001101000001100100110011000011111
www.lab01.com, www.theremediproject.com, www.popinger.com 001100100100001
00101000101011011010110010010010010010001010110010001

096 Author: Alexander Baumgardt, 27 ↘ alex@method.com 10100010001011001110000111001011001001011001001010 046
works at Method Inc. ↘ www.method.com 100010010110010001010010010001110011000110
Autodidact.... ↘ Companies: pixelpark, freelance, metadesign, method ↘ Projects: wildpark.de, tagesschau.de, audi.com, audi-tt.com 000110110100110010011000111000
Latest/personal projects: 1011010100010110011010000011001001100110000111000
www.theapt.com, www.versus.de 0110010001001010010010001001010010001011
Personal milestones & inspirations: 0010010010010010010001010010010001
1. my son, Laurenz 2. my wife, Sophie 3. San Francisco 4. Berlin 5. getting kicked out of school 1011011001100101001010010011010000001100100110011000011001000
0010100101011011010110010010010010010001011010110010001

010 Author: Gui Bonsiepe, 66 ↘ bonsiepe@ds.fh-koeln.de 101000100100110000110010010010001001001100101
works at Design Department, University of Supplied Sciences, Cologne (Germany), teaching interface design. 0010010010100100100100100110010100010100
↘ Brabanter Strasse # 55, Koeln, Deutschland ↘ F. +1.221.952.0514 1001000011101 022
↘ www.ds.fh-koeln.de/-bonsiepe 0010010010010010010010010001010010001
Studied information design at the HfG Design Institute, Ulm, Germany. Worked mainly in South America (Chile, Argentina, Brazil). 3-years as interface designer in a softwarehouse in Berkeley. Published various books on design, including "Interface: An Approach to Design" (Maastricht: Jan van Eyck Academy 1999) and others in English 100110100001110010010010010010011001100101100101000
Latest personal/ commercial projects: 00100100101001001001000101010010001
Interface for an intranet-based knowledge management software (together with G. Joost and M. Ort); site, cd and book on technological innovation for industries (in Brazilian Portuguese) for the National Industries Association, Brazil. 01100110
↘ 100110010010010010010010010010010010010010000
Milestones (though I am sceptical about that): 1001010010010010010100
Having had the good luck to have met A A, moving from Europe to Latin America, getting a critical handbook for industrial design published in Italy (1975), getting involved in interface design in 1987 ↘ Inspirations: I don't get them, I produce them. ↘ Toys: made of recycled material and found in popular markets in peripheral countries ↘ Music: Brazilian songs by Chico Buarque and Caetano Veloso ↘ Websites: praystation.com 100010011001101100001100110010010010010010001010010

034 Author: Jonathan Briggs, 39 ↘ jonathan@othermedia.com 010001100110010100100100100110010010001100101 086
works at the OTHER media, (15 km from London) 0000011001100100110001000011
↘ the OTHER media, 11 Penrhyn Road, Kingston on Thames, K11 2BZ, UK 01011

↘ C.: George Crabb ↘ T. +44.20.8541 5355 ↘ F. +44.20.8541 5507 110011001000111
↘ www.othermedia.com 001100100101001001100010001100100010
Professor of New Media Design at Kingston University in SW London. Trained in computing and information systems but has fallen in love with new media as the creative, technical and business worlds collide. Wanted to combine teaching with doing, so started the OTHER media with 2 colleagues, now 26 people. Four years ago started Hyper Island School of New Media Design in Sweden. Consults, speaks and writes for all sorts of people including the EU, DEMOS, Unilever and Virgin. Fellow of the British American Project. 011001101100000111001001100110010010100
Latest personal/ commercial projects: 011001101100100110010010010001100
www.worldbookdealers.com, www.virginstudent.com, www.otherobjects.com 110
Personal milestones & inspirations: 110011001100110011001100110010001100
Things that bring me pleasure: being upgraded, long drives, big skys, trips around the harbour, psychological crime novels ↘ Toys: espresso machine, Palm V, GPS, mobile phone, bread maker ↘ Music: Gregorian chants, Cafe del Mar, whatever is playing on the car radio ↘ Drugs: chilled Sauvignon Blanc, chocolate, whatever is in mixed nuts ↘ Must haves: silence when I'm thinking or writing, long hot baths, great people to work with, at least two future travels to look forward to, an audience ↘ Would like: longer days, browser compatibility, cloning ↘ Love: Nick, my partner in all senses of the word 10110000011100100110010010011001100101

Author: Da5d, 29 ↘ da5d@fork.de 11010110110010010010010100100100100100100100110010110
works at Fork Unstable Media in Hamburg/Berlin ↘ www.fork.de 001010010010010110
see index: ↘ feed.de, nolo.de, fork.de 01100101011011010110010010001100101
David Linderman: Born: August 27, 1970; Education: University of Wisconsin-Stout, BFA Art concentration: graphic design; Work Experience: 1994: Meire und Meire, Cologne ↘ 1995: Springer & Jacoby, multimedia department, Hamburg ↘ 1996: founded Fork Unstable Media.
Fork is characterized by its makers' sense of rootlessness in the modern world. A recurring theme throughout the site is the questioning of the notion of "home", and, in turn, related notions such as nationhood. The studio combines the talents of both American and German designers, a fact which is constantly alluded to and played with. Forks early history was founded in creative play with diverse web formats using games and unusual interfaces as well as a unique visual language in creating truly immersive experiences on the Web. 00000011101001100110010010110
Latest personal/commercial projects: 010110010110001011001001100010010
Fork site, promotions, Ultramegafinanz toolsite, Sonar Art Festival installation "doglovers", Berlin Beta programming, creative direction, Hamburg. 011001100111
Top 5: lo-tech, hi-tech, no-tech, last, update 0110010010010010010010001001001
Personal milestones & inspirations: 0010010010110010010010010010010
farmhand, biblebanger, c64, breakdance, skate, 286, smalltown, architectural drafting, snowboard, lisa, mac, macpaint, girls, clothes, hair, school, art, quark, work, fork, grass, booze, crack, feed. god. dog. love. deutschland. - citykid. 111001
0010010010010010110100110010010001010010110100110010010010010010010

Author: Joshua Davis, 29 ↘ CHAOS@praystation.com 0100100101100101101001001001001001001100110
works at Kioken Inc. ↘ kioken.com 10001010010010010010010001001100100110010110
see index: ↘ www.once-upon-a-forest.com 0100100101001001001001001001001001
PrayStation.com (maintained by Joshua Davis) is a one-man research and development website. Its objective is to apply design and technology to a collection of small, sometimes daily, modules. 010010010110011110111011111010010001001
Once-upon-a-forest.com is the nemesis of what we perceive the Web to be. No easy, short domain name. No easy to use navigation. No instructions. No Faq's. No Ads, No Links, No Tech Support. No Help. No Answers. 11001001100110010010011001
Latest personal/commercial projects: 010110010110010010010010010001100110
personal: dreamless.org, commercial: barneys.com 10000011100110010010010010
Personal milestones & inspirations: May I skip this question please. 001100100111
0010010010010110010100110110010010001010010001011001010010010010100

Author: Tanja Diezmann, 31 ↘ diezmann@pre-view.de 01001001001100100100110010110 022
works in Dessau and Berlin, Germany ↘ pReview digital design GmbH 100011001
↘ Schwedterstr. 34A, 10435 Berlin ↘ F. +49.30.44008164 01001001001001001001100110
Born 1969. Studied visual design at the FH Technical University for Design, Schwäbisch Gmünd, Germany, 1990-1994. ↘ Advanced studies at the HdK, Berlin, 1994-1995. ↘ Artdirector, Pixelpark, Berlin, 1994-1995. ↘ Creative director, Pixelpark, Berlin, 1995-1998. ↘ Lecturer at various technical universities, vocational colleges and management institutes, 1994-1998. ↘ Co-Founder with Tobias Gremmler of the pReview group (Digital Design | Interface Design), 1997. ↘ Appointed to a Chair in Interfacedesign in the Faculty of Design at the FH Anhalt Technical University in Dessau, Germany, 1998. ↘ On tour as VJ (generic visuals) since 1999. ↘ Founder of pReview digital design GmbH, Berlin, 2000
Latest personal/commercial projects: 010010010110010010010010010001100100010
Address Vision (Project to develop a visionary workflow management interface); Generic visuals - digital VJ Engine; 25 students each term 100100110011001001001
Personal milestones & inspirations: 00100100101001001001001001001001001010
nature, 1 bit classic mac, studio 1/LSG, digital (interactivity/programming/timebased), shotokan karate 101011001001001001001001001001001001001001010010010010010

086 Author: Sabine Fischer, 28 ↘ koenigin@its-immaterial.com 010100100110010010001001001100101
works at it's immaterial Gmbh, Berlin ↘ Winterfeldtstrasse 7, 10781 Berlin 00111
↘ T. +49.172.3090660 ↘ www.its-immaterial.com 0001100100110010010010010011001

Degree in Media Consultancy, German Literature/ self-employed print journalist/
self-employed TV journalist/ online manager, Pixelpark AG/ on-line general
manager, MetaDesign GmbH/ managing partner, it's immaterial GmbH 111001
First project: www.wildpark.com 0010011011000011001001100100011100101
Nihil in intellectu, quod non ante in sensu. 011000001100110110010011001011001010
0011001101100011001001101001101001100011100100110111001011001

110
Author: Ansgar Hiller, 31 ↘ ansgar@planetpixel.de 001001100111000011100100110100011001011
with Anja Wülfing, Oliver Funke | works at Planet Pixel, Cologne ↘ www.planetpixel.de 111001011001110110010010001001
Born 5 March 1969 in Cologne, Germany, school leaving certificate, 1989 ↘ work
experience at Meiré and Meiré, 1989-1991 ↘ studied at the FH Cologne Technical
University, Design Faculty, 1991-1996 ↘ 2&3D – Blum, Hiller, Strecke gbr, 1993-
1996 ↘ emanon creartive network – Han, Hiller, Strecke gbr, 1996-7 ↘ planet
pixel – Funke, Hiller, Wülfing gbr, 1997 001011001100100110010011001100100011001
Latest personal/ commercial projects: www.planetpixel.de 011000001101100100011001
Personal milestones & inspirations: 011001011000011001001100100010011000
1. www.stinkymeat.net (very greenawayesque), 2. I love you, 3. Michael Schuhmacher,
4. the CocaCola logo, 5. Big Brother 011001011000011001001100100011001101000

101

www.m9ndfukc.com/botz – www.m9ndfukc.com/bit_revolution/ 01100101111000001
Milestones: present ↘ Inspirations: you ↘ Toys: you ↘ Websites: 127.0.0.1
↘ Music: www.m9ndfukc.org/krop3rom ↘ Love: you ↘ Drugs: you + coca cola +
fr. zigaretten = genial 11010001100111000011001001111000001110011001101001001
0010110010011001011010111000011001001100010011001001100101100101

Author: Thomas Noller, 35 ↘ thomas@method.com 0010011001011001001100011001011
works in San Francisco ↘ www.method.com 0110010011001001100011001011001011
see index: ↘ www.typospace.com 0110010011001001100010011001011001011001
Born in Darmstadt, Germany. Degree in Design (Dipl. Designer) from the FH
Darmstadt Technical University, 1989 ↘ Fulbright Scholarship to the Pratt
Institute, New York City, 1994-7; MetaDesign, Berlin, 1997-1999 ↘ Method, San
Francisco, 1999-present 110010011001001100011001001100101100100110010011
Latest personal/ commercial projects: 010011001101100001110010011001001100110
www.typospace.com (updated!), www.aro.net, defytherules.com
No ranking, just a cloud of inspiration: 0110010011001001100010011001011001011001
my parents, Murial Cooper, Alexander Rodtschenko, Herbert Bayer, Charles and
Ray Eames and, and, and....... 0101100100110011011001011001011001011001011001
0010110010011001011010110111000011001001100010011001001100101100101

110

Author: Netochka Nezvanova, 23 ↘ f1f0@m9ndfukc.com, eldysone@eusociaz.com 0001111000011001001100010010
works in Copenhagen, Denmark 0001011001100011001001100101100101100101
↘ c/o Babeltech A/S, Estromgade 15 opq 3, 2200 KBH N – Denmark 01100110011001011
see index: ↘ www.m9ndfukc.com 01100100110010011001001101100101
1994-1997 bachelor of music ↘ 1994-97; canterbury university nz, victoria university
of wellington nz, major in electro-acoustic composition, physics and technology;
honours paper – electro-acoustic composition, music and technology ↘ 1997
2 performance pieces – untitled; krop3rom||a9ff audio cd released ↘ 1998 play –
scrutiny my versions 7; audio, graphics, internet software released; pursuing a
degree in performance studies; 8'|sin.x(2^n) audio cd released; a number of
internet presentations and installations; invitations/commissions refused and
accepted from farmers manual, schoemer-haus, cagliari electro-acoustic society,
ORF kunstradio, deaf-v2 amsterdam. leonardo music journal. teleportacia etc.;
articles / interviews for several publications. ↘ 1999 several audio, graphics,
internet software / installations including: nebula.m81. kinematek 0+2. kiberzveta.
mmf9; noctilucent – ektachrome 020 utilized at the Modern Art Museum of Chile;
Musee d'art moderne de la ville de Paris. and several universities; "=cw4t7abs
net action" at the international festival of computer arts in maribor/slovenia - the
festival presented =cw4t7abs internet activism and works; plant syntax - austra-
lia; 1st prize at the 4th INTERNATIONAL COMPETITION MUSICAL SOFTWARE,
BOURGES 1999; ZAC 99 Zone d'activation collective Musee d'art moderne de la
ville de Paris ↘ 2000 nato.0+55+3d modular - virtual reality. 3d. audio + video
environment for macintosh computers; nato.0+00 – internet installation;
nato.0+24 – internet installation; 242.055.antisense - 127.0.0.1 + internet installation;
242.055.pathogen - video agitazie; invitations/commissions/competitions: x-00 event -
France, Gallery ERSEP - Austria| France, farmers manual - Austria; steim -
Netherlands, dfi - Britain, sonar - Spain, Ircam - France, browserday - Netherlands,
history of net.art: alternative museum - USA, "MÈtamorphoses" music compÈtition -
France, audiovisualizers - Canada, BEK - Norway, V2 - Netherlands, schrek ensemble -
Netherlands, 72dpi - Deutschland 0000101100110110010011001001100100011001
Latest personal/commercial projects: 010110011011000011001001100100010011110
↘ agitazie: www.membank.org – www.m9ndfukc.com/v0r0m_3k0r/akkumultr/ 1001
www.freedemo.org/ // karefl – 194.19.130.194/spCa/zveite – www.dfi.org.uk 0110010
www.m9ndfukc.com/kontinuum // karefl – www.m9ndfukc.com/propaganda 0011
↘ web based stochastik image processing: www.m9ndfukc.org/nato.0+00 100110
↘ web based film sampler: www.m9ndfukc.org/nato.0+24 001001100110010011
↘ film played by web based kinematek: 1011001101100100110010011001010011
www.m9ndfukc.com/botz/kinematek_kurrent.html 11000001100101100101001001
↘ web based kinematek: www.m9ndfukc.com/kinematek [with audio] 0100110011
www.m9ndfukc.com/kinematek/zttz [sans audio] 001101100001100101100101
↘ nebula.m81 article etc.: 1100101101100010011000110010010011001011001011
www.m9ndfukc.org/data/t!pe.t!pe/Nebula.m81||USISK.sit.hqx 0000100110011001
www.gmeb.fr/SoftwareCompetition/Softs99/nebulam81.html 00010011001100110
↘ nebula.m81 zkreenshotz: 1001011011000100110001100100100110010110
www.m9ndfukc.org/propaganda/zekuensz/_nebula.m81.000.gif.hTmL 01100111
↘ nebula.m81 audio output: www.m9ndfukc.com/noisz/m_81.0+2_output 1100111
↘ web based nebula.m81 - ultra inferior to the application: www.m9ndfukc.com/nebula_m81
↘ nato.0+55.modular - realtime 2d.3d.vr.streaming etc - program: 1000001001100
www.m9ndfukc.org/korporat/nato.0+55+3d.html - www.eusocial.com 0010011001
www.m9ndfukc.org/nato.0+55/ 011001011000011001001100100010011110010011
↘ downloadable programs: www.m9ndfukc.org/kode/m0dL+c1t1z3n.sit.bin 00011
www.m9ndfukc.org/kode/%21%3dz2c%21ja.sit.bin 0110010011001001100110010
www.m9ndfukc.org/kode/0c3.sndhak.module.sit.bin 1100000110010110010011010
www.m9ndfukc.org/kode/0f0003pRpG.sit.bin 1100001100101100010011001011001
www.m9ndfukc.org/kode/k%21berzveta%7c%7c.sit.bin 001110001100100110010010
eusocial.com/nato.0+55+3d/gm/242.055.antisense.sit.bin 0100111100001101100110
eusocial.com/nato.0+55+3d/gm/242.055.pathogen.sit.bin 100111100000110100110000
www.m9ndfukc.org/kode/%40%25a631%25a8%10%25a5d9%20%7c%20%7c.sit.bin
↘ tekst: www.m9ndfukc.com/forum/prev_released_data 0111000011001001100100
www.m9ndfukc.org/korporat/=cw4t7abs.3nkod0r..0+2.html 011110011001000110
www.m9ndfukc.org/korporat/starledger_inter.bzzp.html 011110000111010000111

204 156 134 062

Author: Matt Owens, 29 ↘ matt@volumeone.com 11001001100101100100110001100110010
works at one9ine ↘ www.one9ine.com 0110010011001001100011001011001011
see index: ↘ www.volumeone.com 011001001100100110001001100101100101001
Matt Owens served as the creative director at web developer MethodFive in New
York, designing websites for clients such as Apple, the American Lung
Association, and Toshiba, among others. In 1997 Matt launched volumeone, a
design studio dedicated to exploring narrative on the Internet and to pushing the
limits of available design technologies online. In turn, volumeone brought an
integrated, cross-media approach to projects such as the Crittercam Chronicles
feature for National Geographic's website, as well developing content features for
Altoids, Razorfish, and Quokka Sports. IN 1999, TOGETHER WITH PARTNER
WARREN CORBITT, Matt founded one9ine is a design company specializing in
visual communications for print, broadcast and interactive media. BOTH Warren
Corbitt and Matt Owens share a broad and in-depth knowledge ranging from
editorial redesign, brand identity development, website development, consulting,
and creative direction. 10110010010001011001100001100100110010011001000110010
Latest personal/ commercial projects: 0101100110110000111001001100100011001001
www.one9ine.com (professional), www.volumeone.com (personal) 00110011001000
0010110010011001011010111000011001001100010011001001100101100101

Author: Eddie Pak, 26 ↘ epak@suction.com 10110010011001001100011001011001011001
works in New York at The Office for Fun and Profit, Inc. ↘ www.theOFP.com 001000111
315 7th Avenue #8B, New York City, NY 10001 00100110011001001100011001011001011
see index: ↘ www.suction.com 01100100110010011001001100011001011001011001
I: grew up in the suburbs of New York City; my best friend got killed in 1st grade;
got mugged in Penn Station as a teenager; loved Club Homeboy and Search for
Animal Chin; got sent to boarding school; thought existentialism was cool; wor-
ked at Shiseido one summer during high school and got discounts on cosmetics
for my mom; drove up to Boston to hear Vaughan Oliver speak about his 4AD
work; attended Carnegie Mellon University for architecture; worked as founding
design director at Plumbdesign (NYC); continuously watched 3 months of daytime
TV and nighttime public access; drank a little too much; got confused in
Amsterdam with David Yu; am a partner of The Office for Fun and Profit (NYC) and
wish to become a new wave DJ. 101100100110010011001001100011001011001011001
Latest/personal projects: 1010001011001101100100111001001100100011001001100
The Office for Fun and Profit, Inc. - company ↘ theOFP.com; Sasha + John Digweed :
Communicate US TV commercial - design (dir. Stacie Passon); Donna Karan training
video - design (dir. Stacie Passon); Coldcut/Steve Reich music video - design (dir.
Jeremy Hollister); UV115.com fashion & lifestyles e-commerce Website and shirt
designs; Rebecca Taylor fashion design Website; MTV.com - graphics; BMX free-
styling - relearn cherry-pickers and miami-hoppers 110110010011001001100101100
Personal milestones & inspirations: 01011001011000011001001100100010011001011
Unfortunately there is always law and gravity to get in the way of desires. 10011001
Here is some music I've been listening to recently:
Def Leppard - Photograph, Fischerspooner - Turn On, Bad Company & Trace -Nitrous,
Doomer's mix MD, Boxcar - Freemason, Sisters of Mercy - Lucretia My Reflection,
Scandal Featuring Patti Smyth - The Warrior, the theme song from Gladiator,
Radiohead - Fake Plastic Trees, Belinda Carlisle - Heaven is a Place on Earth 010
0110010110000011001001100100010011001011001011001011001011001011

Author: Molly W. Steenson, 28 ↘ msteenson@scient.com 011001100100110011001001
works in San Francisco and Munich ↘ www.scient.com 11000110011001000110011001
↘ Scient, 1 Front Street, San Francisco, CA 94111 1001001100110010011001001100
↘ Girlwonder, 81 1/2 Bessie Street,1 Front Street, San Francisco, CA 94111,USA 00
↘ T. +1.415.733.8200 ↘ F. +1.415.733.8299 01100100110010011001001100011001
I'm a: Customer Experience Architect, Content Strategist, of course I'm chaotic,
on some days, and a supervisionary 100100110011001001100100110010011001001
Latest personal/ commercial projects: 1000010110011011000011100100110010001100
The latest commercial ones aren't live! But I'm also the proprietress of Girlwonder
↘ www.girlwonder.com 01100100110010011001001100011001011001011001011
Personal milestones & inspirations: learning to talk, learning to cook, leaving the
US, being able to leap tall buildings in a single bound, just like Superman,
remembering people's phone numbers forever (20+ years) 001100011000110000011

72-dpi

Edited by R.Klanten, H.Hellige, M. Mischler,
V.Tiegelkamp, J.R.Hillmannn

Layout and design by Birga Meyer
Cover image courtesy of Dextro (www.turux.org)
Executive management by Hendrik Hellige
Text editors: Vicky Tiegelkamp & Jan-Rikus Hillmann
Art direction by Robert Klanten

Texts by:
Jan Rikus Hillmann
Vicky Tiegelkamp
Jeremy Abbett
Alexander Baumgardt
Gui Bonsiepe
Jonathan Briggs
Joshua Davis
Tanja Diezmann
Sabine Fischer
Ansgar Hiller
David Linderman
Netochka Nezvanova
Thomas Noller
Matt Owens
Eddie Pak
Molly W. Steenson

Translations by Helen Kelly-Holmes

Printed with Hexachrome Technology
by Engelhardt und Bauer, Karlsruhe
Production research and management
by Ivan Perez and Hendrik Hellige

Made in Europe

Die Deutsche Bibliothek-CIP Einheitsaufnahme
72 dpi
hrsg. von Robert Klanten, Hendrik Hellige,
Michael Mischler. Berlin:
Die Gestalten Verlag, 2000
ISBN 3-931126-35-8

For you local dgv distributor please check out:
www.die-gestalten.de

For more information about the people and the websites
please use the insert like this.